Those who have spent the most time with him are both frustrated and inspired. To know him is to know that you probably will never really know him and to question that is a waste of time ... wasting time is something one should never do ... and something Prince holds in high disregard. He is passionate and funny and smarter than any of you will probably ever believe ... he stretches everyone around him and I'm not sure he even understands why ... and those who get it without trying to understand soar and grow creatively in a way they probably could not find on their own ... it is not a manipulation for control's sake as

it is often judged … it is a way of being … a way of constantly stirring things up … a conduit to achieve creative exhaustion … so that you just do whatever it is you do, free of the limits of how you think you should do it … you are simply forced to trust yourself and to trust him … and in the end it is a gift, one that you have worked very hard for and there is great satisfaction in that. Now that you know this you will see him as I have seen him over these few weeks during the summer of 2007 in a city we hold synonymous with royalty … fitting for a Prince … a man … a musician … an artist who is truly like no other.

—Randee St. Nicholas

PRINCE/RANDEE ST.

NICHOLAS

21 NIGHTS

ATRIA BOOKS | NEW YORK LONDON TORONTO SYDNEY

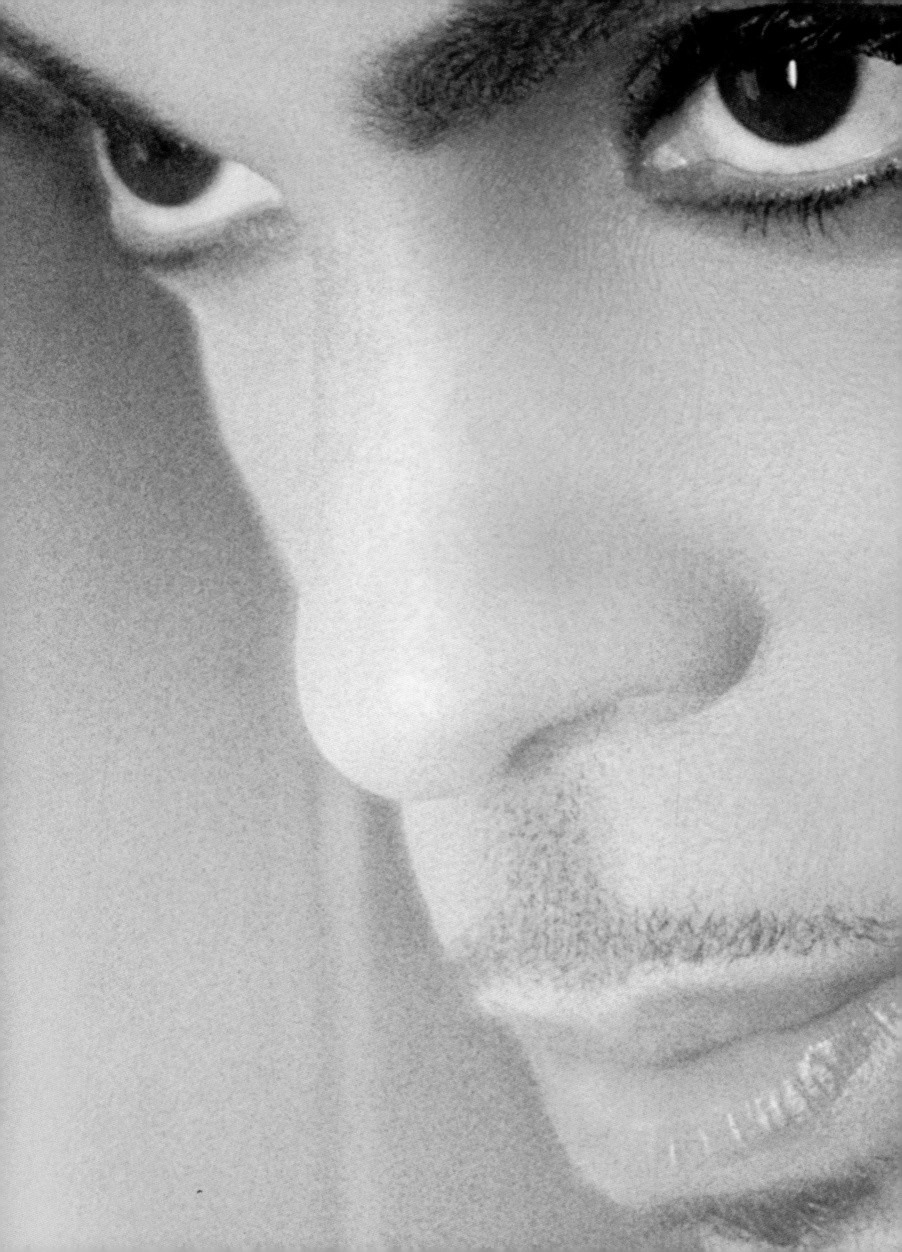

... for 21 nights, Prince does what he does ... he thrives in his dueling worlds of music and solitude. As each day becomes night, Prince prepares for a performance that is never the same. 24,000 people arrive to inhabit the arena known as the O2. There is a charged electricity of anticipation that unites everyone ... the expectations from all involved, band, crew and audience are high as they willingly turn the night over to the music that never lets them down ... the experience can never be duplicated or forgotten ... and then there is an after show where the music continues with tireless passion ... and finally the euphoric reality of a new day beginning ... as the sun devours the last traces of the night's black sky, Prince is more than awake ... he is inspired ... he is reflective ... and he is ready to do it all again.

4:31AM TRAVEL TO

LIGHT ENTERS THE DARKNESS

NO SHAME AND NO REGRETS

U GIVE URSELF 2 THE UNKNOWN

THAT'S WHEN U SOON 4GET

Y U FEARED THE DARKNESS

Y U EVER LET

ANYONE MISLEAD U

THERE'S ALWAYS SOMETHING

WET

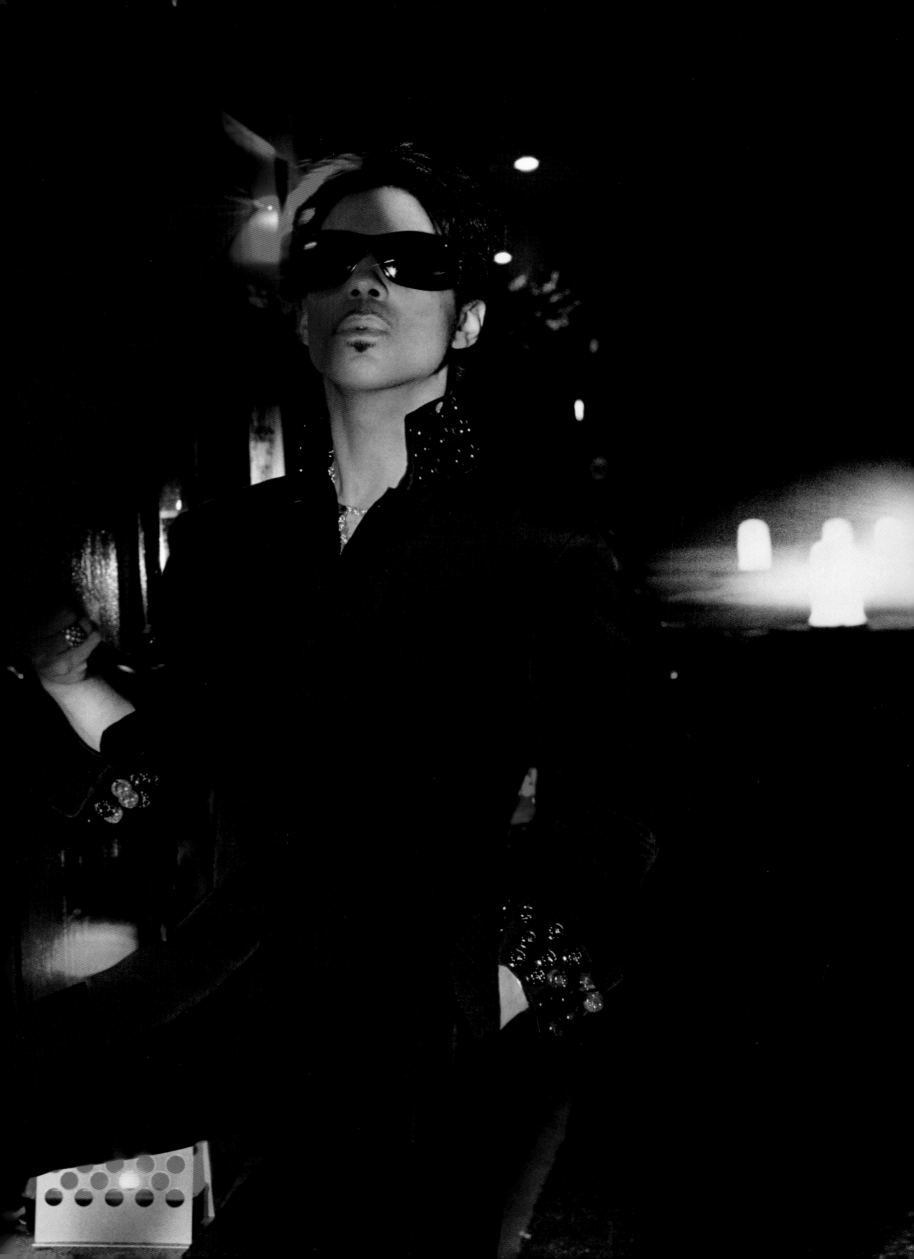

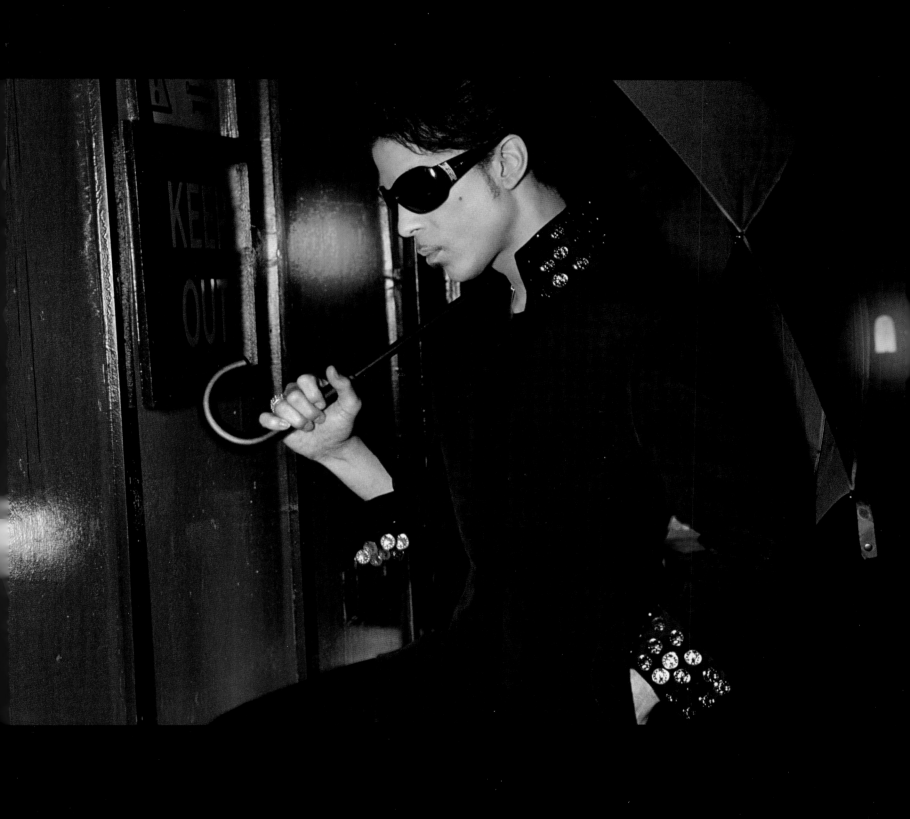

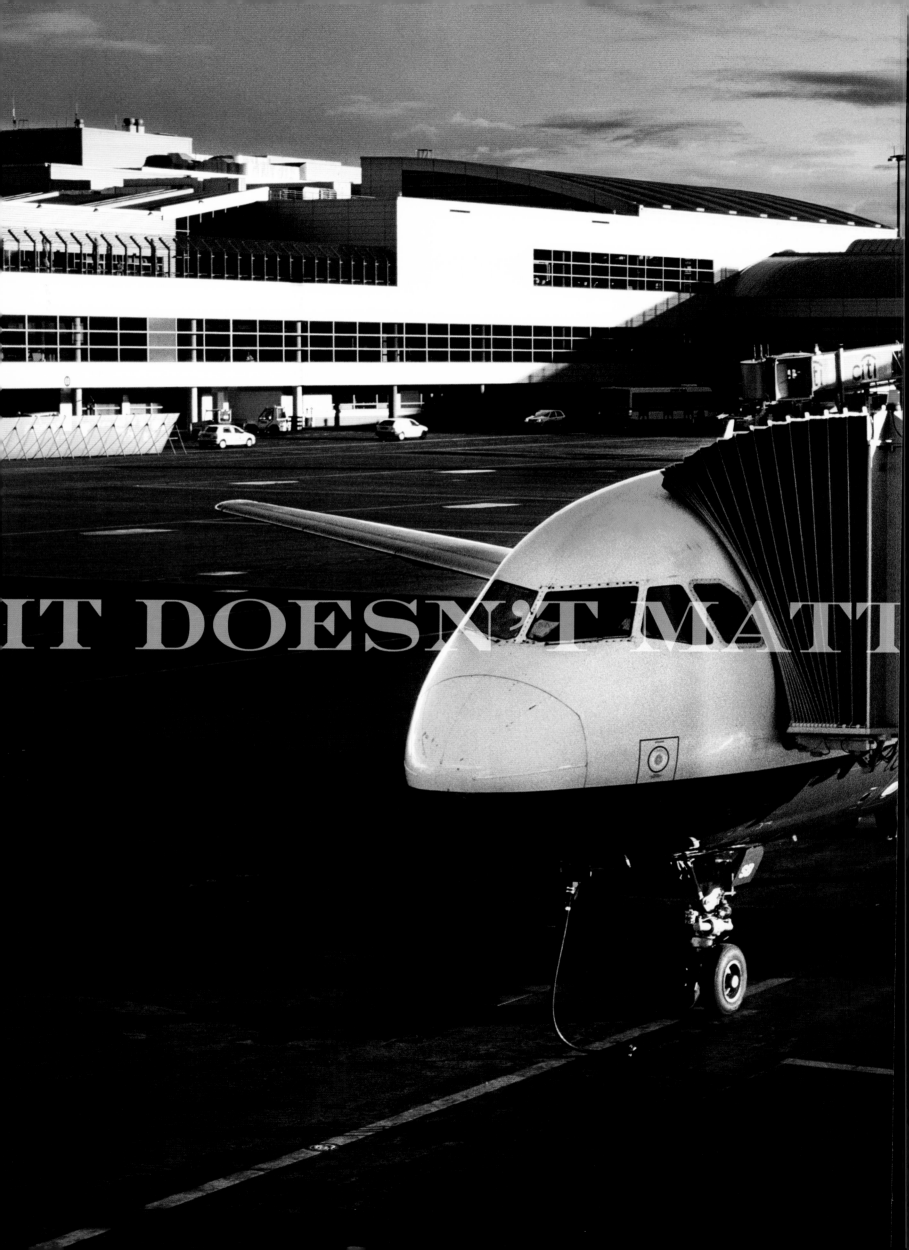

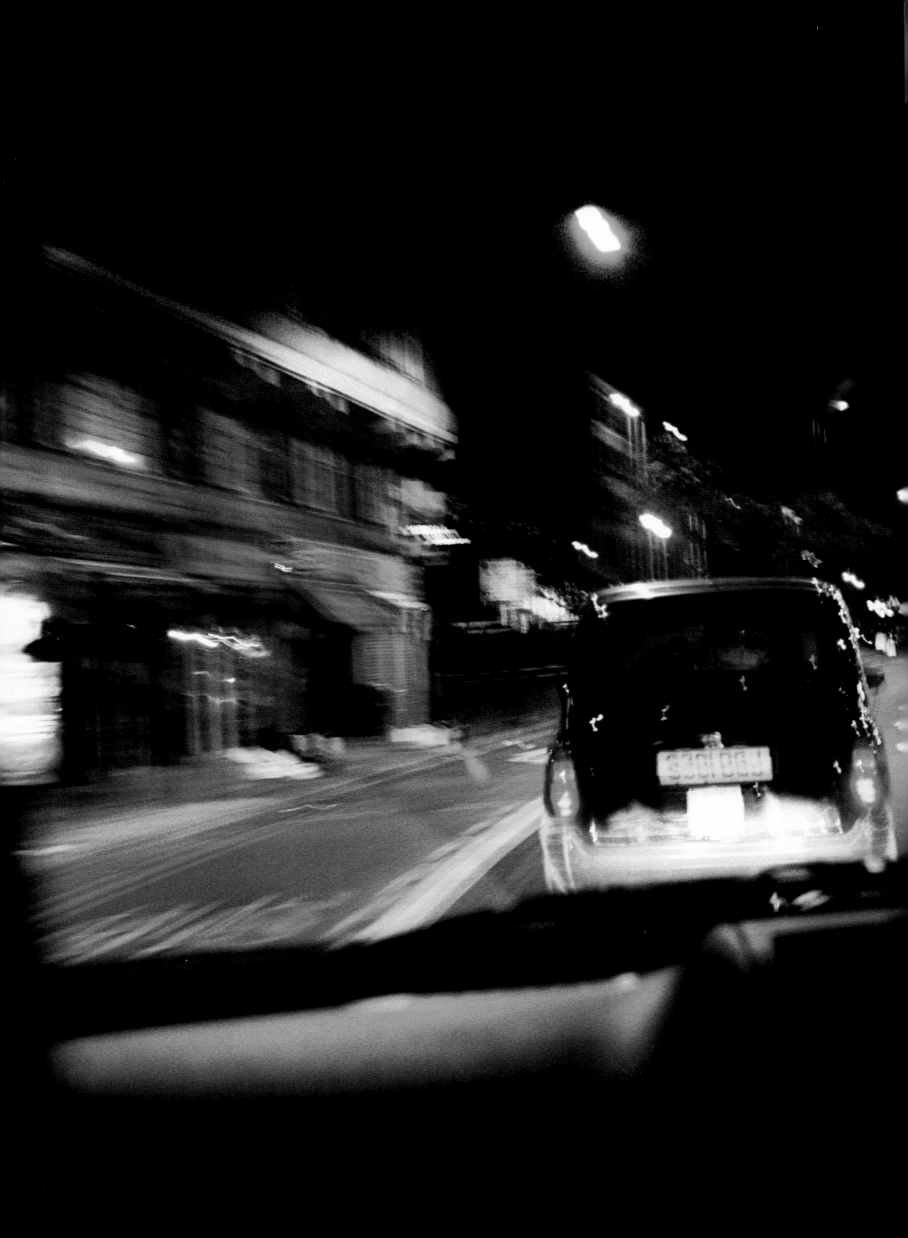

RECURRING DREA

THE THOUGHT OF US 2GETHER WAS CONSUMING
IT SOON BECAME A RECURRING DREAM
EYE SAW US GIVING THINGS 2 ONE ANOTHER
THAT COULD ONLY B UNDERSTOOD BY THOSE WHO HAD SEEN
U IN UR TRUE ESSENCE AND ME IN MINE
WHILE THE WHOLE WORLD PAYS JUST 2 WAIT IN LINE
2 C US DO WHAT WE HAVE WAITED 4 A LIFETIME
EACH OTHER ... 4 21 NIGHTS

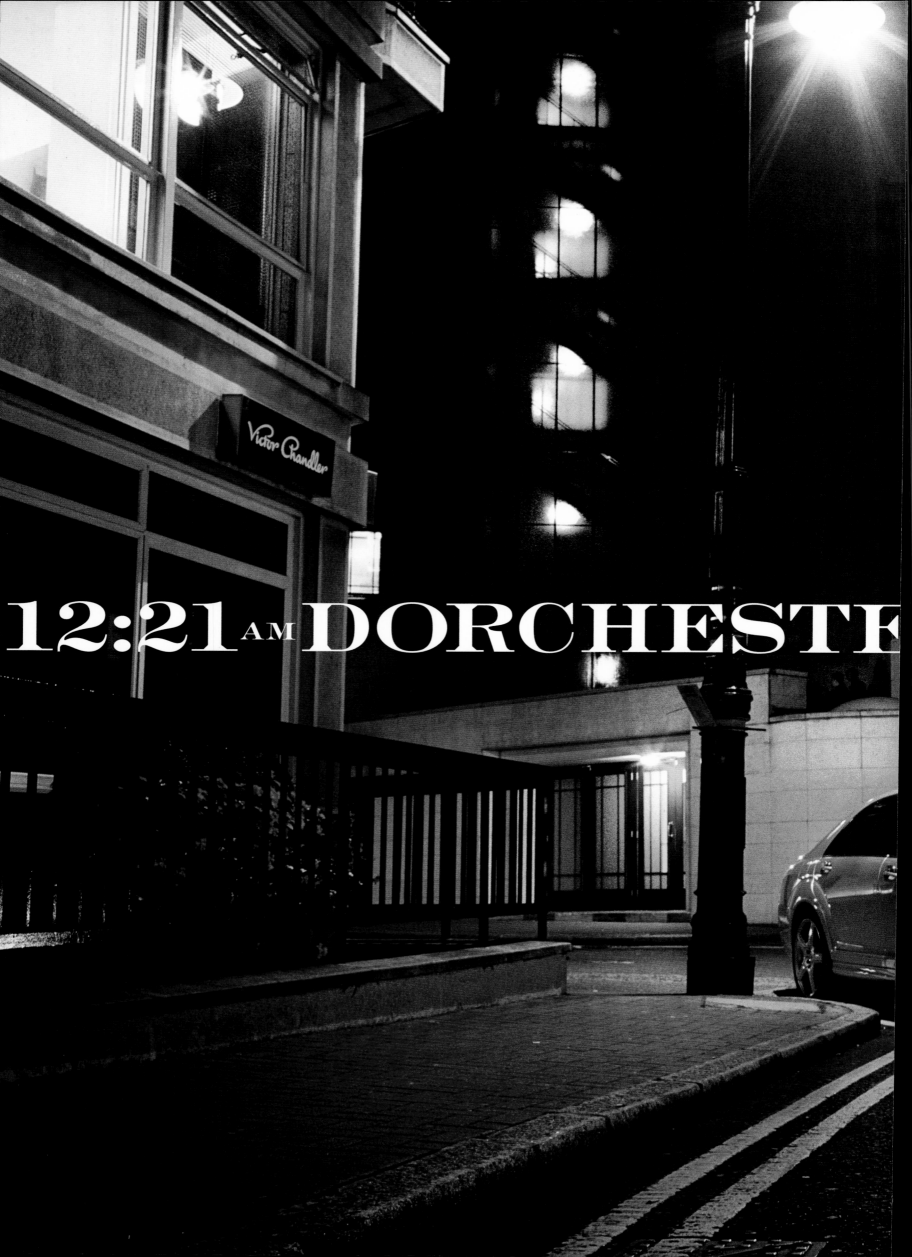

12:21 AM DORCHESTER

R HOTEL

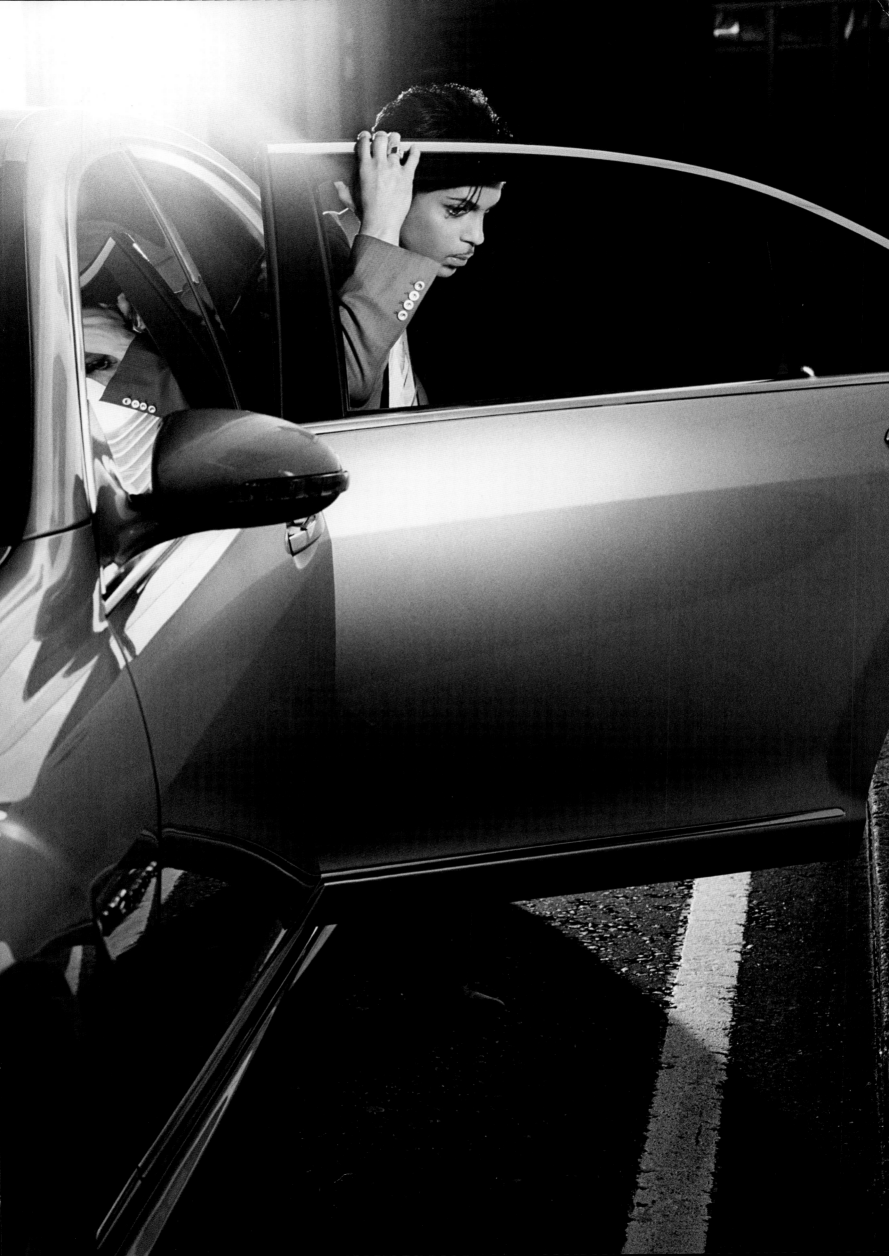

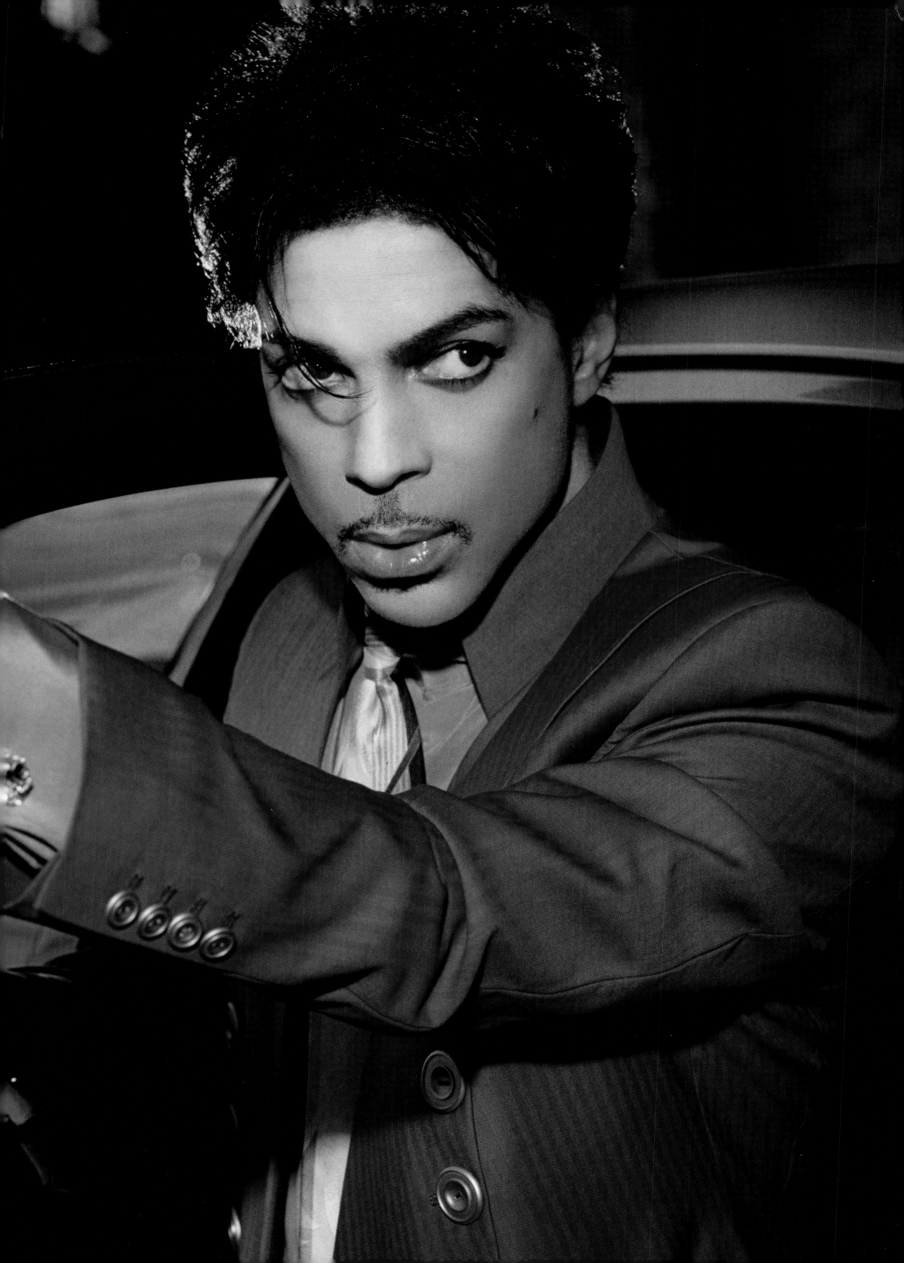

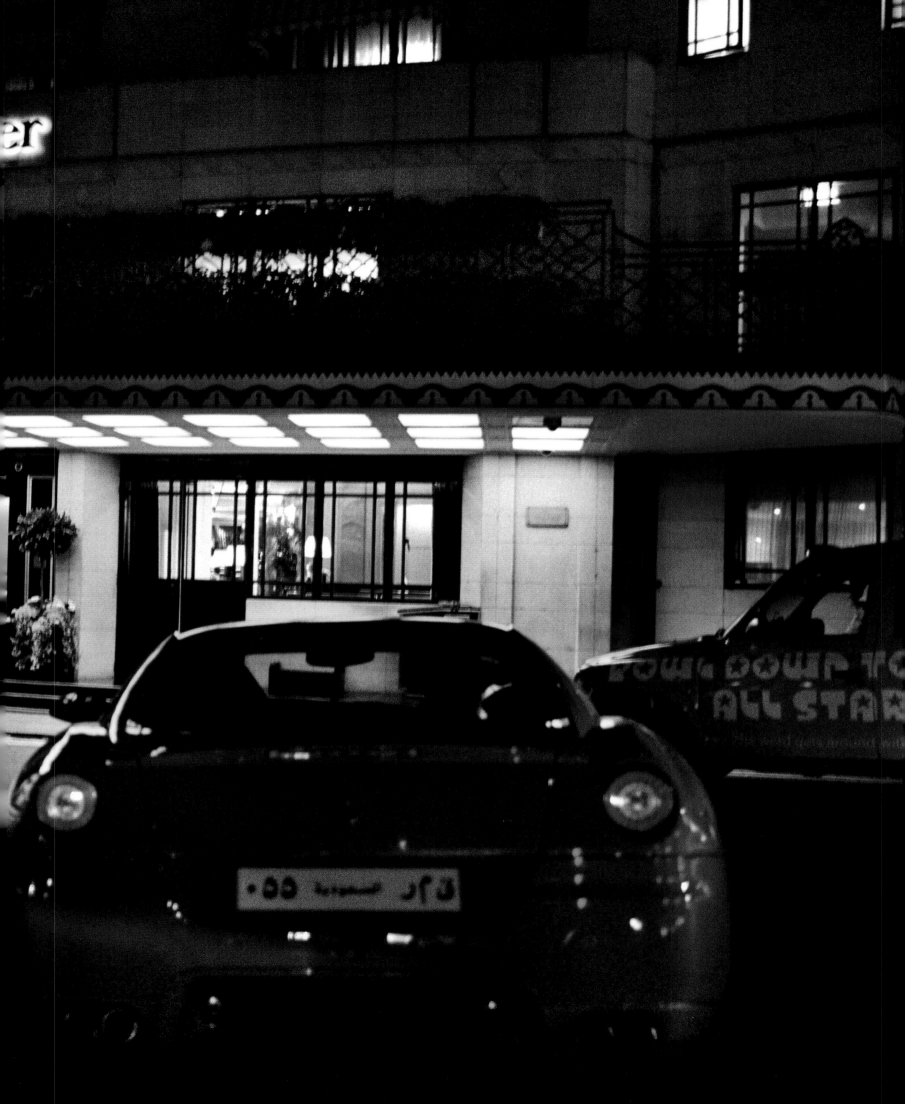

IMAGINE HOLDING PLANET EARTH
IN THE PALM OF UR HAND
WITH NO REGARD 4 UR PLACE OF BIRTH
OR CLAIM 2 ANY LAND
THE ONLY THING BETWEEN US NOW
IS THE TRUTH WE UNDERSTAND
IF PLANET EARTH WAS IN THE PALM OF UR HAND

50 YEARS FROM NOW
WHAT WILL THEY SAY ABOUT US HERE?
DID WE CARE 4 THE WATER
AND THE FRAGILE ATMOSPHERE?
THERE R ONLY 2 KINDS OF FOLK
AND THE DIFFERENCE THAT THEY MAKE
THE ONES THAT GIVE & THE ONES THAT TAKE

PLANET EARTH

JUST LIKE THE COUNTLESS BODIES
THAT REVOLVE AROUND THE SUN
PLANET EARTH MUST NOW
COME IN2 BALANCE WITH THE ONE
THAT CAUSED IT ALL 2 B
THEN WE'LL C HIS KINGDOM COME
SO SHALL IT BE WRITTEN, SO IT SHALL B SUNG
IMAGINE IF U COULD RID THE EARTH
OF ANYONE U CHOOSE
WHICH ONES WOULD U NEED THE MOST
AND WHICH ONES WOULD U LOSE?
DO U WANT 2 JUDGE ANOTHER
LEST WE B JUDGED 2?
CAREFUL NOW … THE NEXT ONE MIGHT BE U

IMAGINE SENDING UR 1ST BORN
OFF 2 FIGHT A WAR
WITH NO GOOD REASON HOW IT STARTED
OR WHAT THEY'RE FIGHTING 4
AND IF THEY'RE BLESSED 2 MAKE IT HOME
WILL THEY STILL B POOR?
PRAY 4 PEACE RIGHT NOW AND 4EVERMORE

IT DOESN'T MATT

701-703 →

ER WHERE WE GO

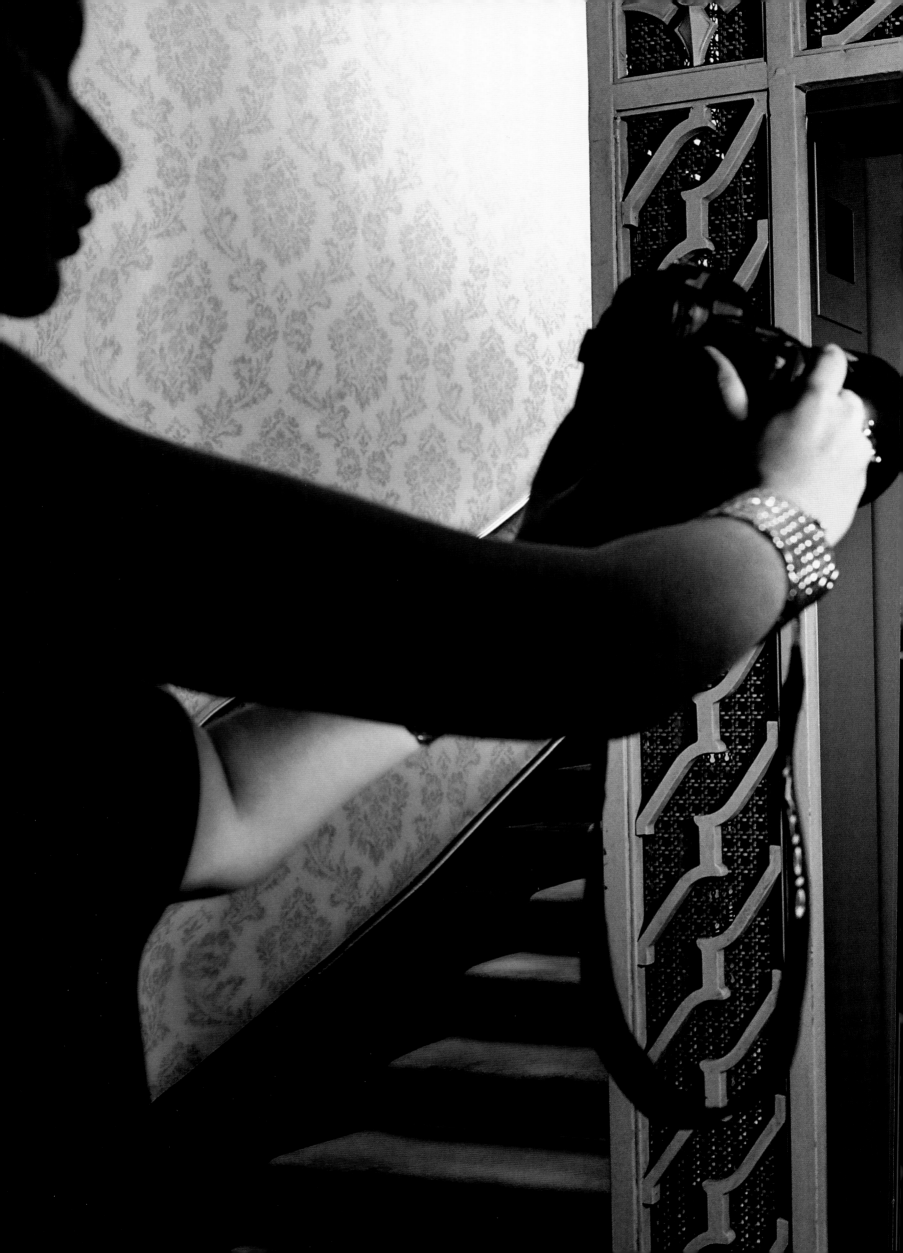

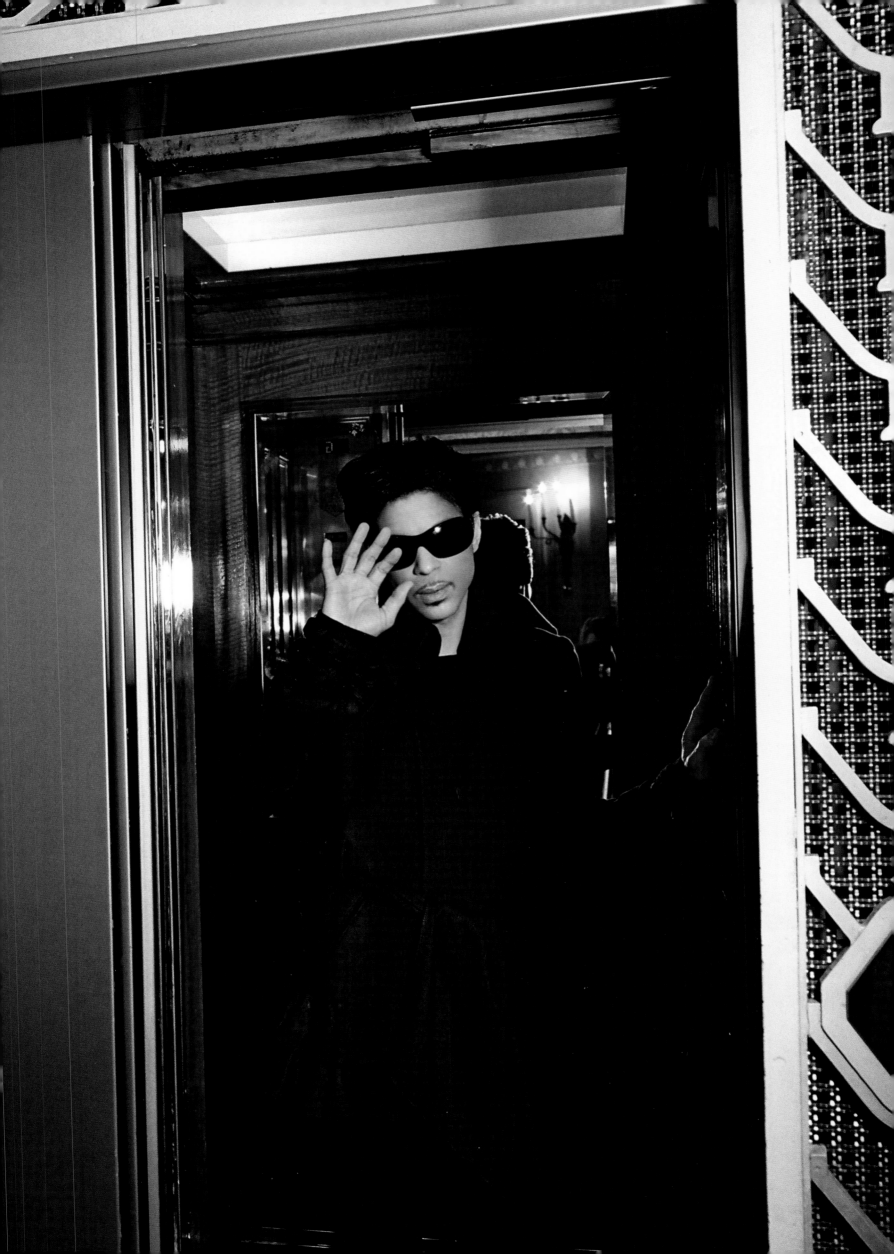

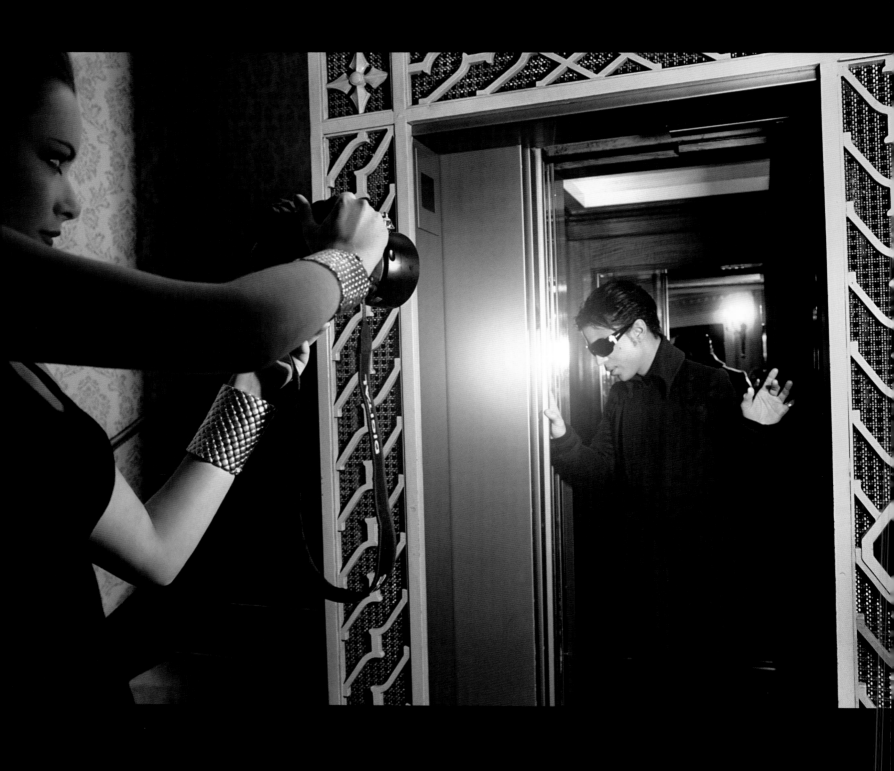

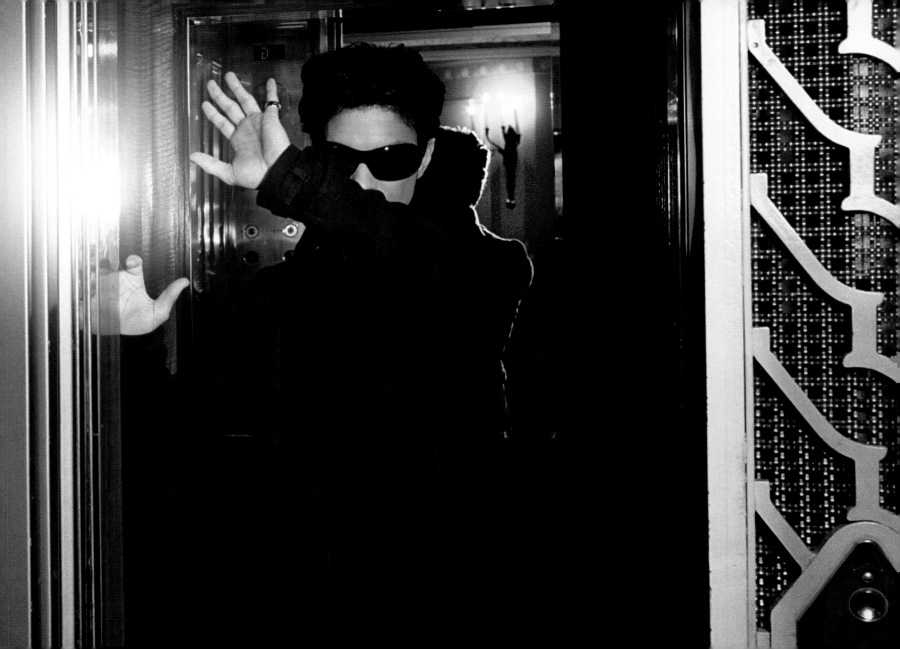

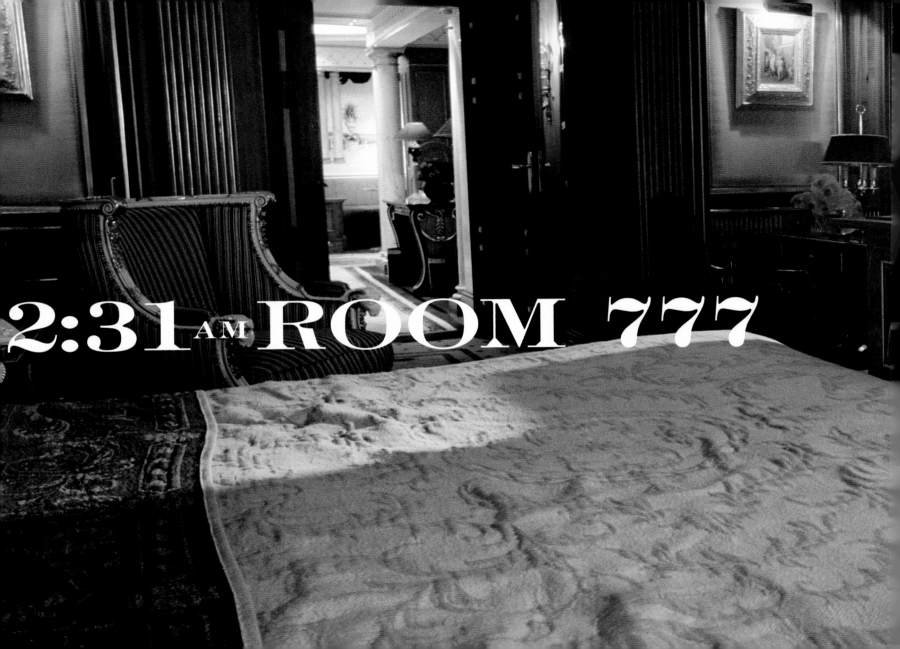

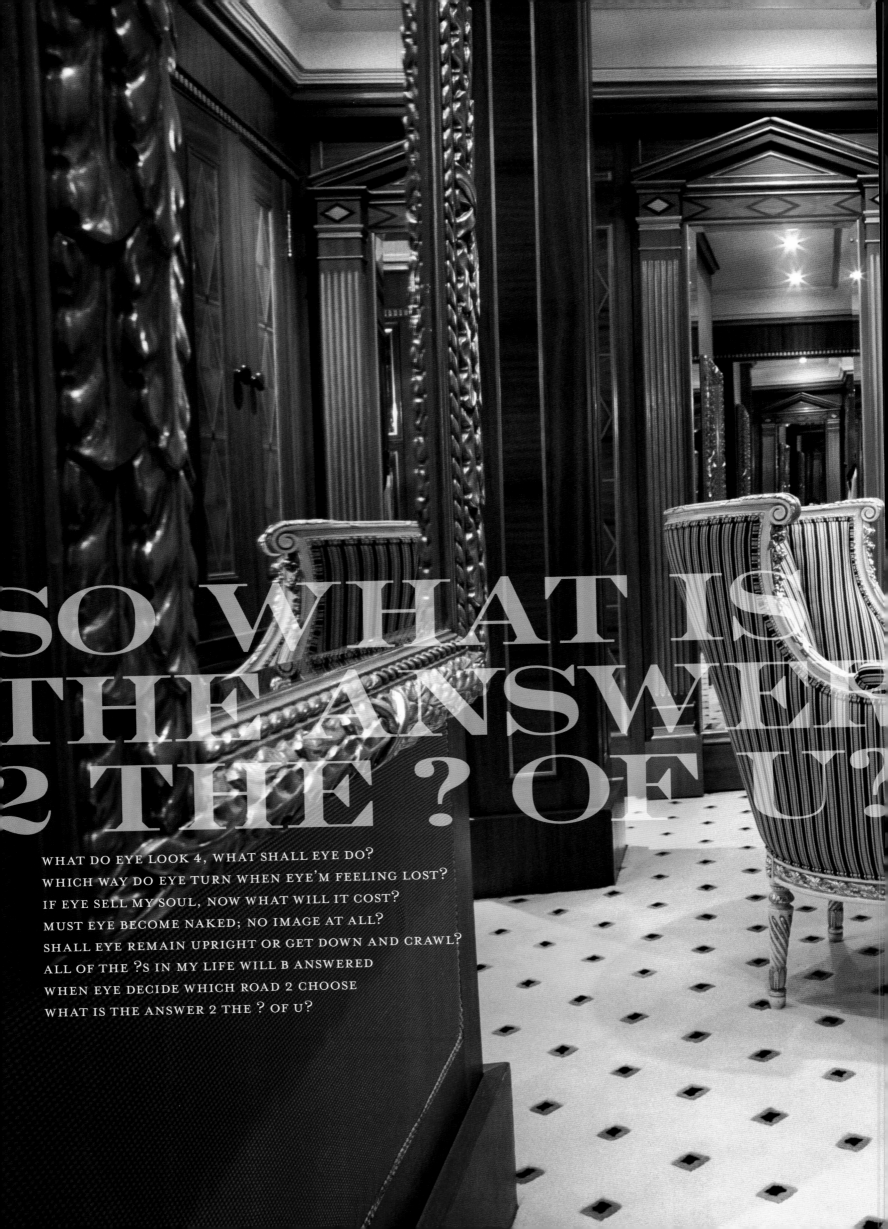

SO WHAT IS THE ANSWER 2 THE ? OF U?

WHAT DO EYE LOOK 4, WHAT SHALL EYE DO?
WHICH WAY DO EYE TURN WHEN EYE'M FEELING LOST?
IF EYE SELL MY SOUL, NOW WHAT WILL IT COST?
MUST EYE BECOME NAKED; NO IMAGE AT ALL?
SHALL EYE REMAIN UPRIGHT OR GET DOWN AND CRAWL?
ALL OF THE ?S IN MY LIFE WILL B ANSWERED
WHEN EYE DECIDE WHICH ROAD 2 CHOOSE
WHAT IS THE ANSWER 2 THE ? OF U?

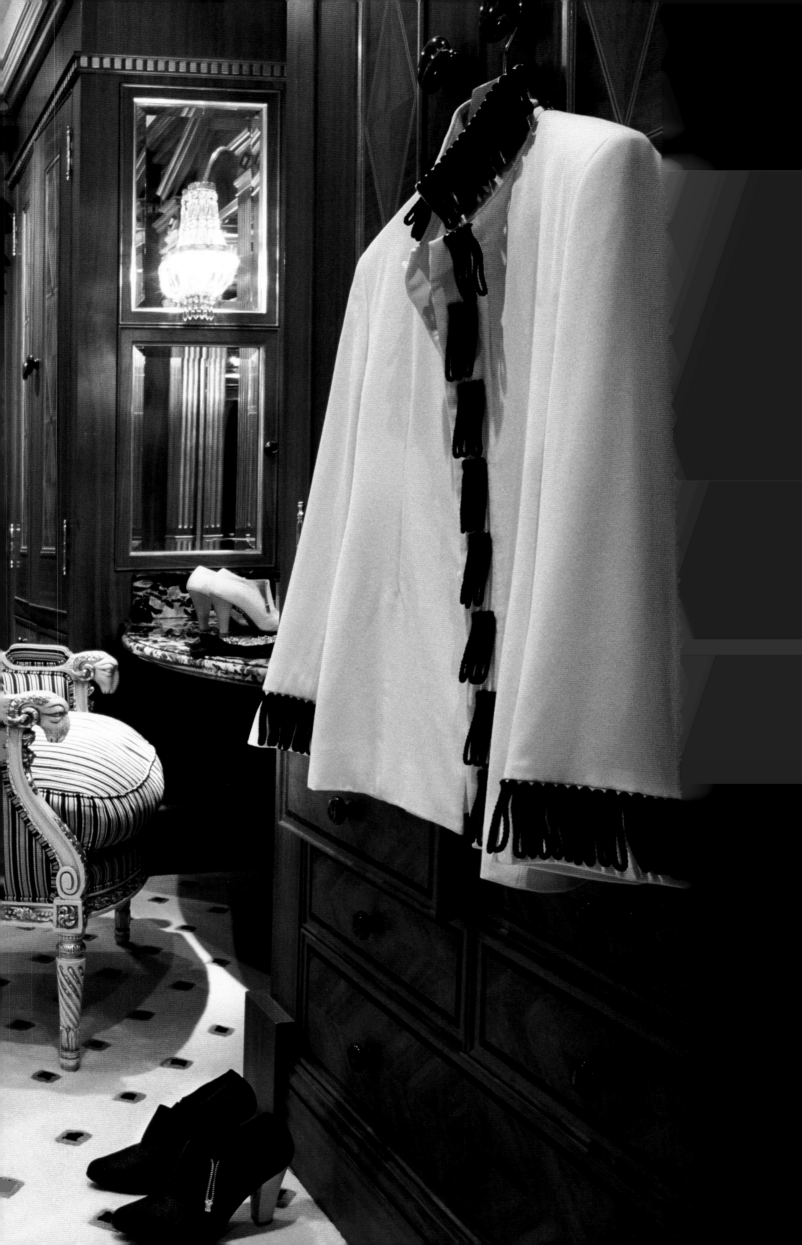

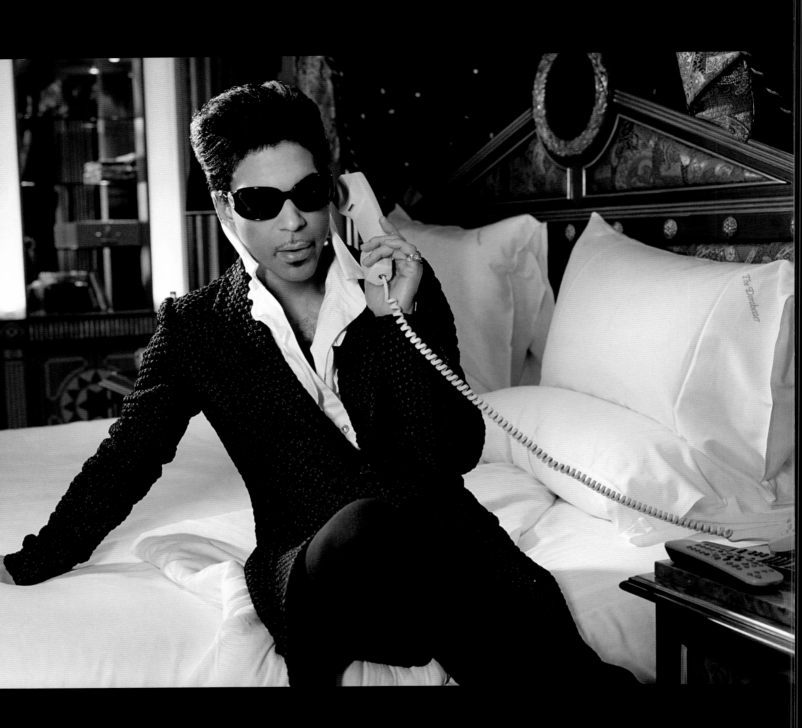

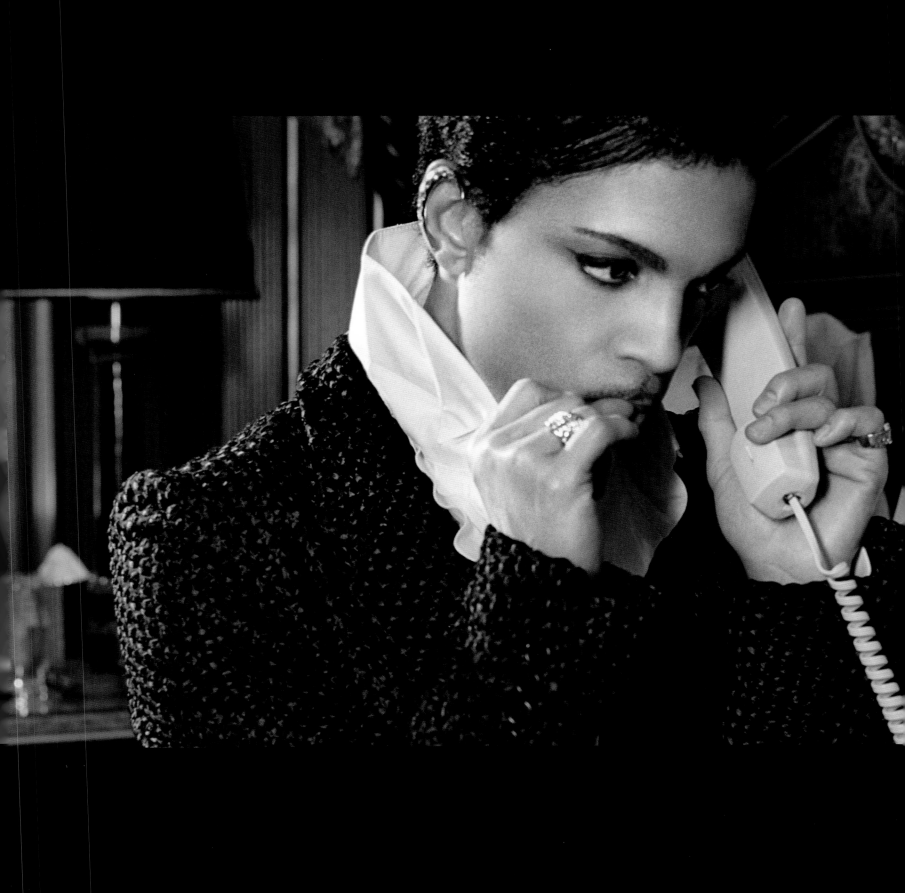

HEY BABY SITTIN' ALL ALONE IN MY COURTYARD
LOOKIN' AS IF U HAD EVERY RIGHT
ALL OVER THE WORLD THEY CALL ME PRINCE
BUT U CAN CALL ME MR. GOODNIGHT
SURELY THE DANDIES THAT ESCORT U PLACES
IMPARTED A RUMOR OR 2
ABOUT THE PARADE OF LOVELY FACES
THAT FOLLOW ME, SURELY THEY DO
WHAT SAY U 2 THAT WITH LIPS SO INVITING
IT'S ALL EYE CAN DO NOT 2 STARE
WHAT SAY U 2 THEM PAST PRESENT AND FUTURE—
THAT U DON'T CARE?
IF SO U'LL B THE 1ST AND EYE'LL GIVE U THE KEYS
2 THE WHIP OF UR DREAMS, ALRIGHT?
ALL OVER THE WORLD THEY CALL ME PRINCE
BUT U CAN CALL ME MR. GOODNIGHT
CALL MR. GOODNIGHT, HE'LL MAKE U FEEL ALRIGHT
MAKE U THROW UR HEAD BACK AND HOLLA
IT'S SO NICE, SO NICE
BETTER NOT TELL UR GIRLFRIEND
U CAN TRY WITH ALL UR MIGHT
JUST CAN'T KEEP A SECRET
ABOUT GOODNIGHT, GOODNIGHT

MR. GOODNIGHT

NOW EYE DON'T WANNA PUT U 2 SLEEP
WITH A BUNCH OF CHATTER AND A RAP THAT REALLY DON'T MATTER
BUT NOW THAT U KNOW WHO EYE AM U NEED 2 MAKE PLANS
AND ALL UR OTHER PENNIES SHOULD SCATTER
A LIMOUSINE IS ABOUT 2 PICK U UP AND THEN TAKE U 2 A PRIVATE JET
AND THEN U'RE GONNA MEET A LITTLE SPANISH MAN
WHO WILL OFFER U WINE AND MOËT
IN AN HOUR OR TWO U'LL B TAKEN 2 A SUITE THAT WILL RIVAL UR WILDEST DREAMS
AND ON THE BED THREE DRESSES 2 CHOOSE ONE, PICK ONE
AND THEN U'LL GET A CALL FROM ME
TELL ME WHICH DRESS U CHOSE SO EYE COULD PUT ON, PUT ON
A MATCHING SUIT
ALL THE REAL DIMES HOLD UR HANDS UP ... U KNOW HOW MR. GOODNIGHT DO

12:00AM

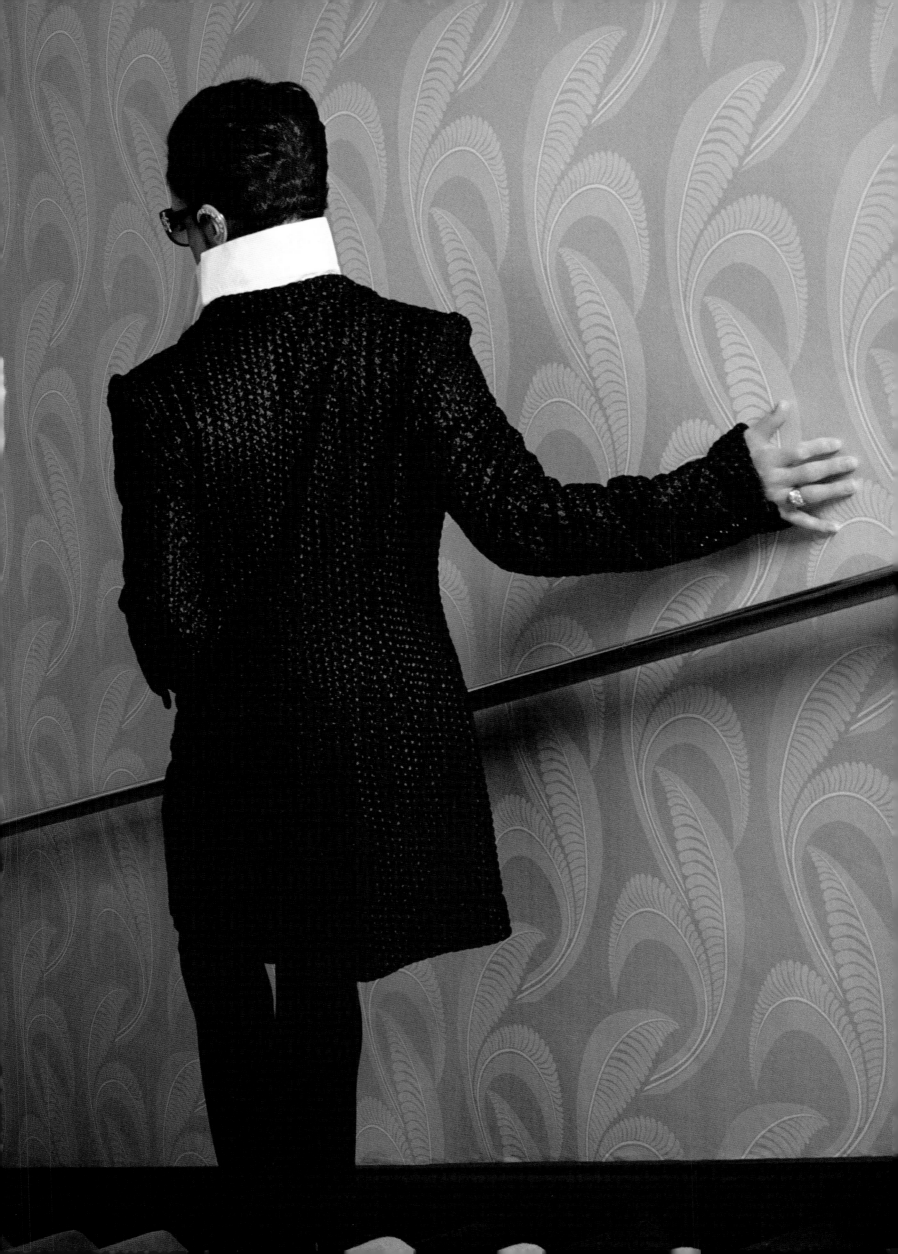

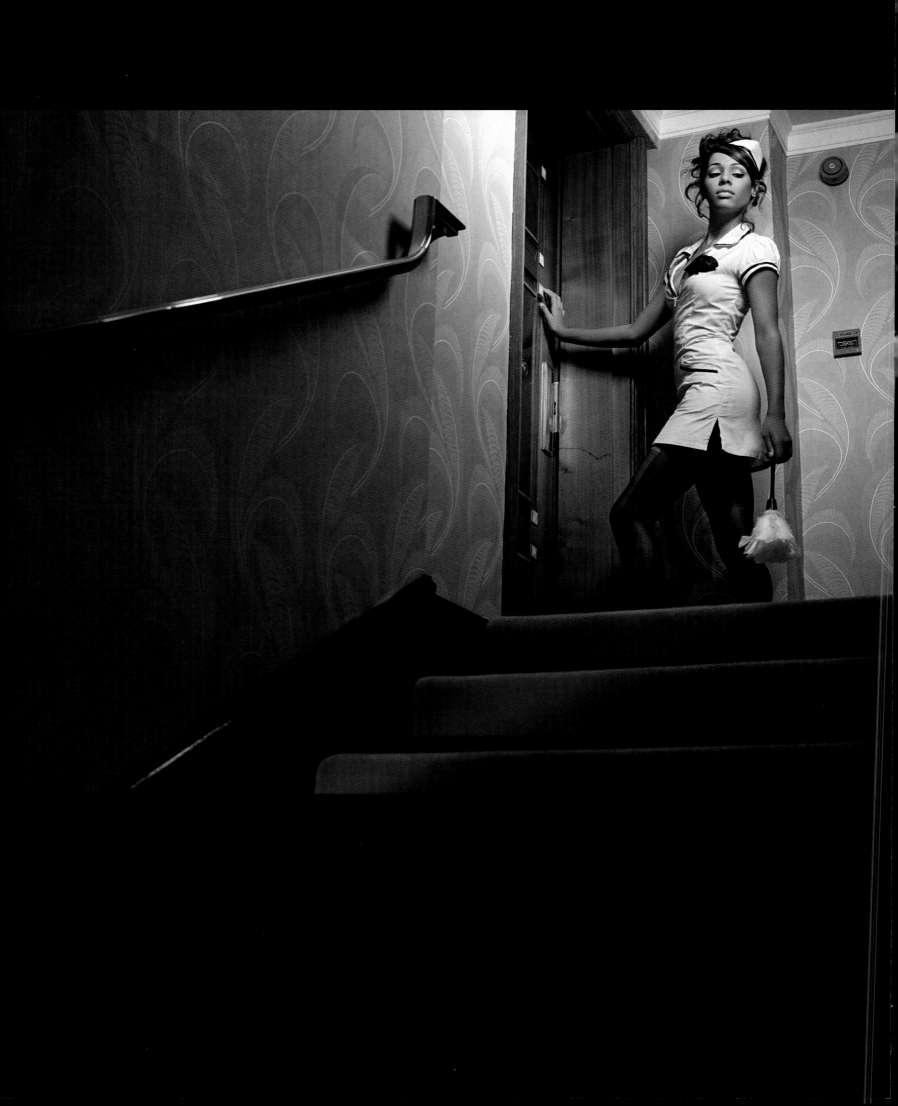

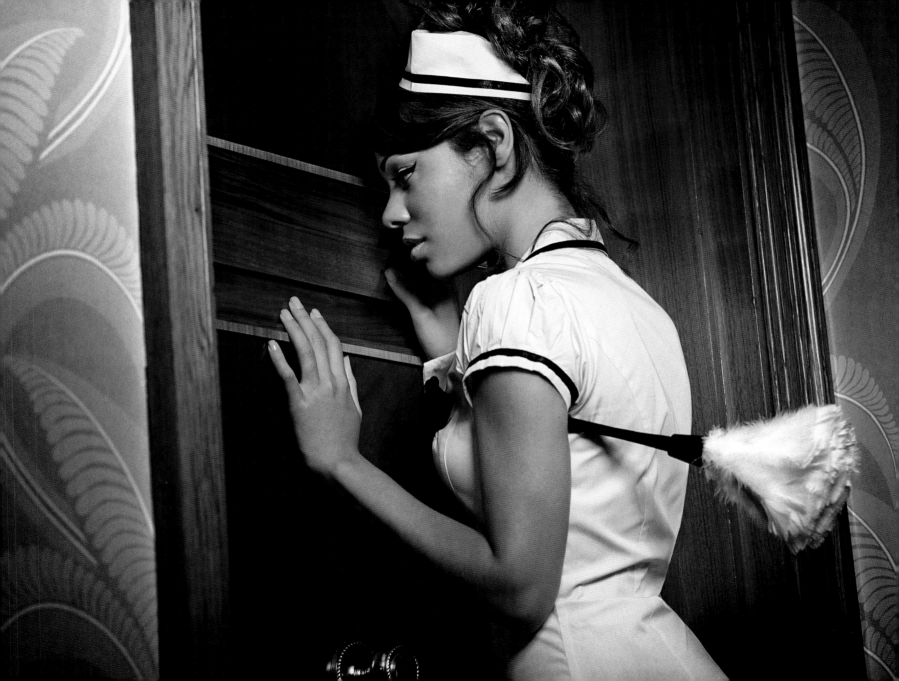

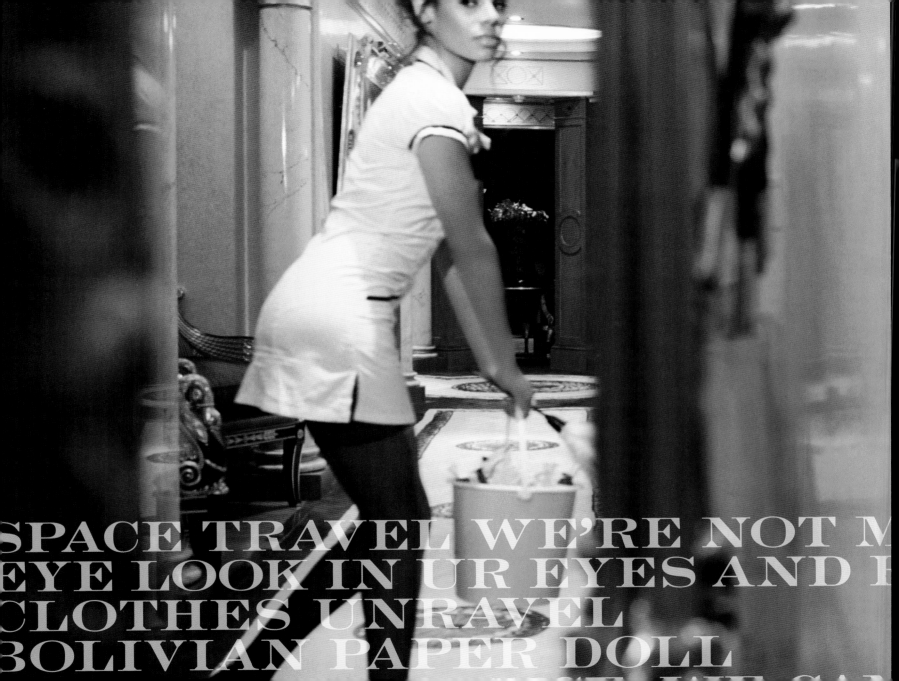

SPACE TRAVEL WE'RE NOT M

EYE LOOK IN UR EYES AND F

CLOTHES UNRAVEL

BOLIVIAN PAPER DOLL

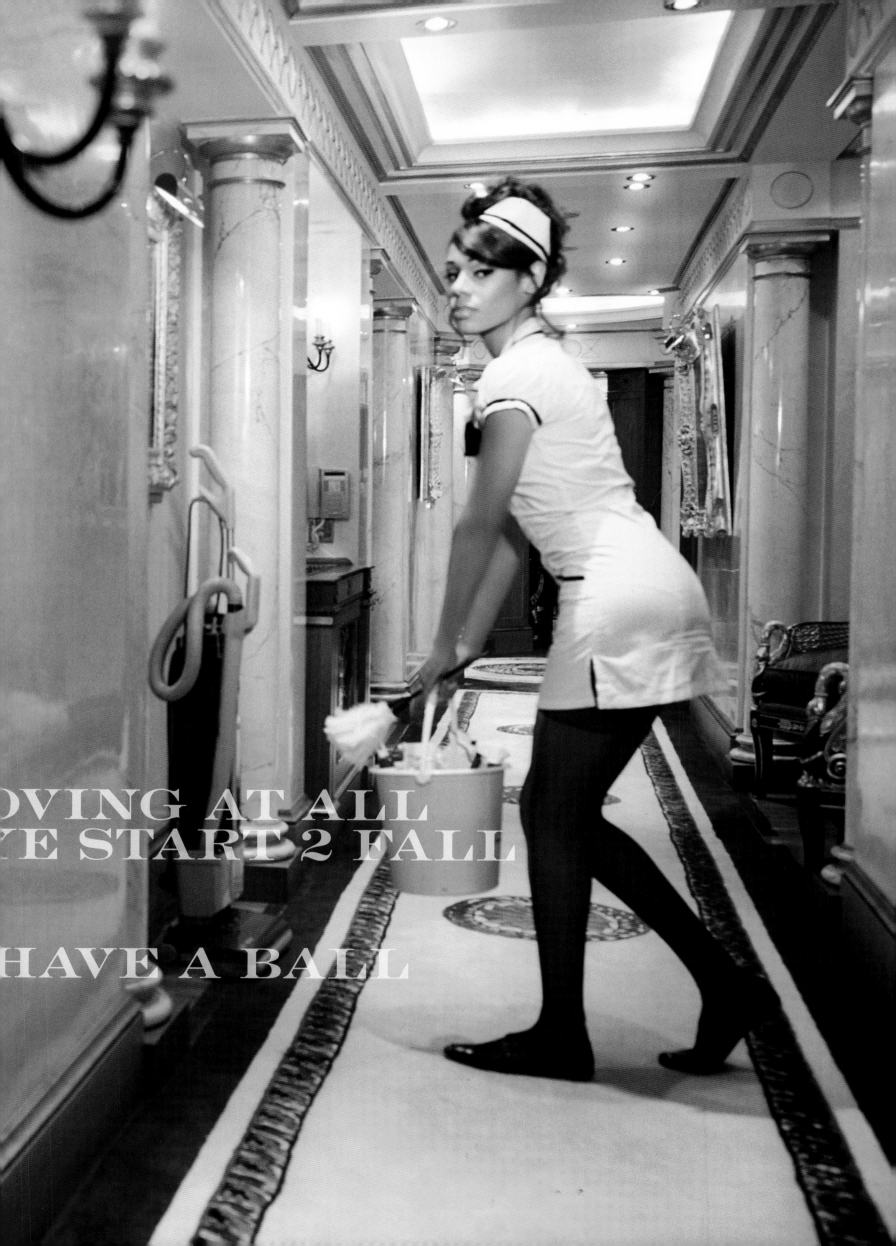

GETTIN' DIRTY AT THE CLUB AGAIN
USUALLY 'ROUND UR WAIST LIKE A CHAIN BUT THEN
EYE GOT THAT CALL SO EYE JUMPED IN MY CAR
EYE LOVE U, BABY, BUT NOT LIKE EYE LOVE MY GUITAR
UH UH … NOT LIKE EYE LOVE MY GUITAR … NO

U COULDN'T DO IT ALL BY URSELF
U HAD 2 GO AND GET SOMEBODY ELSE
U'RE HIGH ENUFF 2 CALL ME BUT U CAN'T REACH THE BAR
EYE LOVE U, BABY, BUT NOT LIKE EYE LOVE MY GUITAR
NO … NOT LIKE EYE LOVE MY GUITAR

EYE TRIED 2 WARN U THAT IT'S HARD 2 B A STAR
ESPECIALLY WHEN U'RE DRIVING OTHER PEOPLE'S CAR
WOULDA GAVE U MINE BUT U TOOK IT 2 FAR
EYE LOVE YOU, BABY, JUST NOT LIKE EYE LOVE MY GUITAR
NOT LIKE EYE LOVE MY GUITAR

EYE KNOW U LOVE ME AND U WANNA B FRIENDS
AND IF YOU DON'T AT LEAST U NEED 2 PRETEND
WE'RE STILL 2GETHER EVEN IF WE DON'T GET THAT FAR
EYE LOVE YOU, BABY, BUT NOT LIKE EYE LOVE THIS GUITAR
EYE LOVE YOU BABY … NOT LIKE EYE LOVE MY GUITAR

GUITAR

EYE LOVE U BABY AND EYE WISH U WELL
EYE'LL WRITE A LETTER WHEN EYE LEARN HOW 2 SPELL
UNTIL THAT DAY U CAN GO 2 _____
EYE LOVE U BABY … U KNOW THE REST

1:07AM

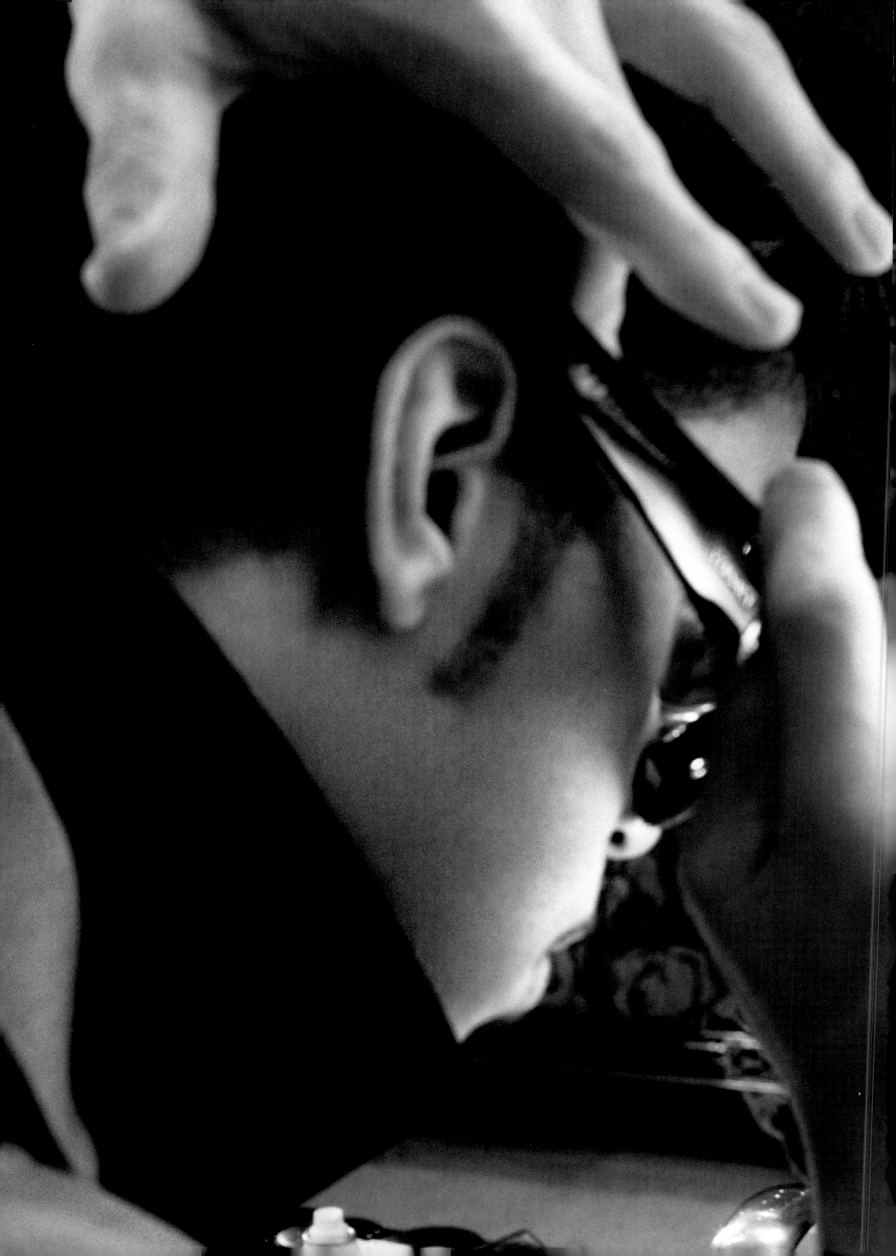

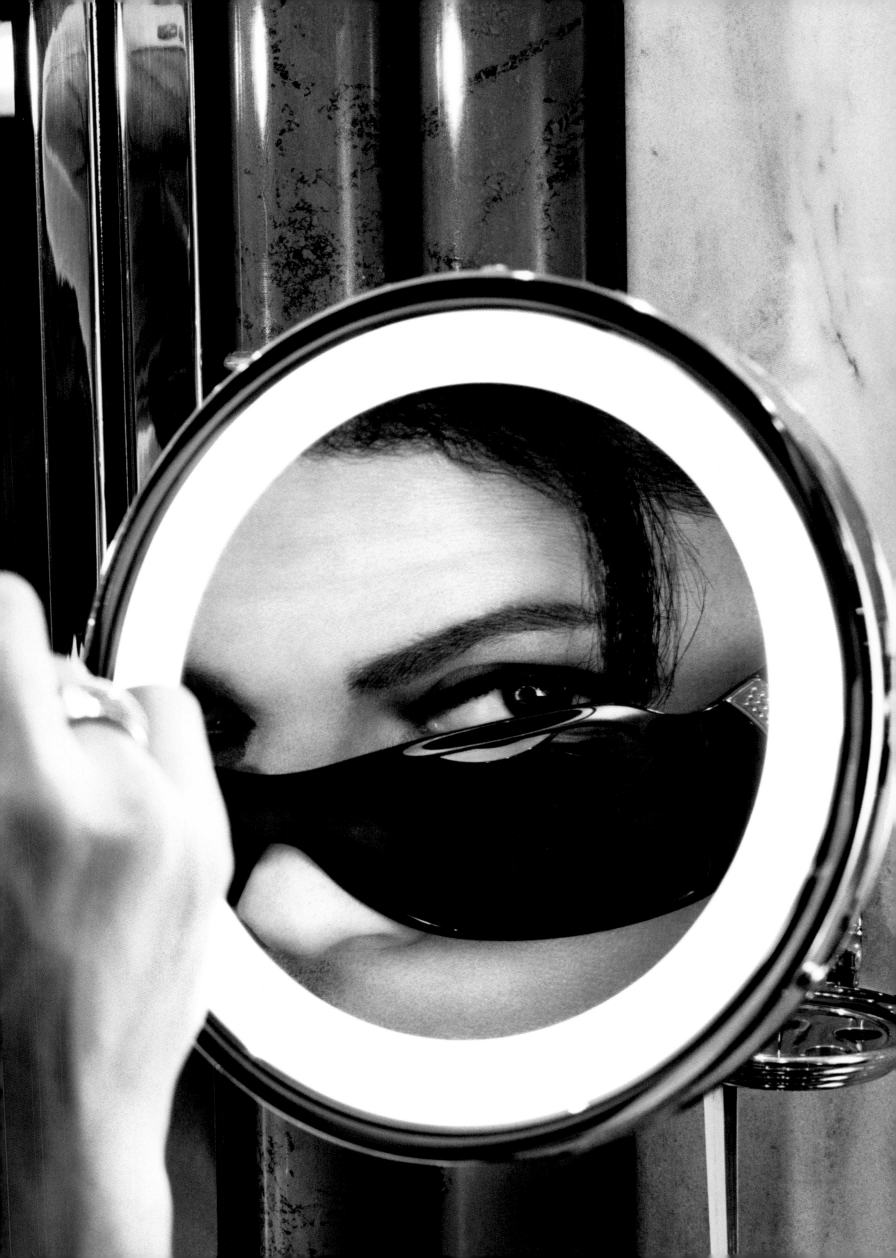

DOUBLE THE TROU

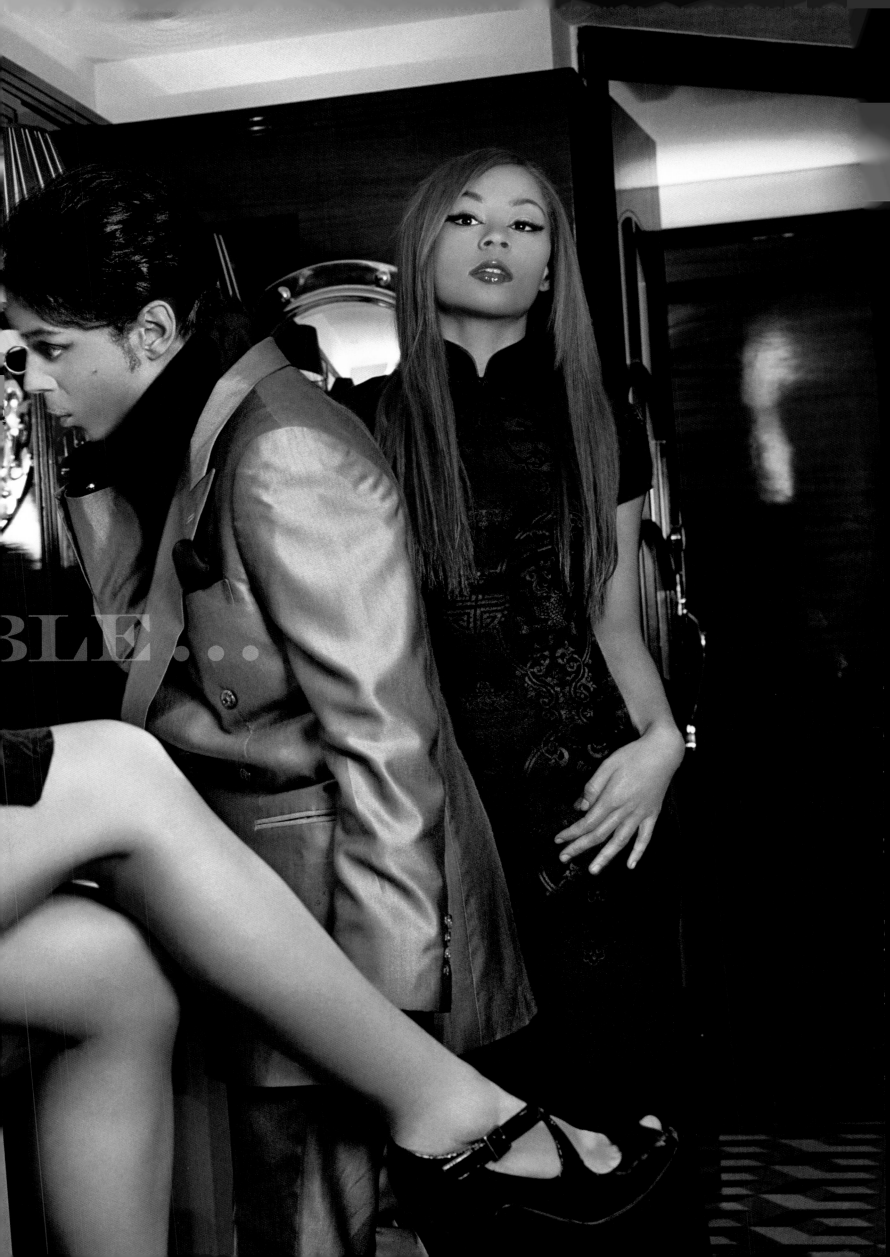

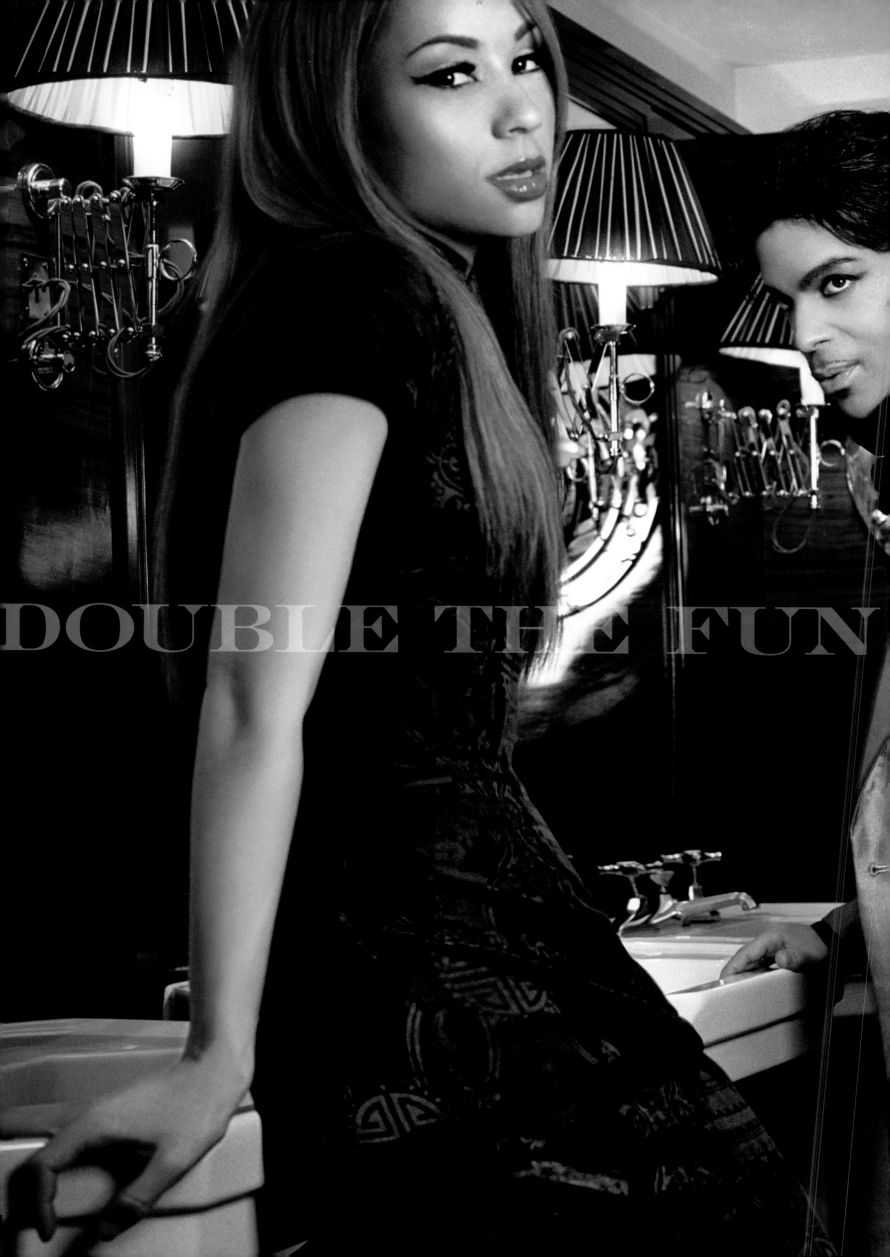

DOUBLE THE FUN

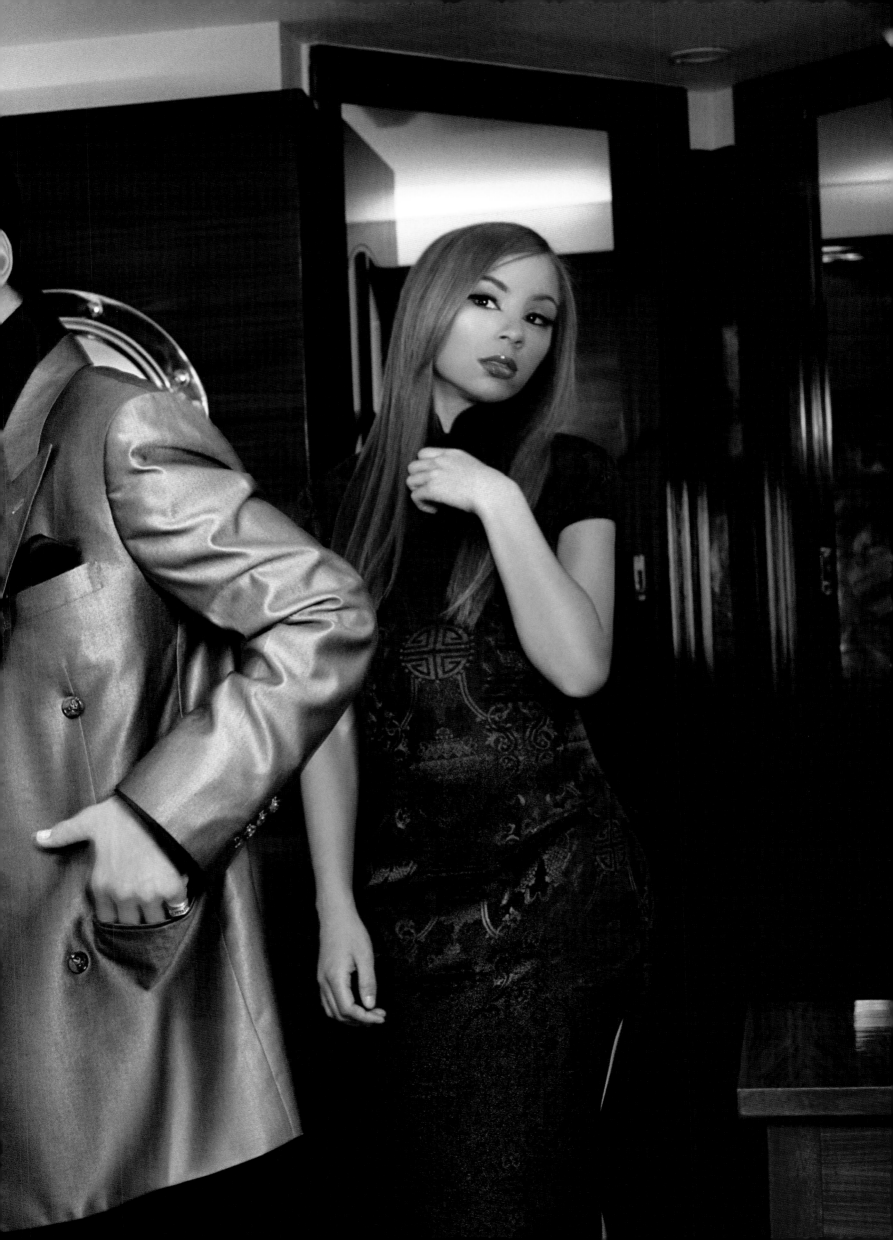

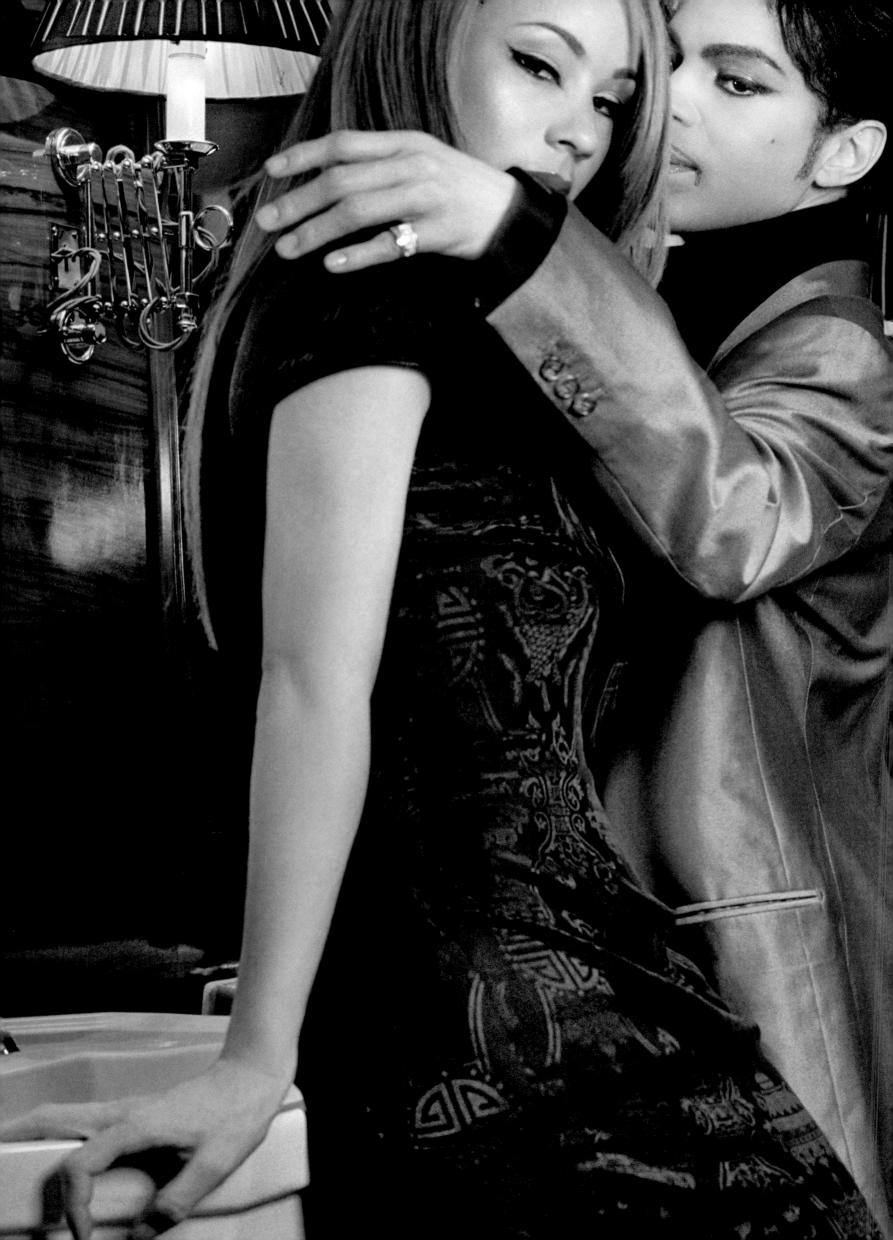

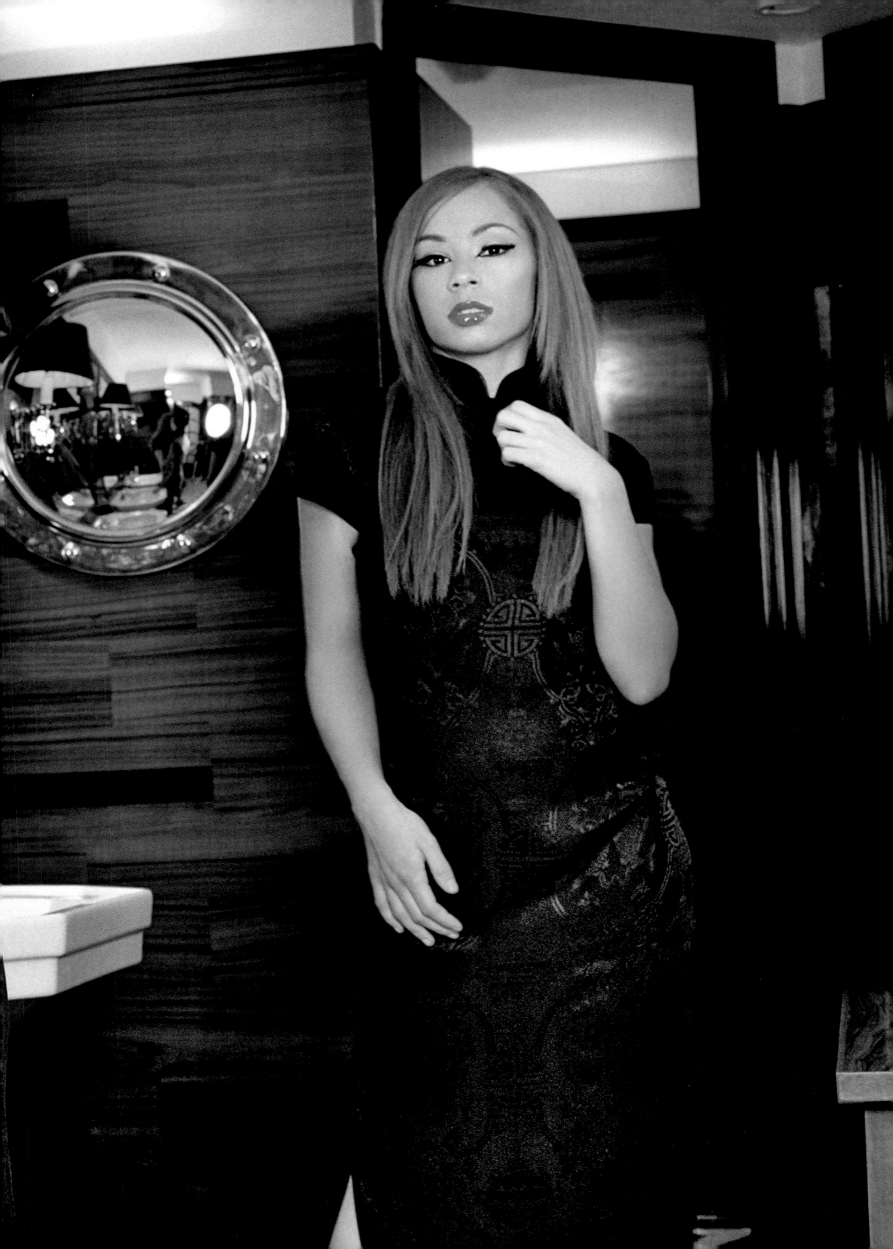

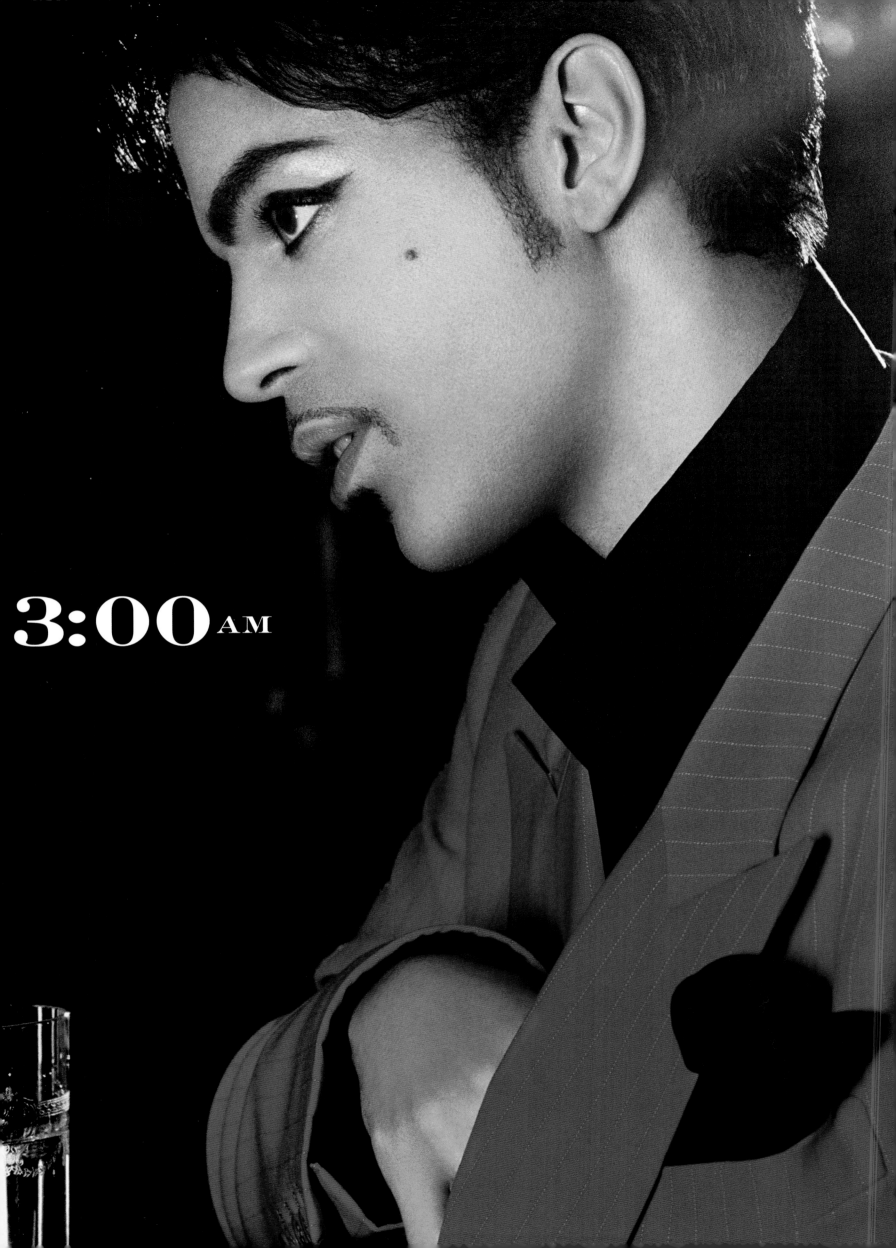

3:00 AM

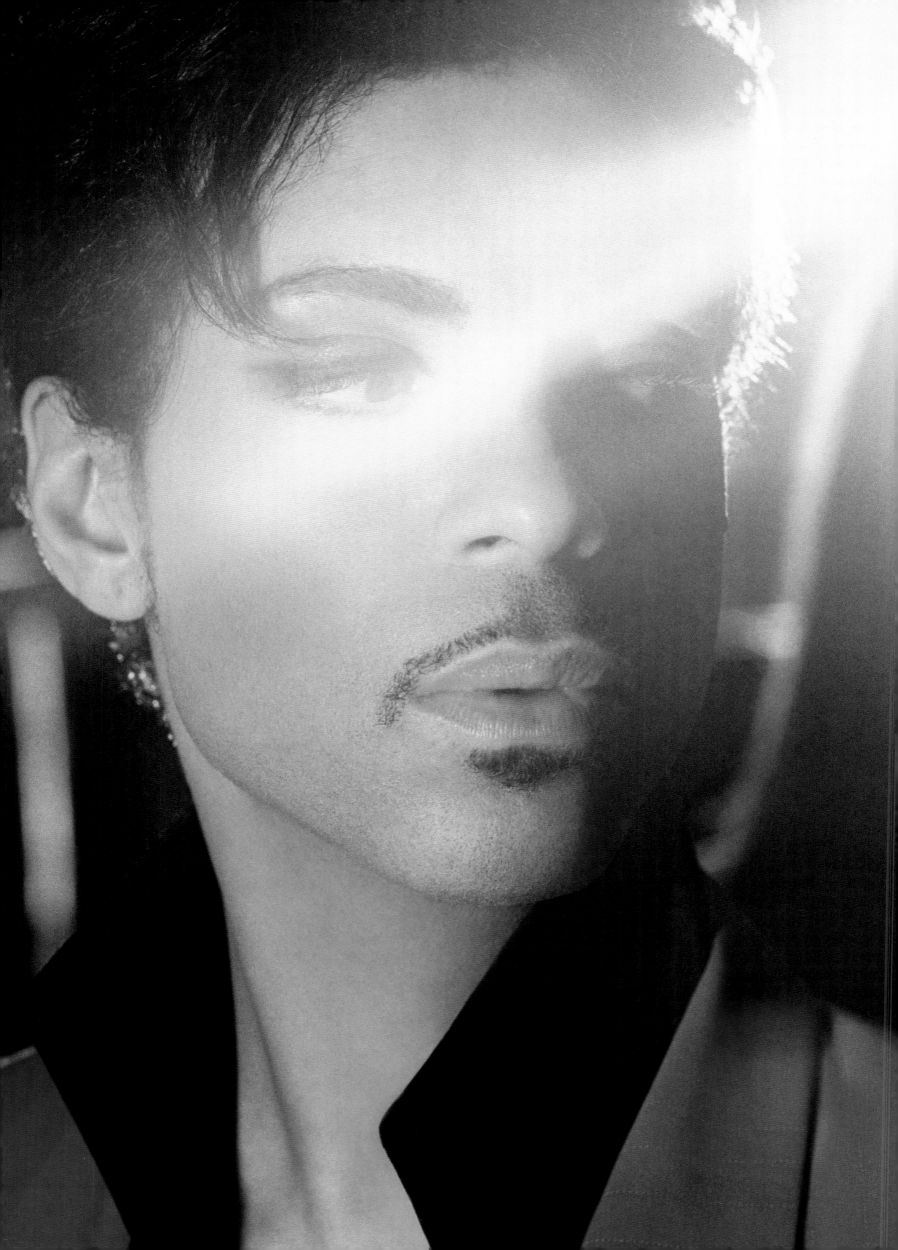

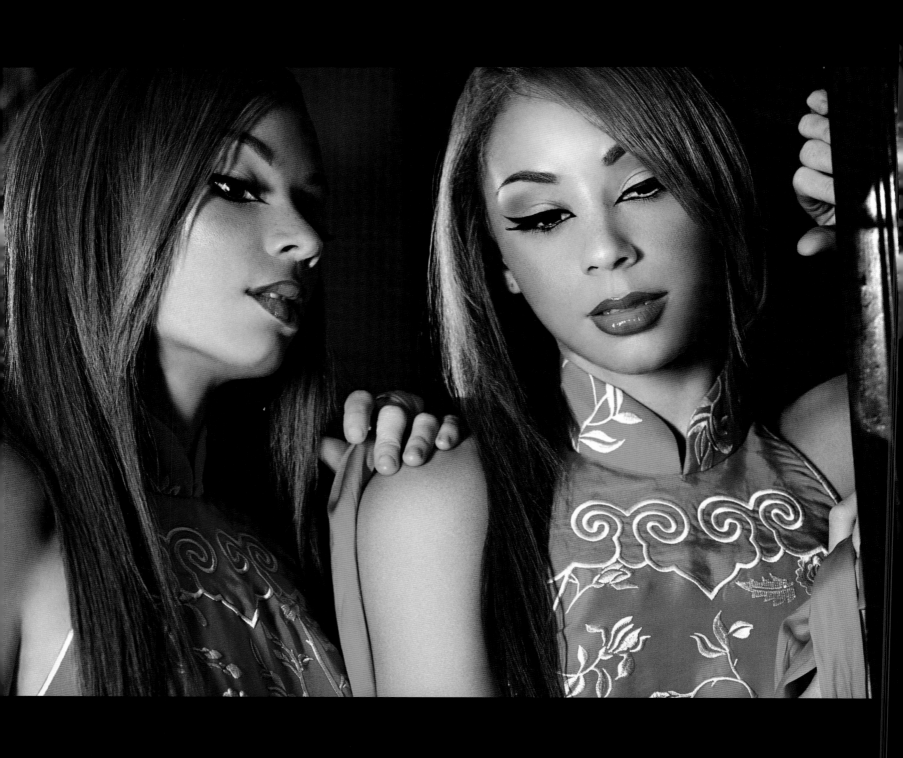

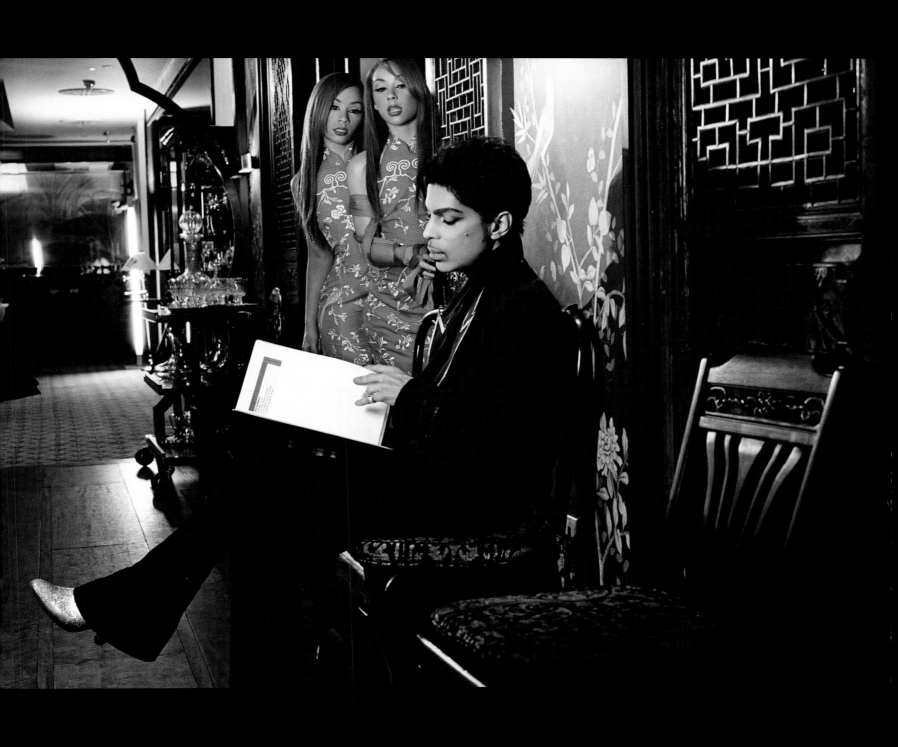

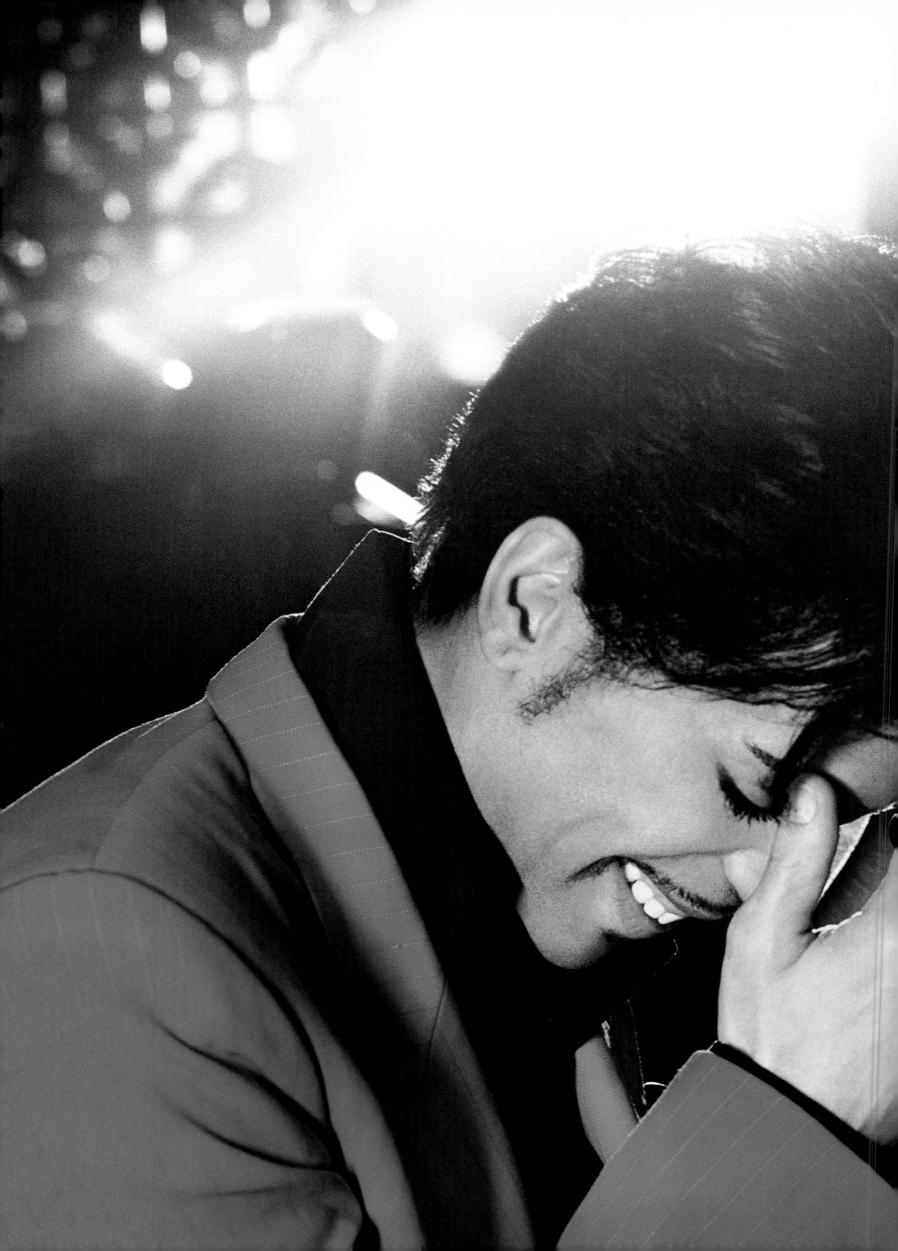

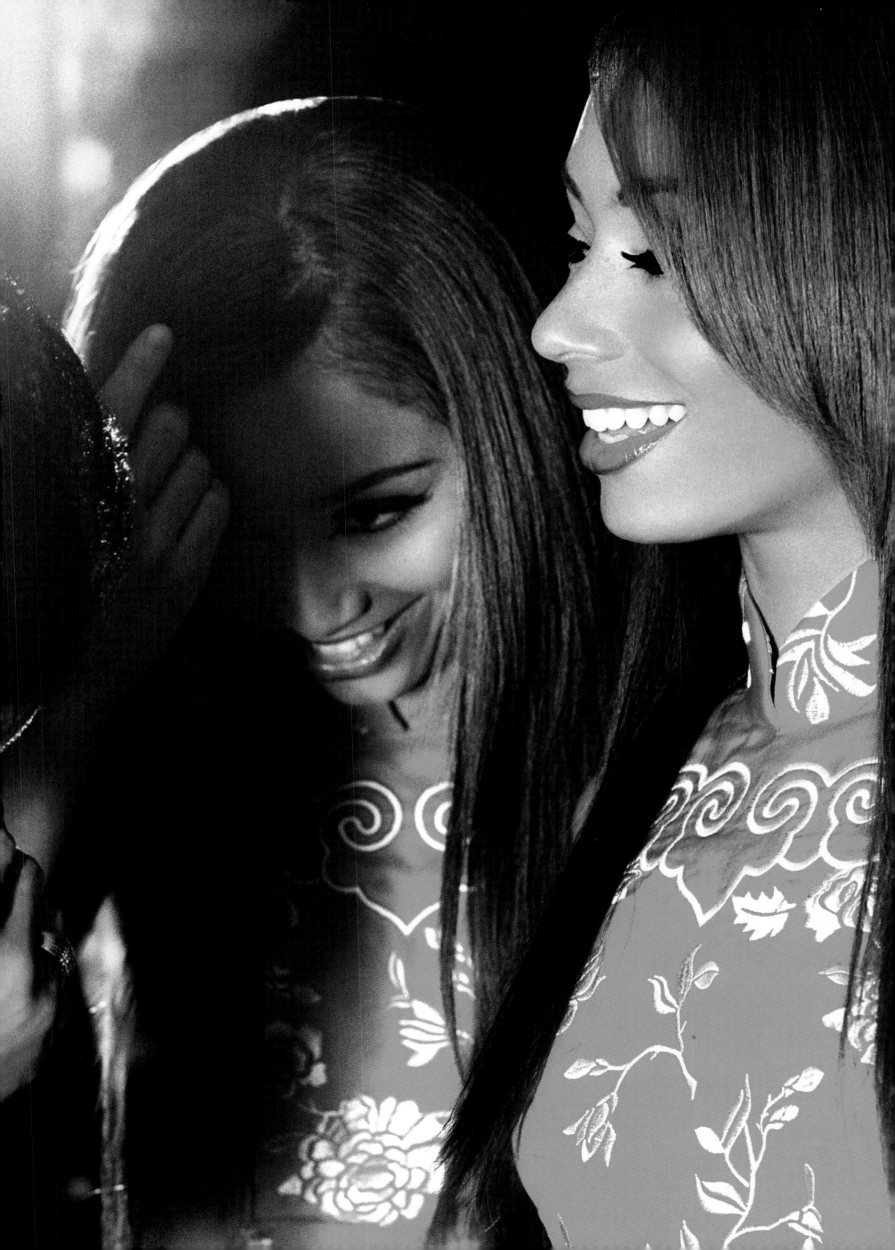

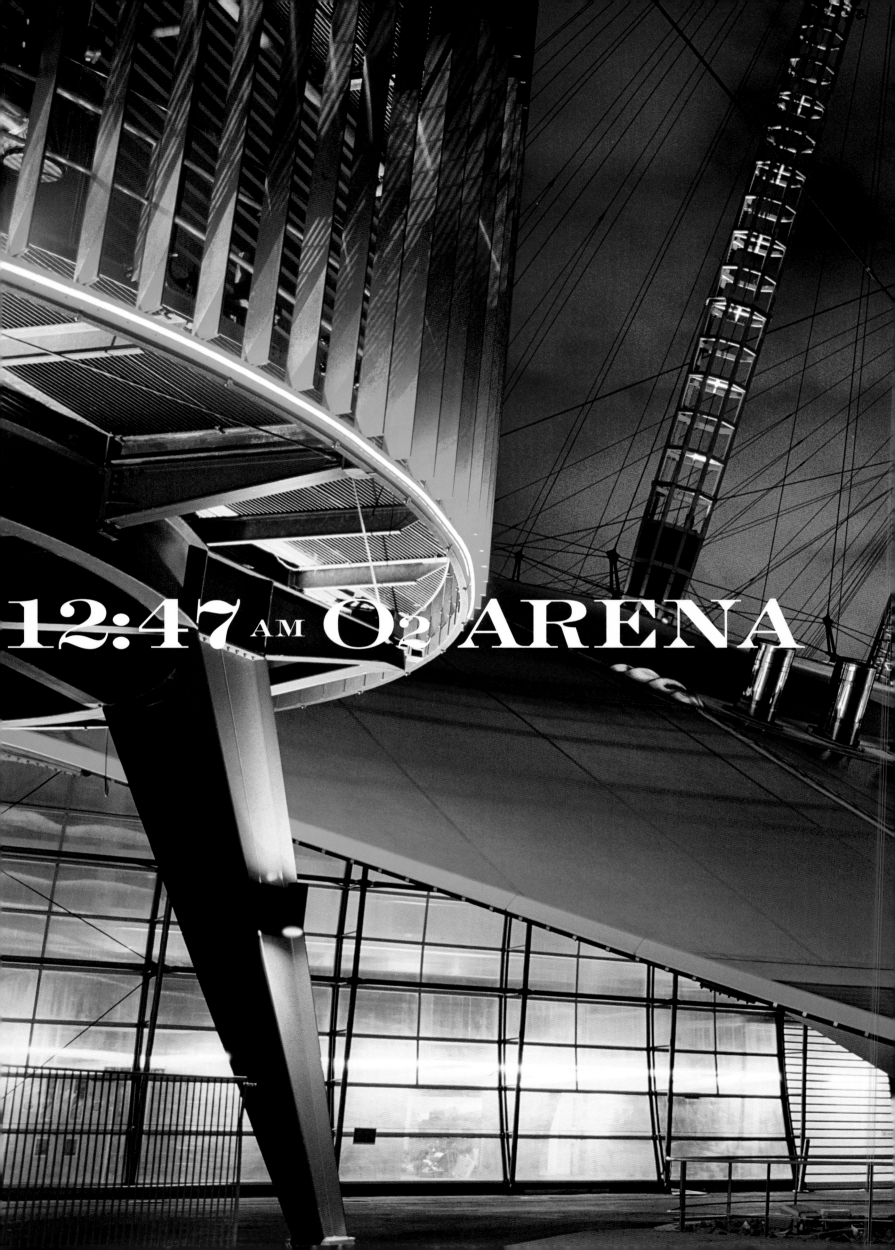

12:47 AM O2 ARENA

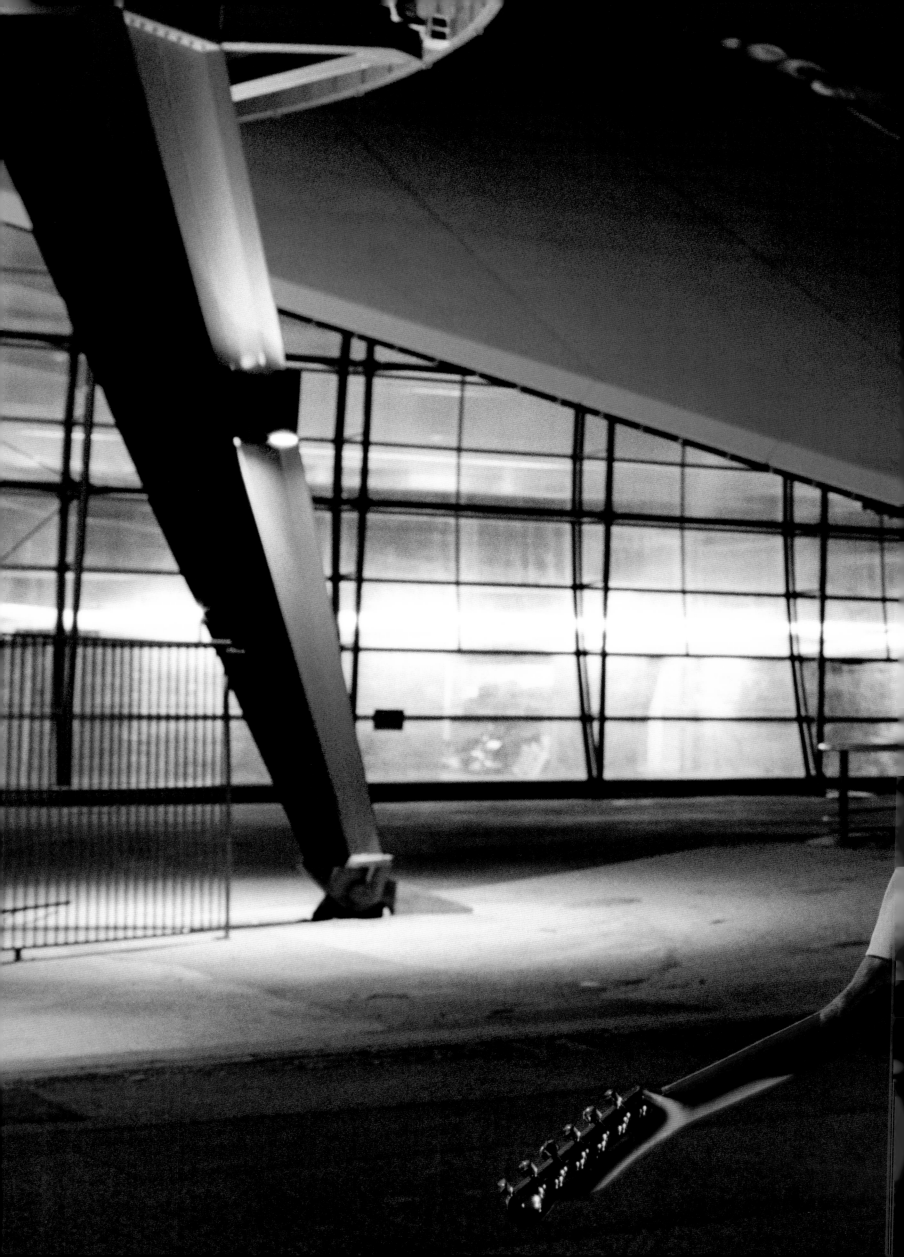

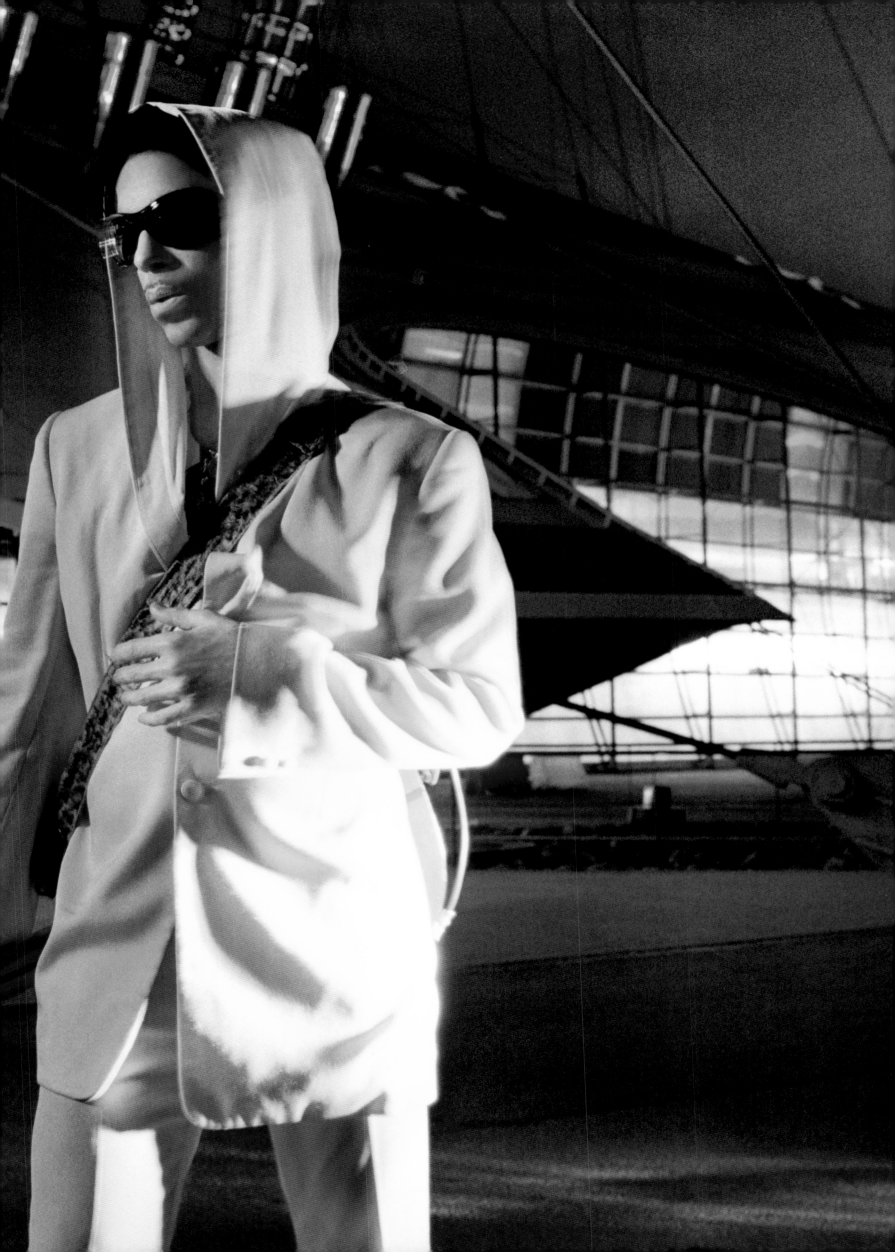

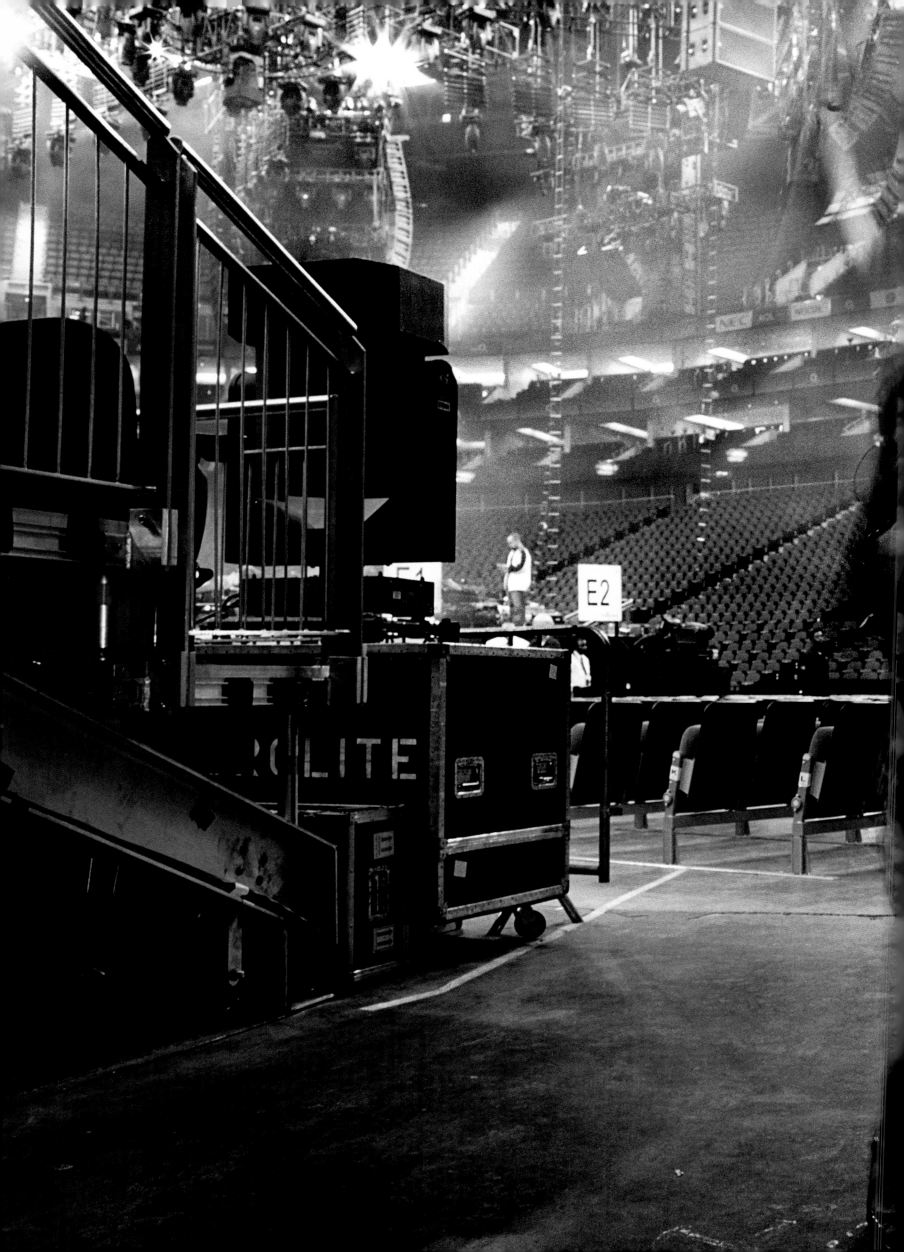

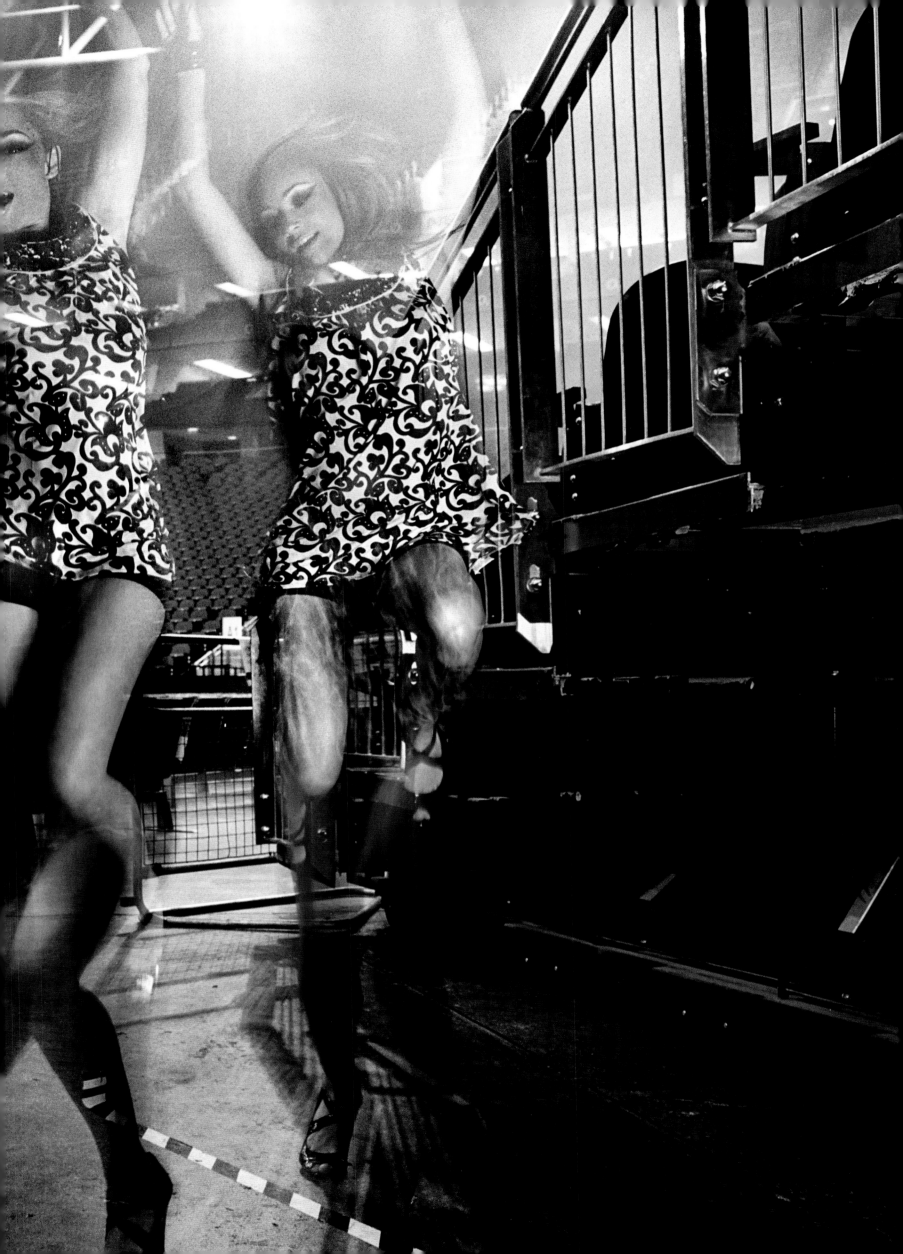

BECUZ EYE TURN

BECUZ EYE TURN MY EYE 2WARD U

BECUZ EYE SEEK UR HAND

EVERY OTHER WOMAN ENVIES U

AND ME EVERY OTHER MAN

ALAS THE CIRCLE OF JEALOUSY IS COMING AROUND AGAIN

THOSE PRICKLY-FINGERED SCALLYWAGS THAT MASQUERADE AS FRIENDS

MAKE A PROMISE THIS VERY NIGHT THAT THEY WILL NO LONGER POSE

A THREAT 2 EITHER ONE OF US THEN LET THE CHAPTER CLOSE

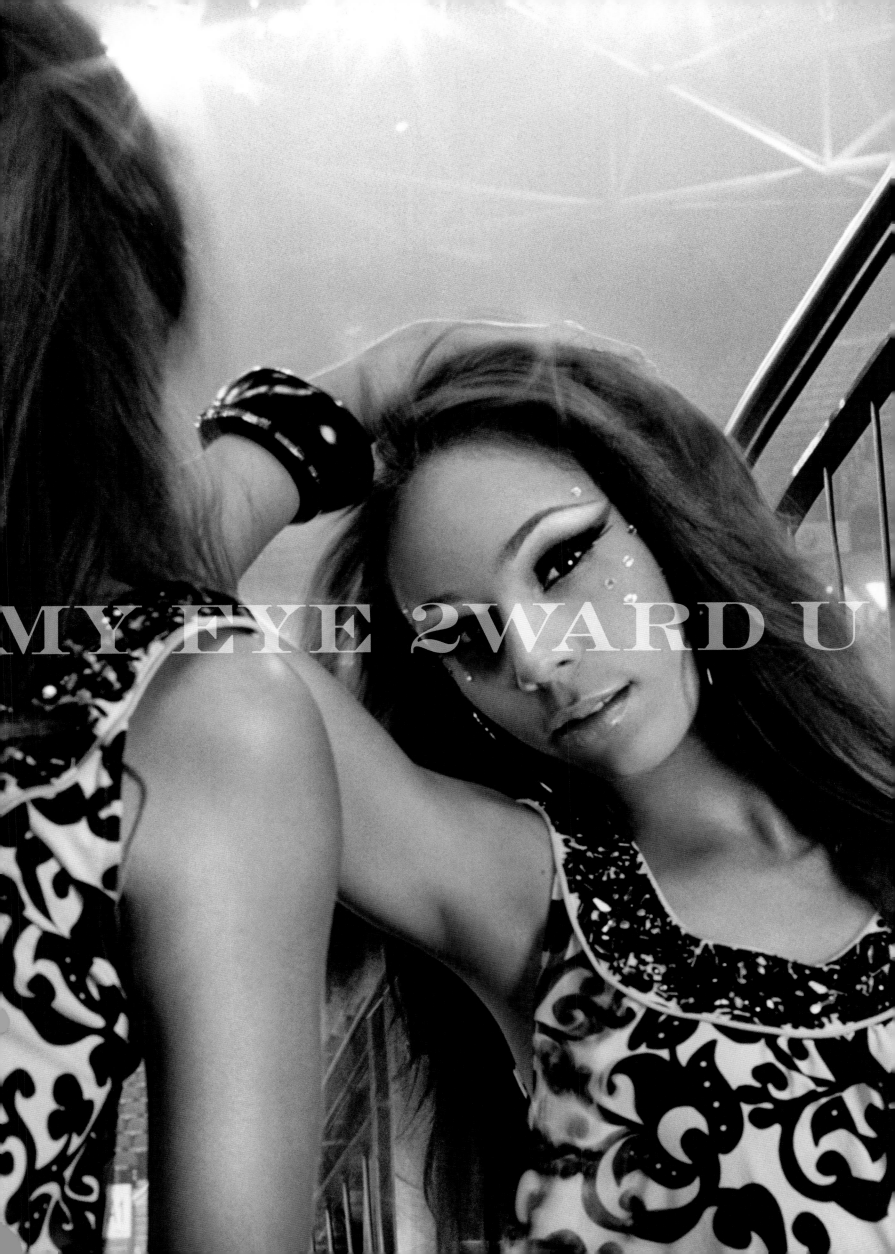

7:21PM

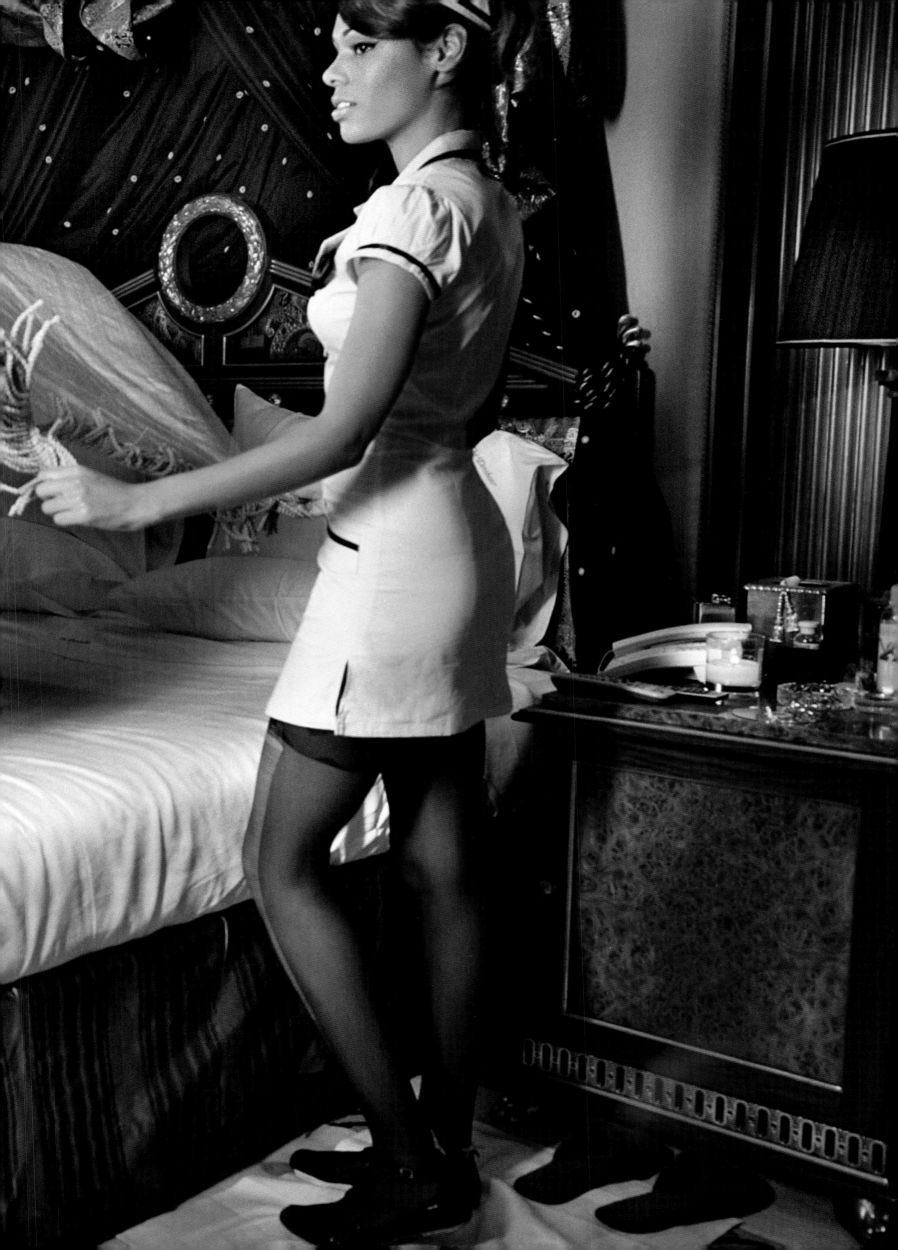

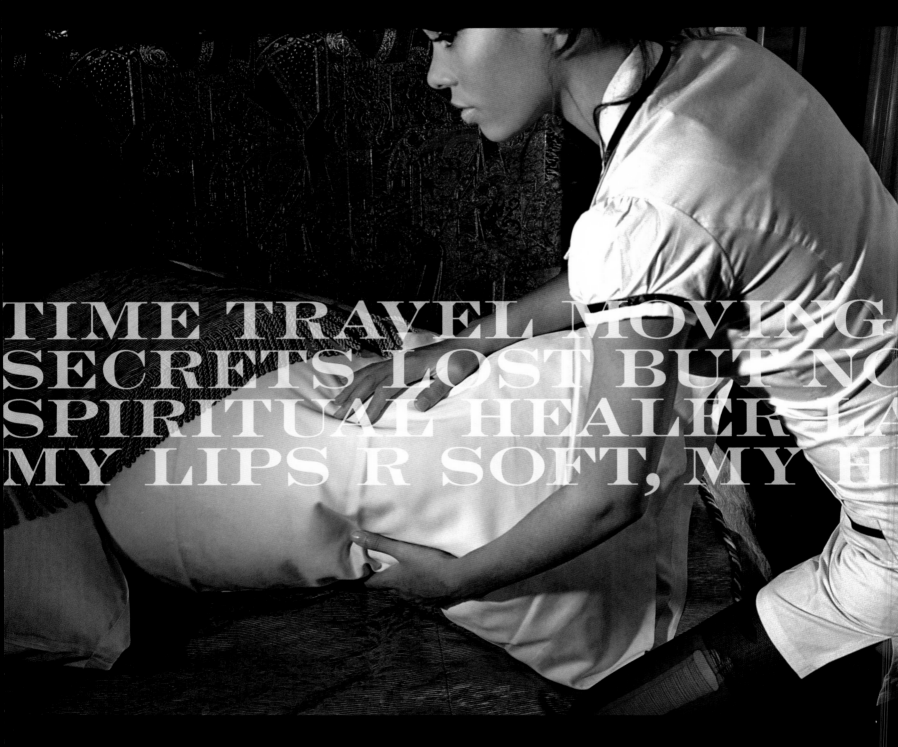

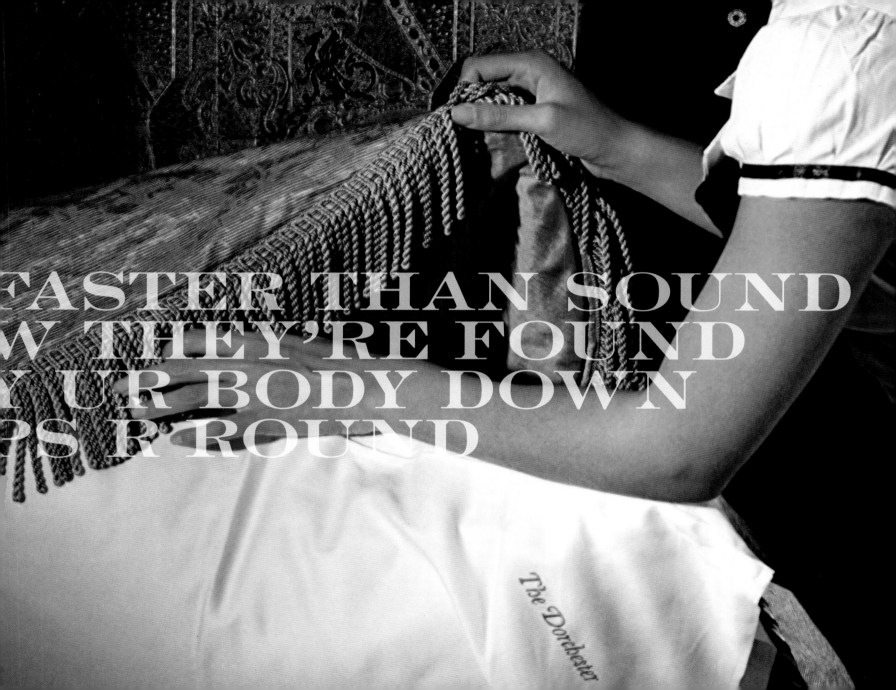

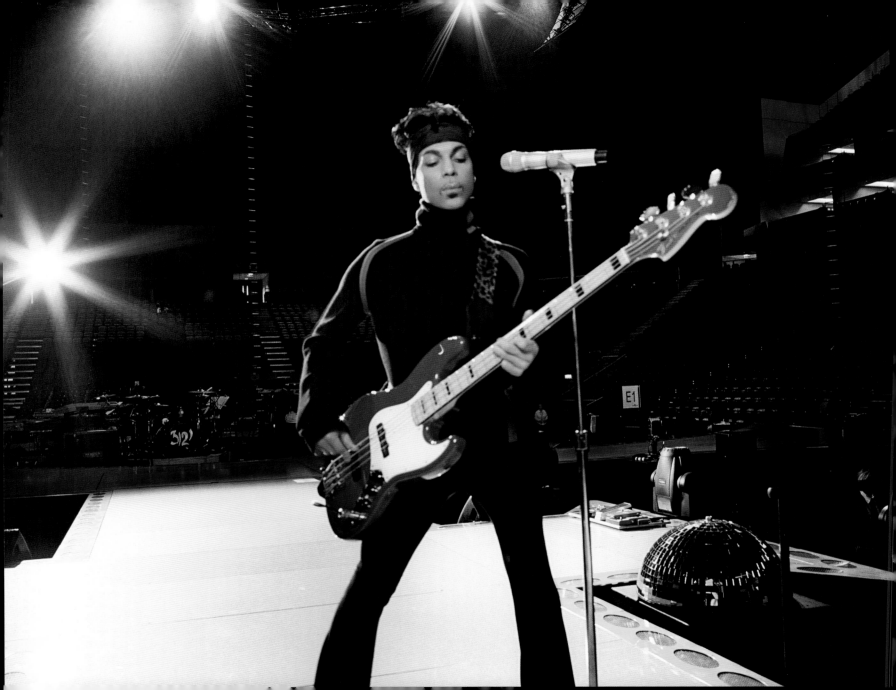

S MY NAME ?

TAKE THIS BASS, EYE CAN'T PLAY IT
IT ONLY MAKES ME WISH 4 THE WAY IT USED 2 B
U COULD SLAP MY FACE, BUT EYE GOT 2 SAY IT
U NEVER WOULD HAVE DRANK MY COFFEE IF EYE HAD NEVER SERVED U CREAM
NOW TELL ME, WHAT'S MY NAME?

8:30 PM THE NPG

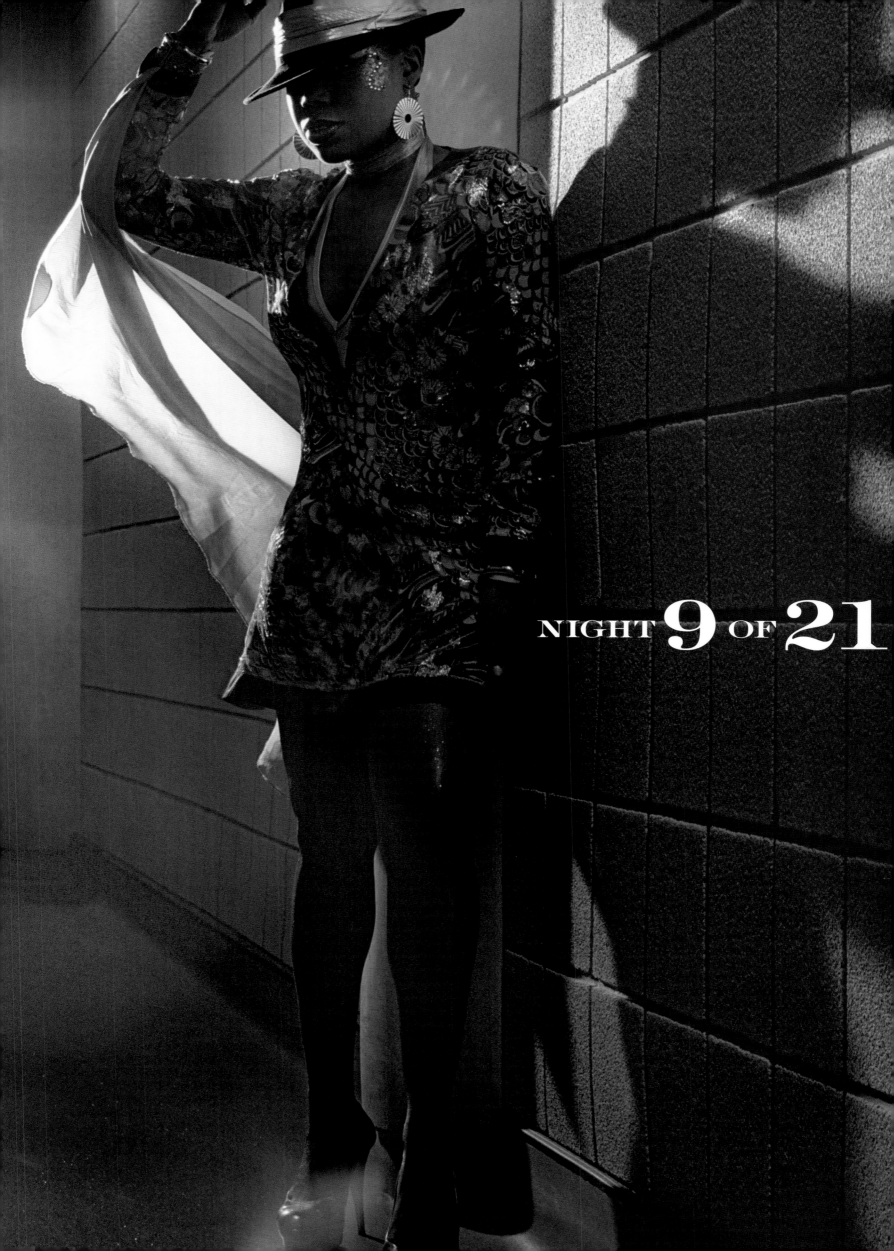

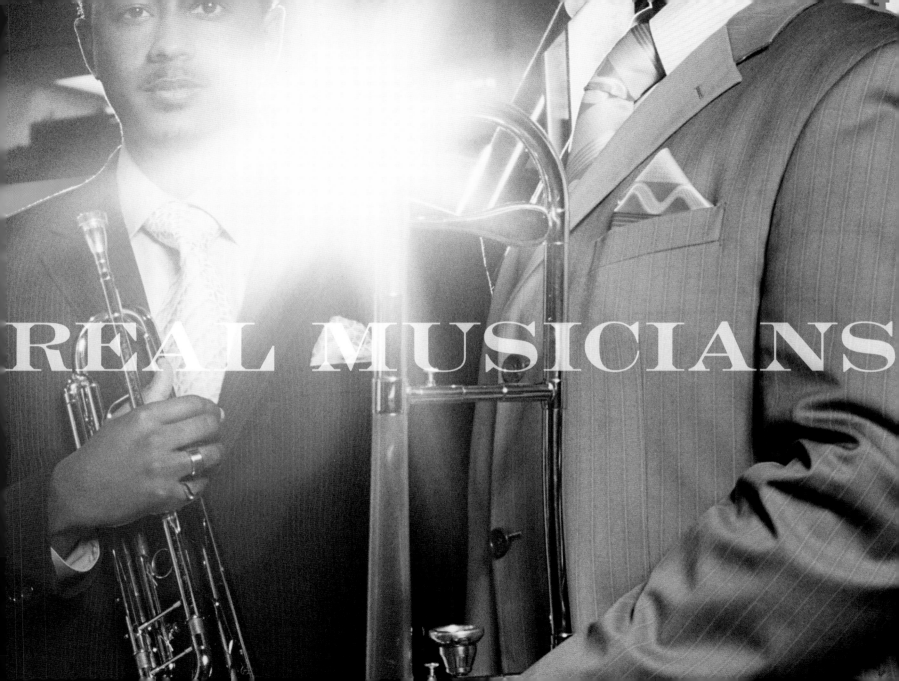

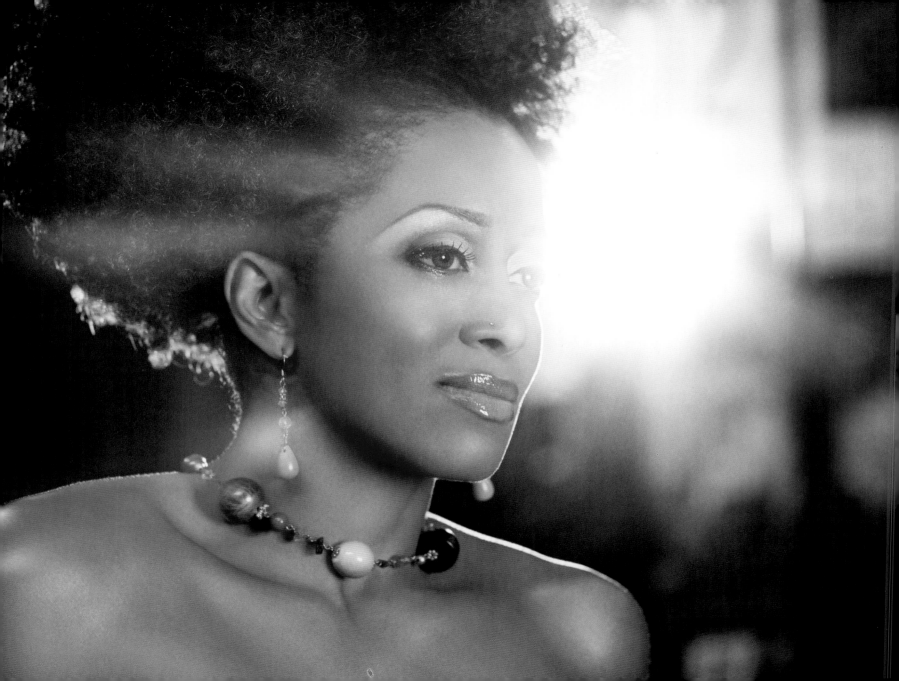

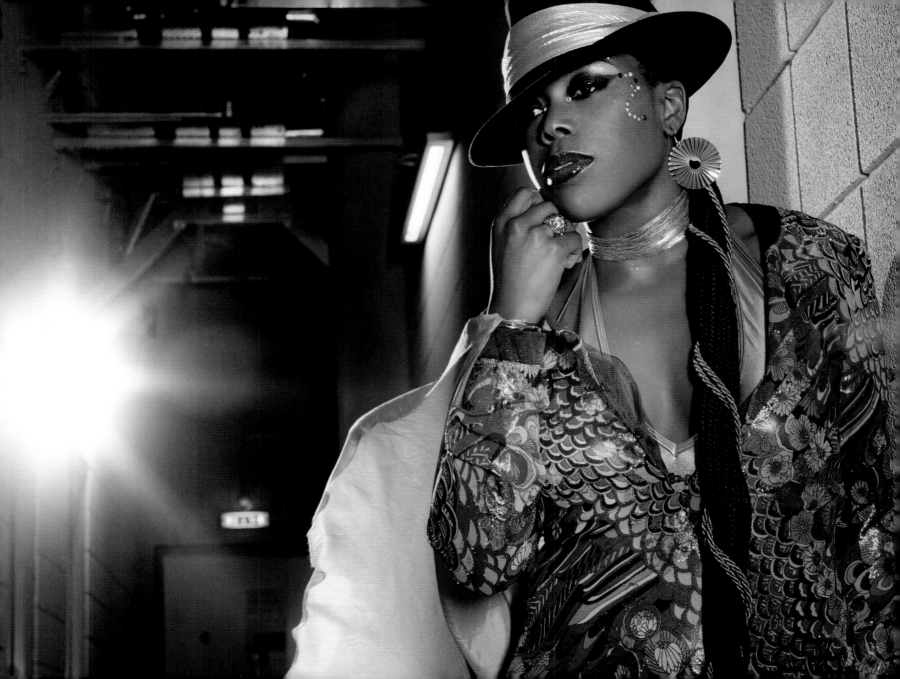

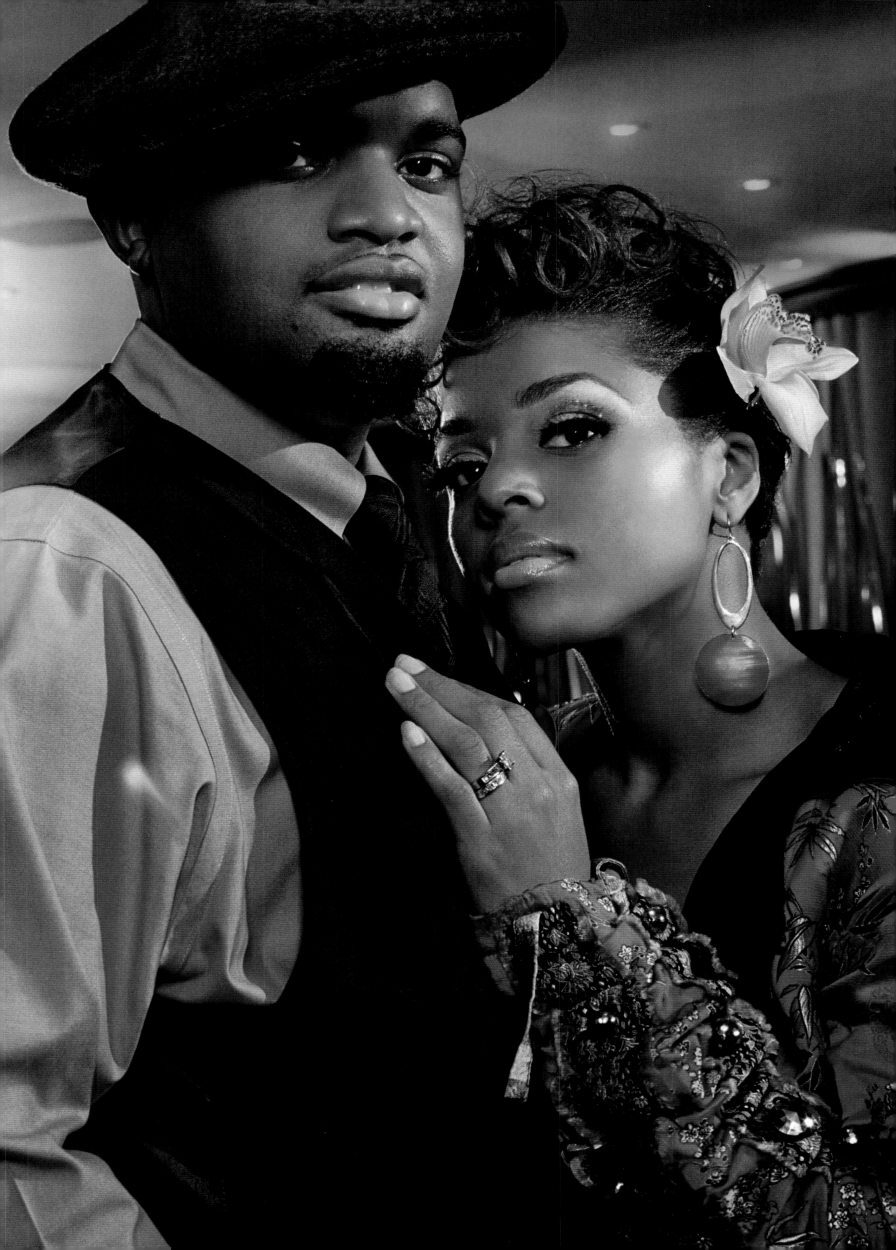

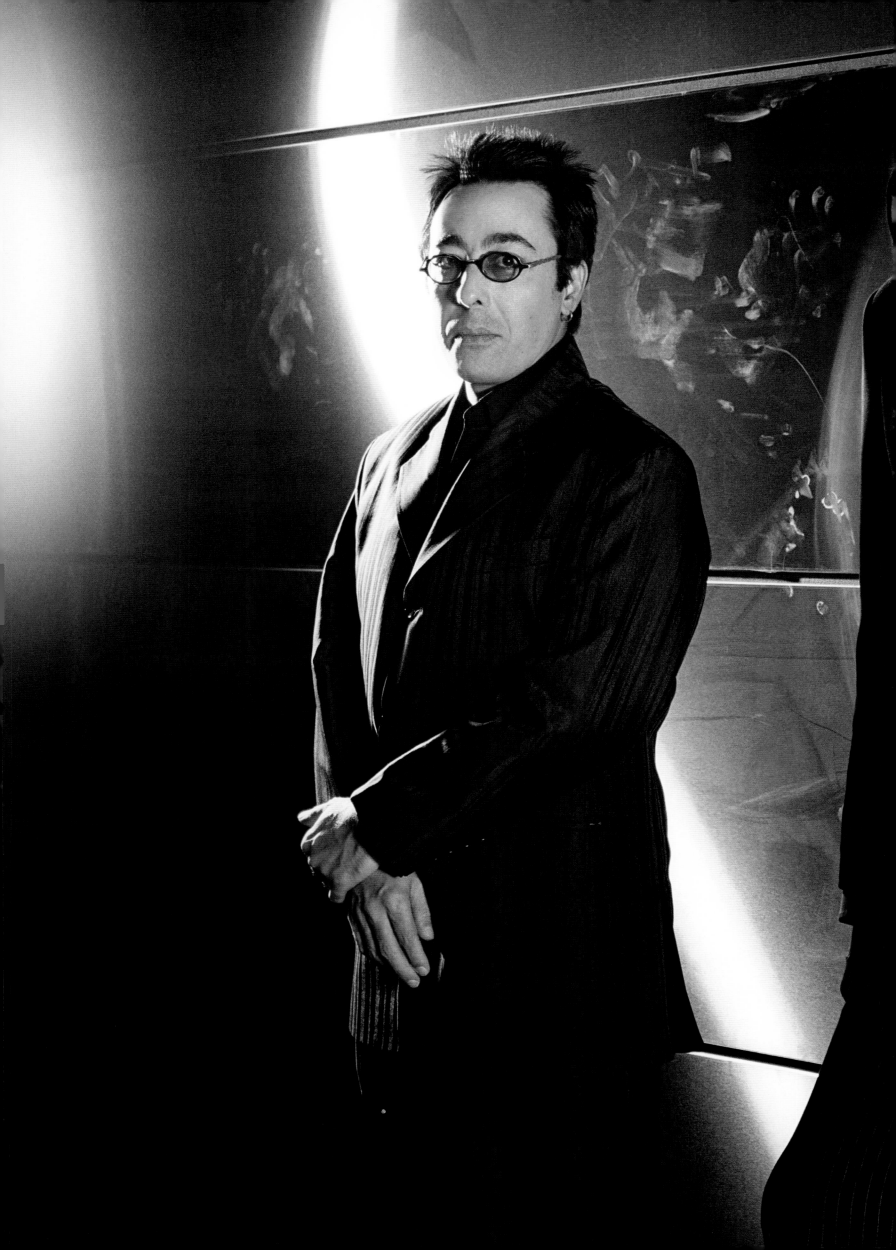

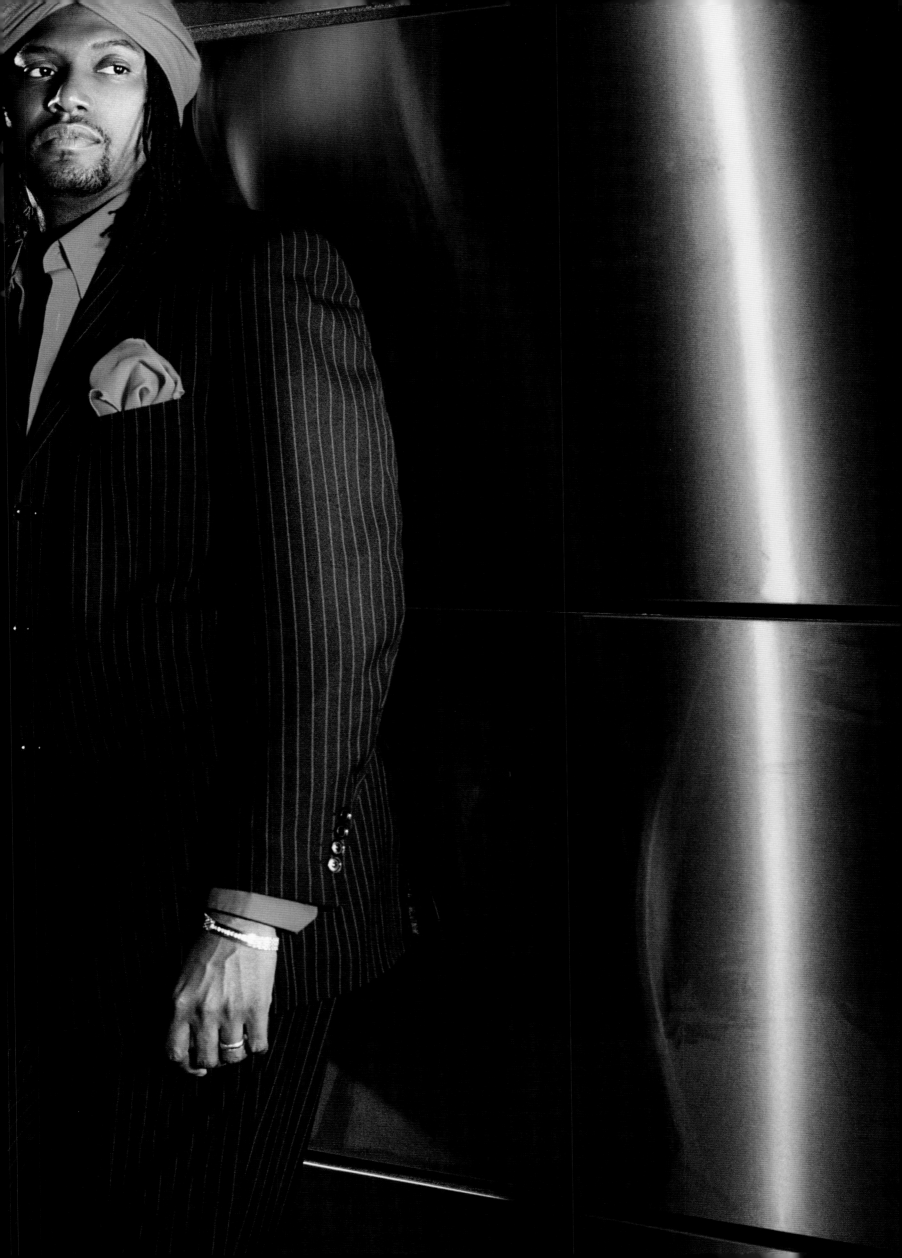

FUTUR

EYE'VE HEARD IT SAID THAT MY LOVERS LOOK ALIKE
COULD IT B THAT EYE WAS LOOKING 4 U?
THEY WERE COOL BUT SOMETHING WASN'T RIGHT
THEY HAD ME FOOLED 4 A MINUTE AND THEN EYE SAW THE TRUTH
NONE OF THEM GOT WHAT IT TAKES 2 B A FUTURE BABY MAMA
GOTTA BEND IN THE WIND BUT DON'T BREAK 2 KEEP UR MAN
SHOW ME ONE OF THEM AND EYE'LL MAKE HER MINE WITH NO MORE DRAMA
FUTURE BABY MAMA
EYE'VE HEARD IT SAID THAT EYE WON'T TREAT U RIGHT
BUT THEY AIN'T SURE 'CUZ THEY DON'T KNOW NOTHING ABOUT U
U'RE 2 SECURE 2 EVER WANNA FUSS AND FIGHT
THAT'S Y UR MAN NEVER GOT A REASON 2 DOUBT U, OOH
NONE OF THEM GOT WHAT IT TAKES 2 B A FUTURE BABY MAMA

E BABY MAMA

FUTURE BABY MAMA
YEAH, EYE KNOW U MIGHT B FINE BUT EYE'VE SEEN IT ALL B4
CINDERELLA WAS A WASTE OF TIME THEN OOPS, SHE'S OUT THE DOOR
2 BUILD A HOUSE 2GETHER, THE THING THAT MATTERS MOST
IS UNDER THE FLOOR ... A STRONG FOUNDATION LASTS 4EVER MORE
EYE'M GONNA MAKE U HAPPY BABY
HAPPIER THAN HAPPY ITSELF
KNOW WHAT? IF U EVER NEED A HAND, CALL ME, EYE'LL HELP
'CUZ EYE GOT U, WHEREVER U WANNA GO
PARIS, LONDON, AFRICA, SAN LUCAS, MEXICO. U C,
EYE KNOW WHAT U WANT—WHAT EVERY GOOD WOMAN WANTS—
A MAN SO IN LOVE WITH U THAT HE CAN'T HELP BUT FLAUNT U
DEEP DOWN EYE KNOW WHAT U WANT
U WANT UR GIRLFRIENDS 2 HATE U
'CUZ THEY CAN'T GET UR MAN
FUTURE BABY MAMA

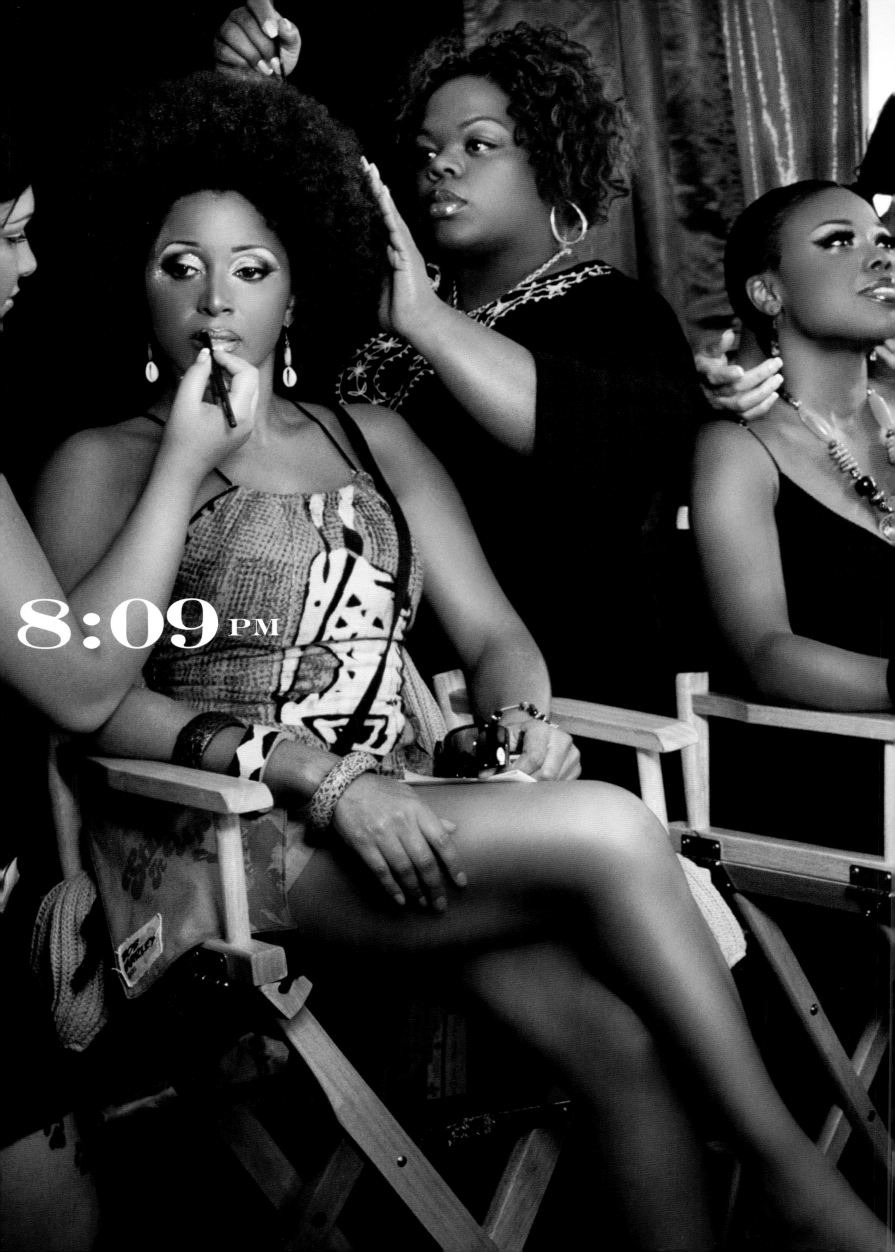

8:09 PM

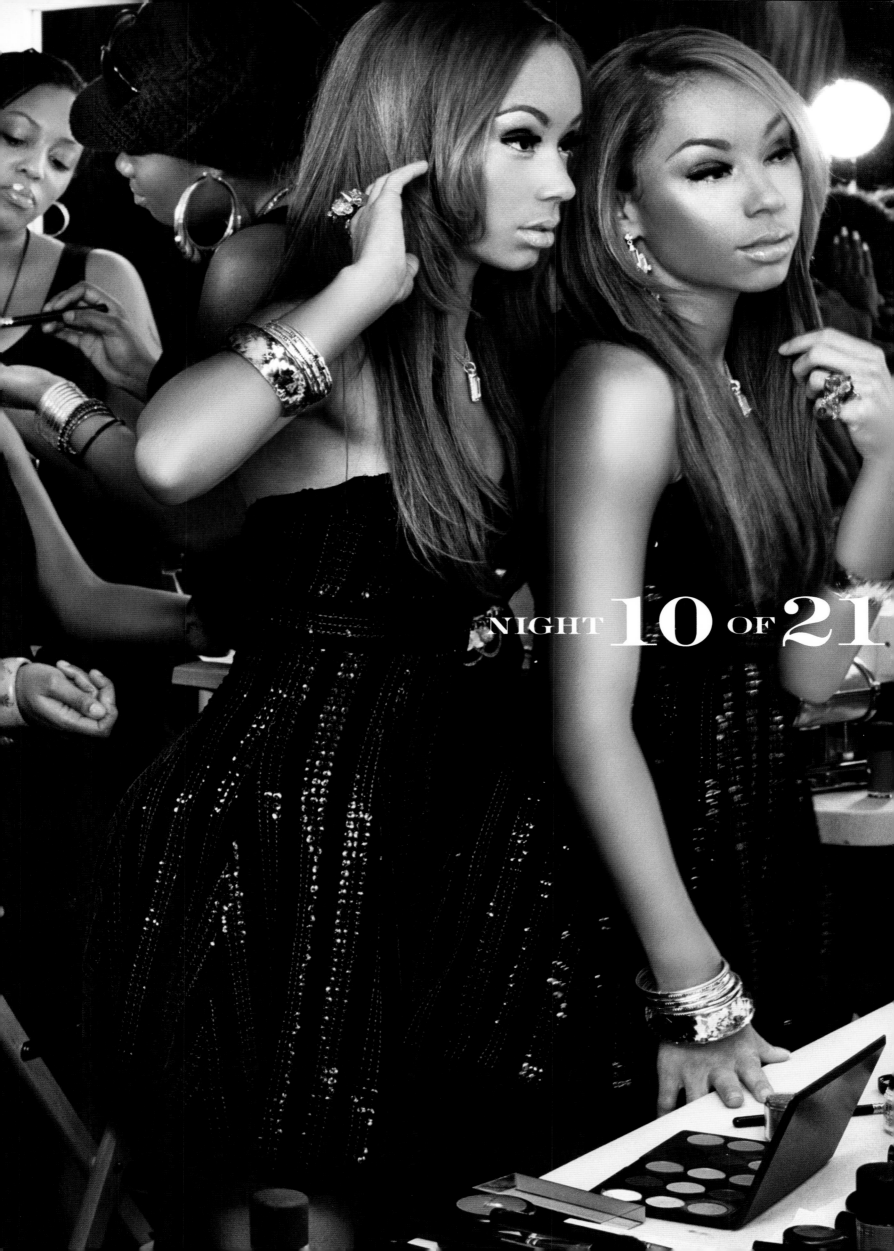

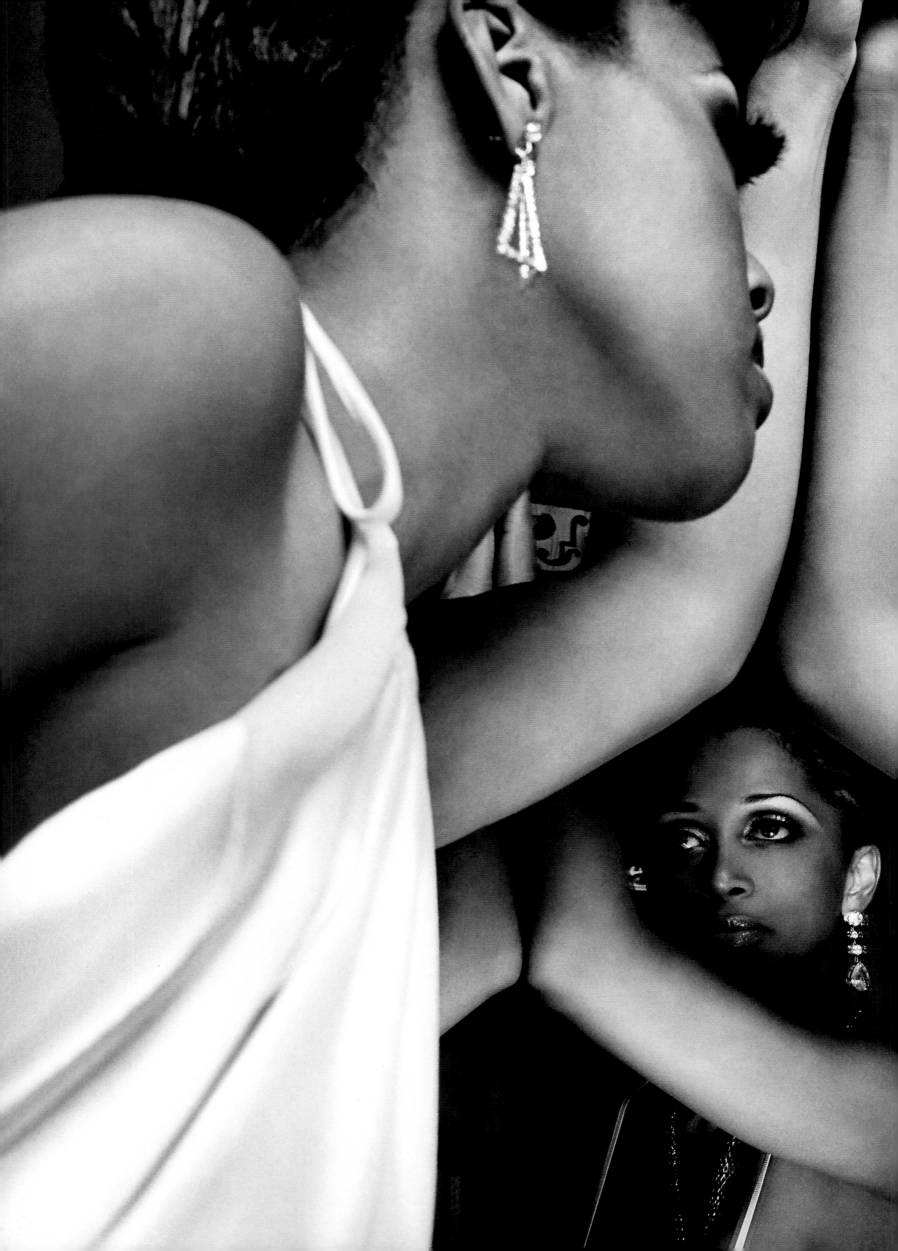

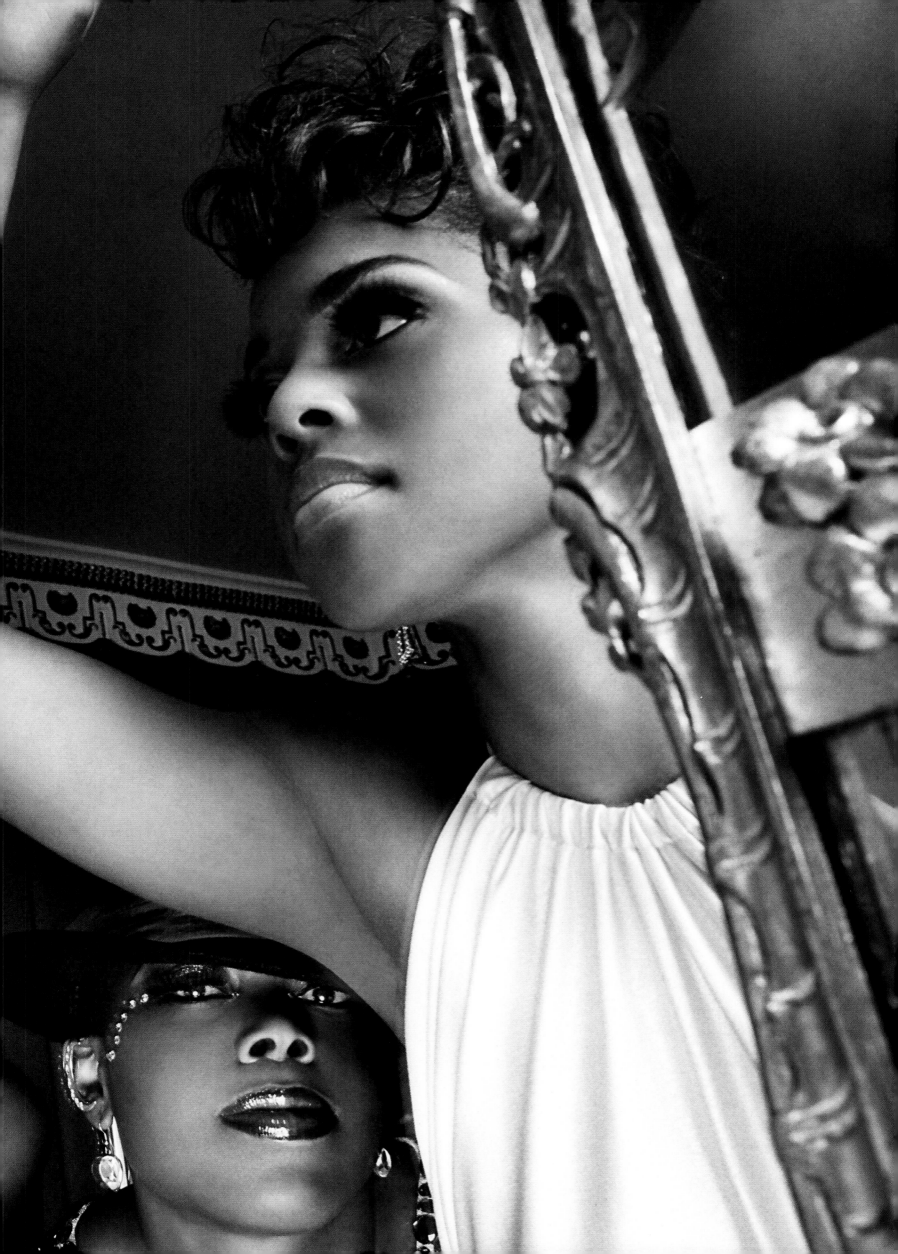

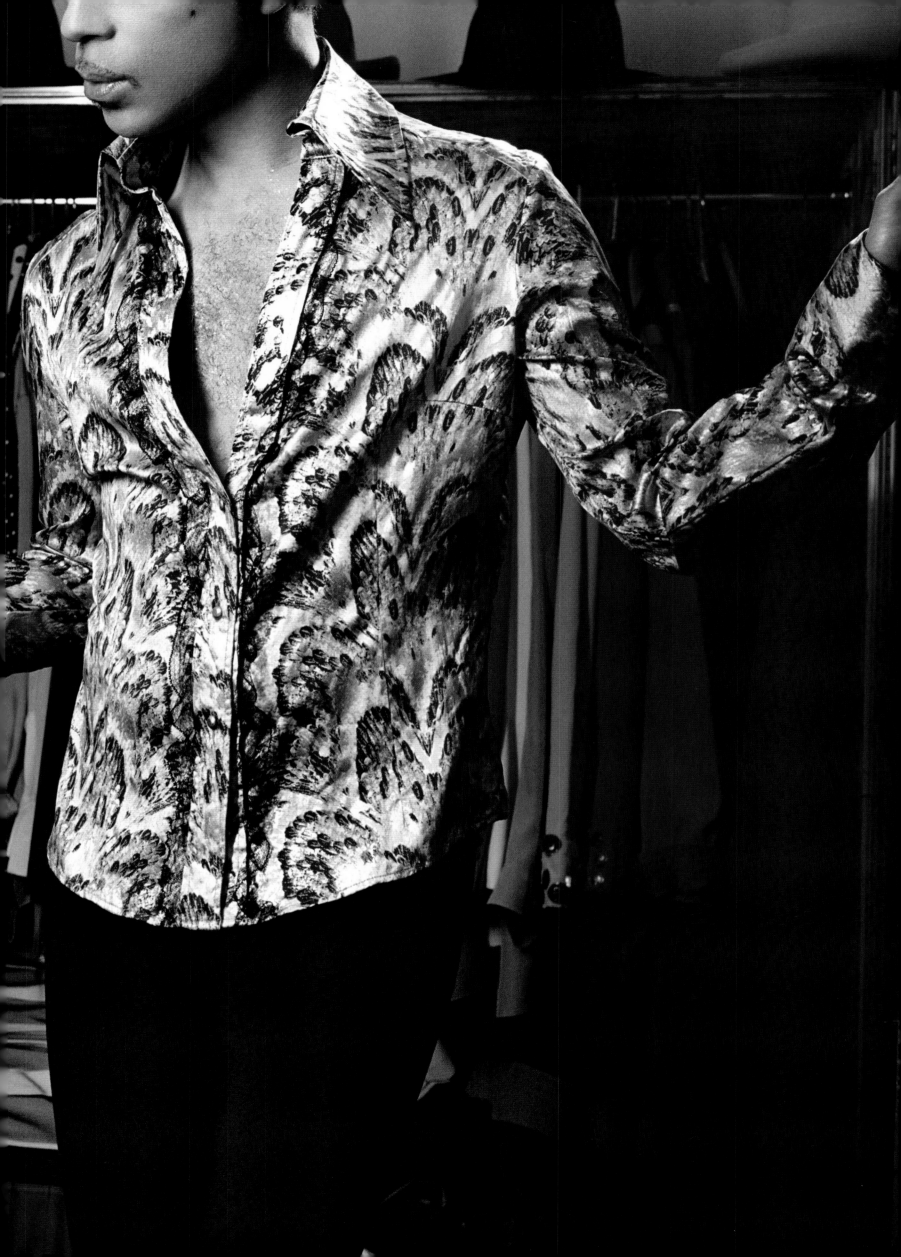

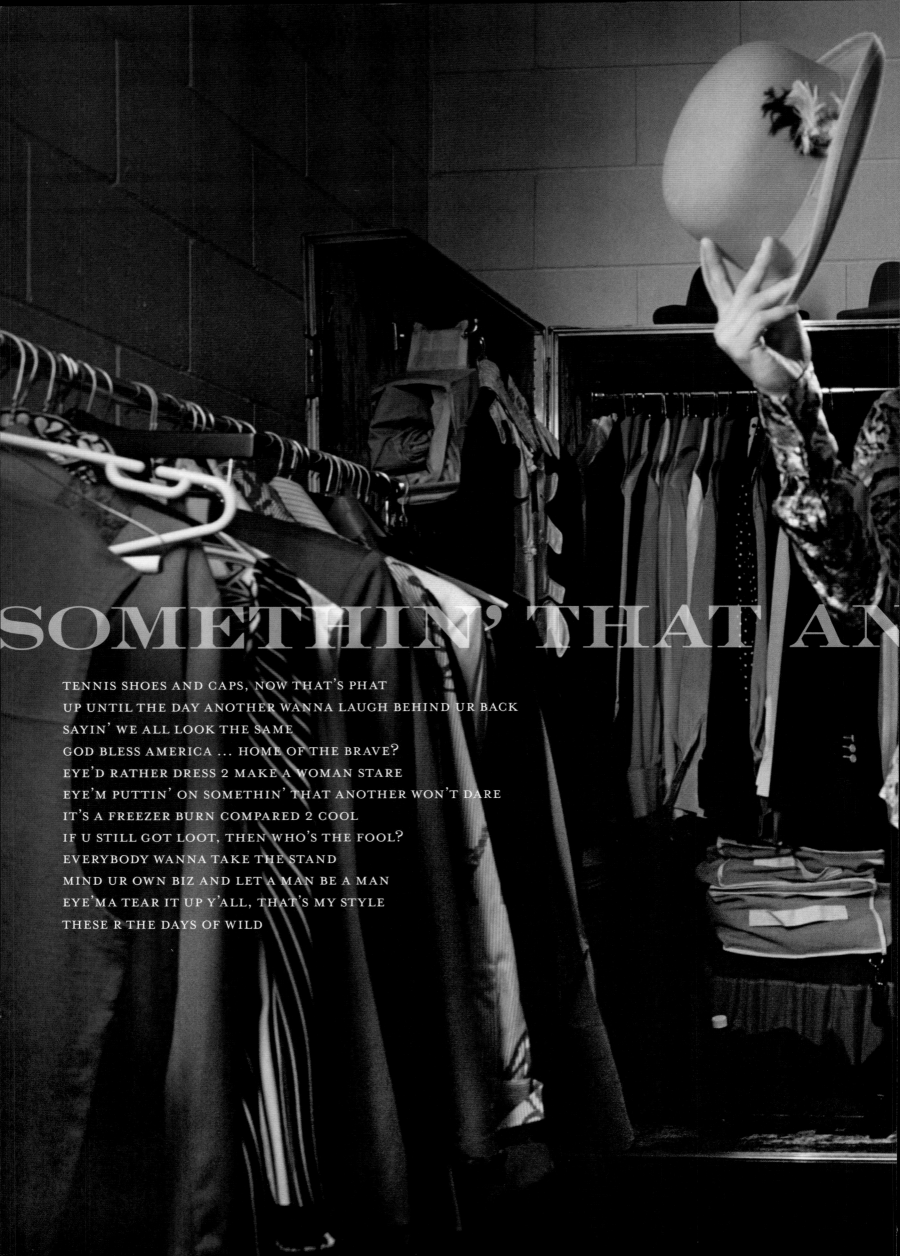

SOMETHIN' THAT AN

TENNIS SHOES AND CAPS, NOW THAT'S PHAT
UP UNTIL THE DAY ANOTHER WANNA LAUGH BEHIND UR BACK
SAYIN' WE ALL LOOK THE SAME
GOD BLESS AMERICA … HOME OF THE BRAVE?
EYE'D RATHER DRESS 2 MAKE A WOMAN STARE
EYE'M PUTTIN' ON SOMETHIN' THAT ANOTHER WON'T DARE
IT'S A FREEZER BURN COMPARED 2 COOL
IF U STILL GOT LOOT, THEN WHO'S THE FOOL?
EVERYBODY WANNA TAKE THE STAND
MIND UR OWN BIZ AND LET A MAN BE A MAN
EYE'MA TEAR IT UP Y'ALL, THAT'S MY STYLE
THESE R THE DAYS OF WILD

OTHER WON'T DARE

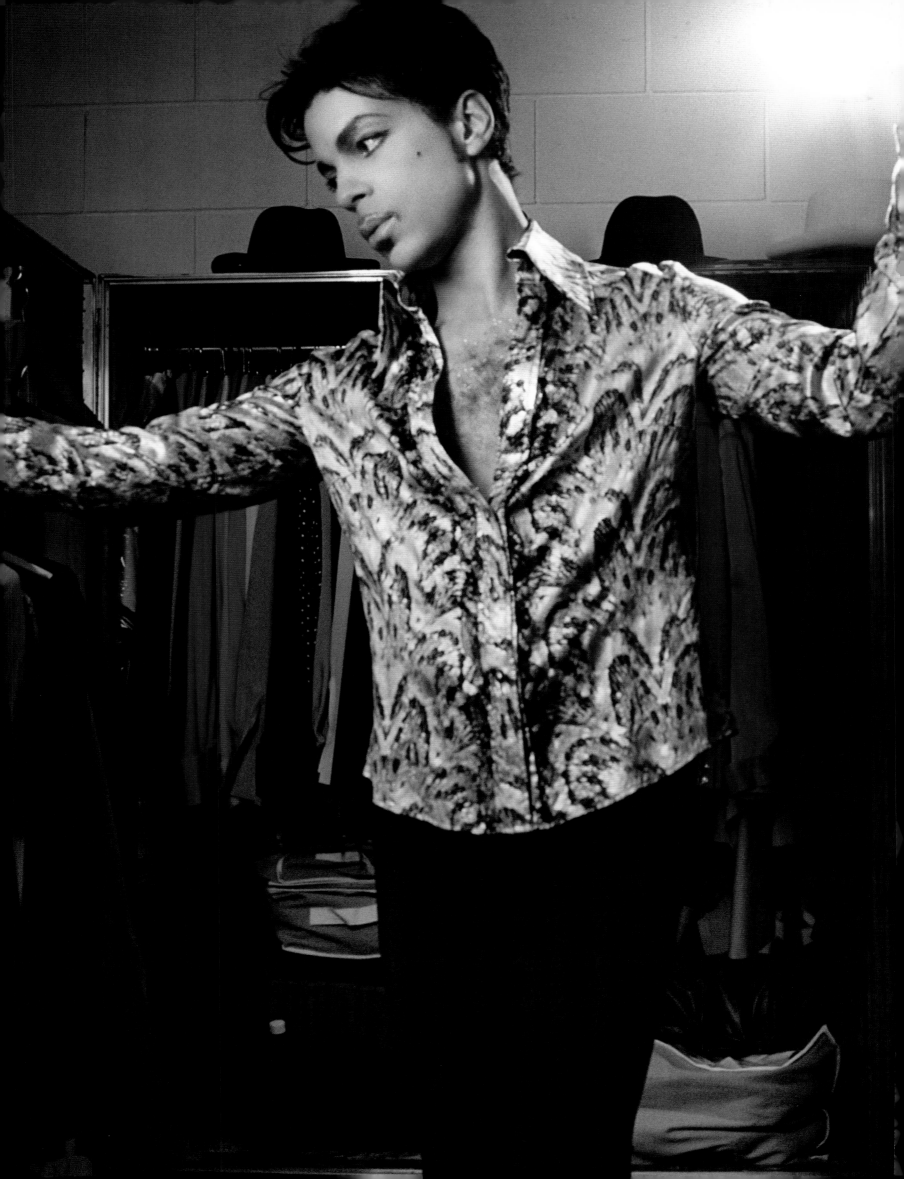

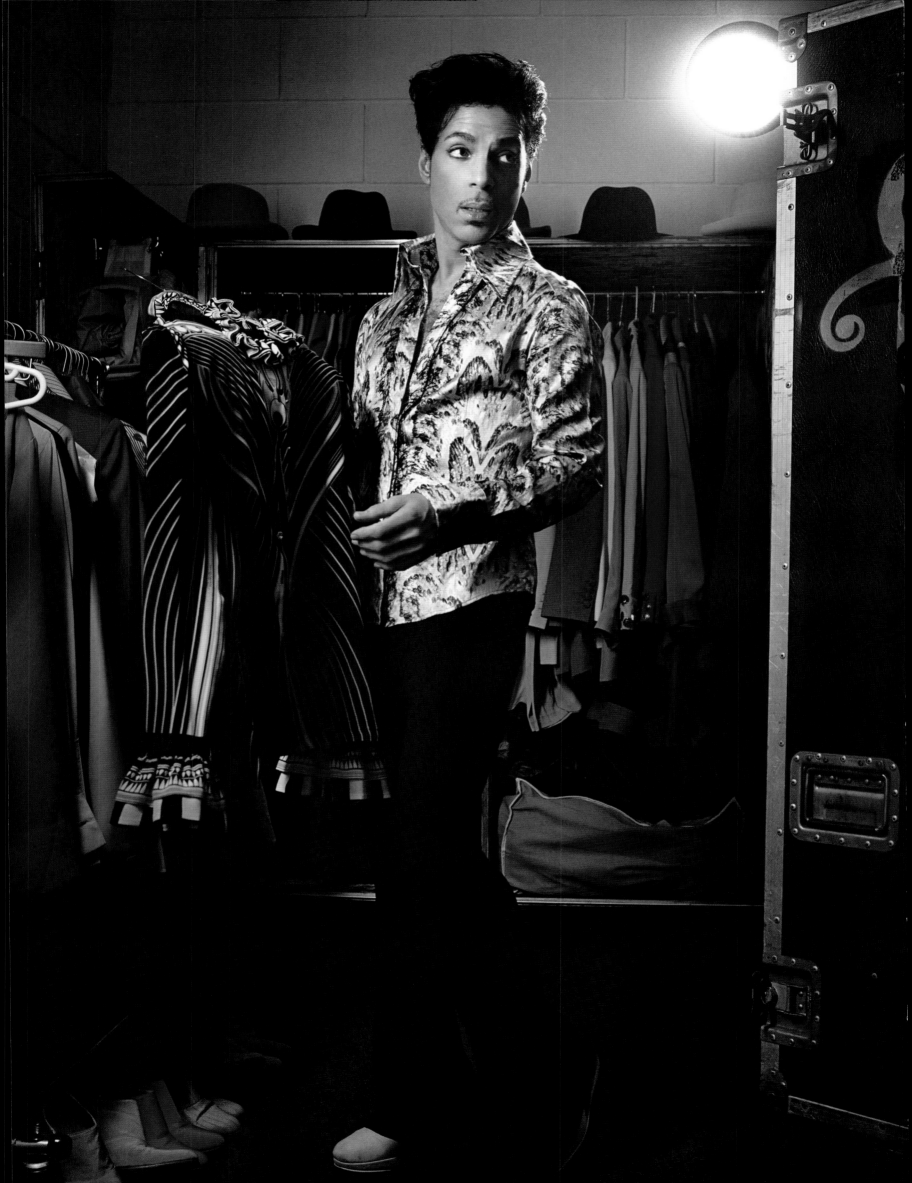

THE

WALKING DOWN THE CORRIDOR IN AN INTROVERTED GAZE
HE SAID, "WATCH OUT, THE NIGHT IS YOUNG"
HE SENT THE SOLDIERS HOME MUCH 2 THEIR DISMAY
ALL XCEPT
THE GUILTY ONES

TIME 2 TEACH A LESSON WITH THE 6 STRING AND THE STIX
THAT HE WAS STILL THE MASTER AND NOT SOME MAGIC TRICK

STEP IN2 A PHONE BOOTH ... ALL ILLUSIONS DIE
THE TRUTH COMES OUT 2 ACKNOWLEDGE OR DENY
MOVIE STARS & BANK TELLERS ... SINGLE MOMS & DRUNK FELLAS
SOME EASIER 2 TEASE, SOME HARDER 2 PLEASE (STILL HE TRY)

THE WHISPERINGS OF TYRANTS THAT SELDOM GO UNHEARD
HE'S ABOUT 2 WIN THEM OVER WITHOUT A SINGLE WORD

GENERATION 2 GENERATION ... LET IT B UPHELD
WHO EYE REALLY AM ONLY TIME WILL TELL
2 THE ALMIGHTY LIFE 4CE THAT GROWS STRONGER WITH EVERY CHORUS
YES GIVE PRAISE, LEST YE B AMONG ... THE GUILTY ONES

GUILTY ONES

BEHOLD THE DAMAGE DONE
WALKING DOWN THE CORRIDOR ... THE BATTLE HAS BEEN WON
ALL HAIL 2 THE MATADOR THAT GIVES PRAISE 2 THE SON ...
THE GUILTY ONES

WALKING 2WARD THE SYMBOL THAT 4 21 NIGHTS UPHELD
REAL MUSIC BY REAL MUSICIANS
IMPACT—
TIME WILL TELL

NIGHT AFTER NIGHT
WE FOUGHT 4 TIME/SPACE HISTORIC POSITION
RESERVED 4 THE ONE
THAT GIVES PRAISE WHEN IT'S DONE—

2 THE ALMIGHTY LIFE 4CE
THAT GROWS STRONGER WITH EVERY CHORUS
YES, GIVE PRAISE LEST YE B AMONG

THE GUILTY ONES

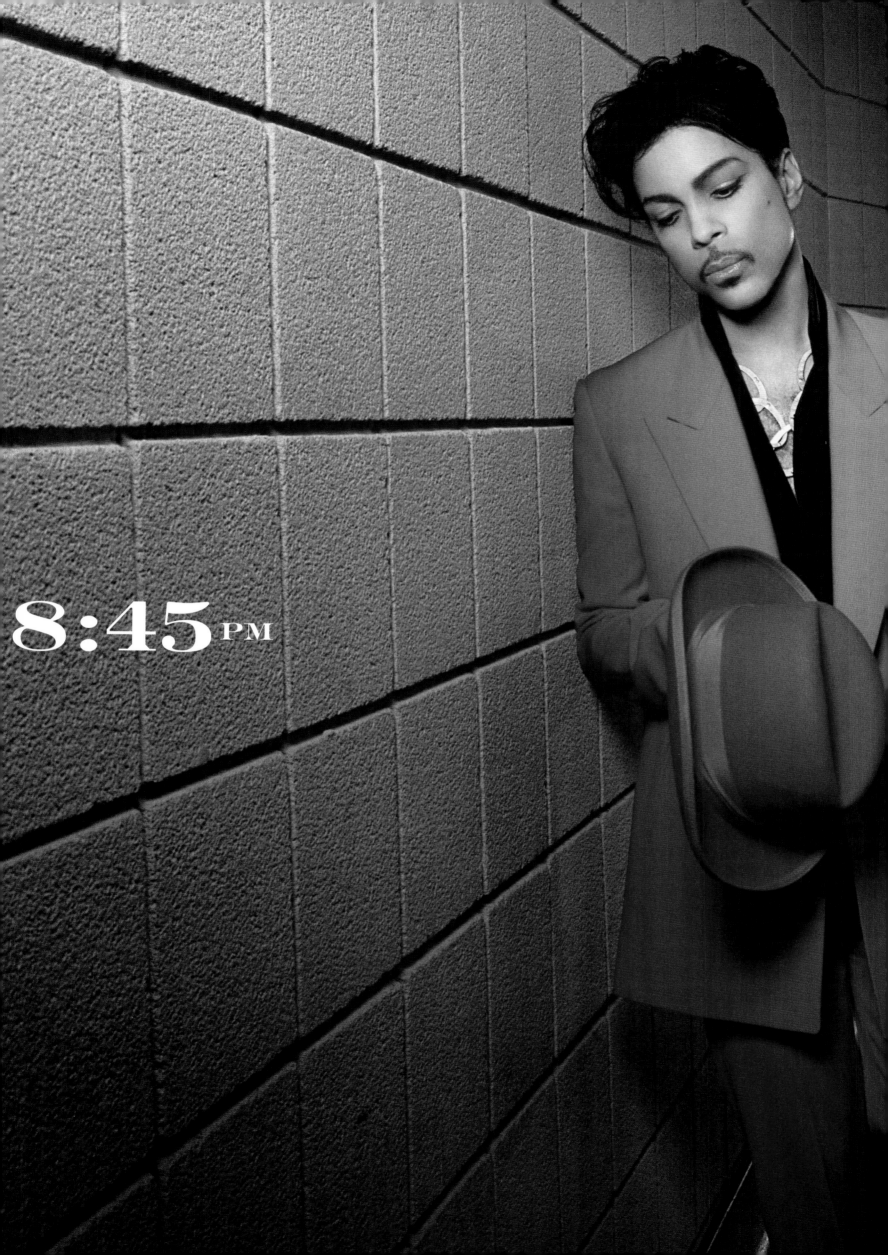

8:45PM

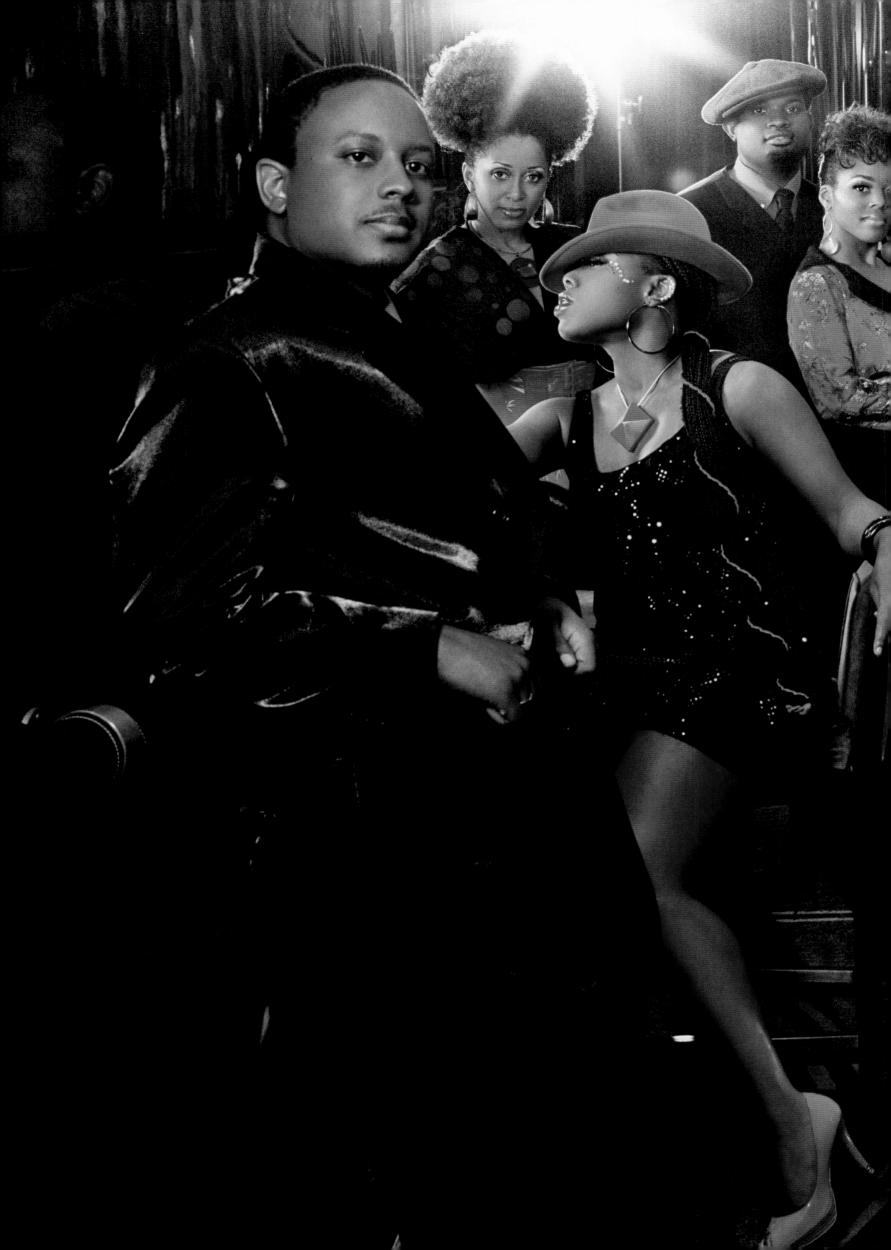

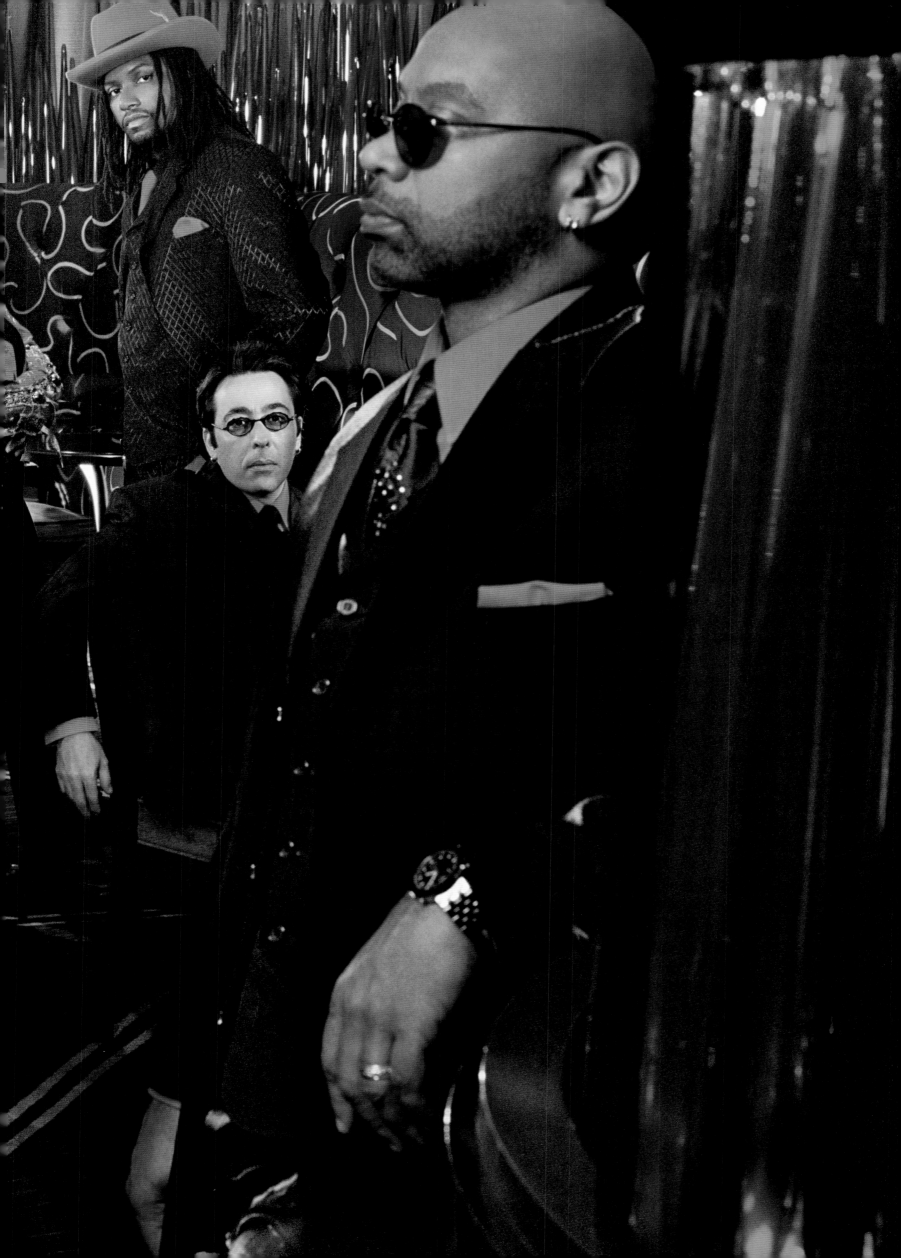

HEARD ABOUT THE PARTY NOW
JUST EAST O' HARLEM
MACEO'S GONNA B THERE
BUT U GOT 2 CALL HIM
EVEN THE SOLDIERS
NEED A BREAK SOMETIMES
LISTEN 2 THE GROOVE YA'LL
LET IT UNWIND UR MIND
NO INTOXICATION
UNLESS U C WHAT EYE C
DANCIN' HOT N' SWEATY
RIGHT IN FRONT OF ME
CALL IT WHAT U LIKE
EYE'M GONNA CALL IT HOW IT B
THIS IS JUST ANOTHER ONE OF GOD'S GIFTS—

MUSICOLOGY

MUSICOLOGY
KEEP THAT PARTY MOVIN'
JUST LIKE EYE TOLD U
KICK THE OLD SCHOOL JOINT
4 THE TRUE FUNK SOLDIERS
MUSICOLOGY
WISH EYE HAD A DOLLAR
4 EVERYTIME U SAY
DON'T U MISS THE FEELING
MUSIC GAVE YA BACK IN THE DAY?
LET'S GROOVE
SEPTEMBER
EARTH, WIND AND FIRE
HOT PANTS BY JAMES
SLY'S GONNA TAKE U HIGHER
MINOR KEYS AND DRUGS
DON'T MAKE A ROLLERSKATE JAM
TAKE UR PICK: TURNTABLE OR A BAND?
IF IT AIN'T CHUCK'D
OR JAM MASTER JAY
KNOW WHAT? THEY'RE LOSIN'
'CUZ WE GOT A PHD IN ADVANCED BODY MOVIN'
KEEP THE PARTY MOVIN'
JUST LIKE EYE TOLD U
KICK THE OLD SCHOOL JOINT
4 THE TRUE FUNK SOLDIERS
MUSICOLOGY

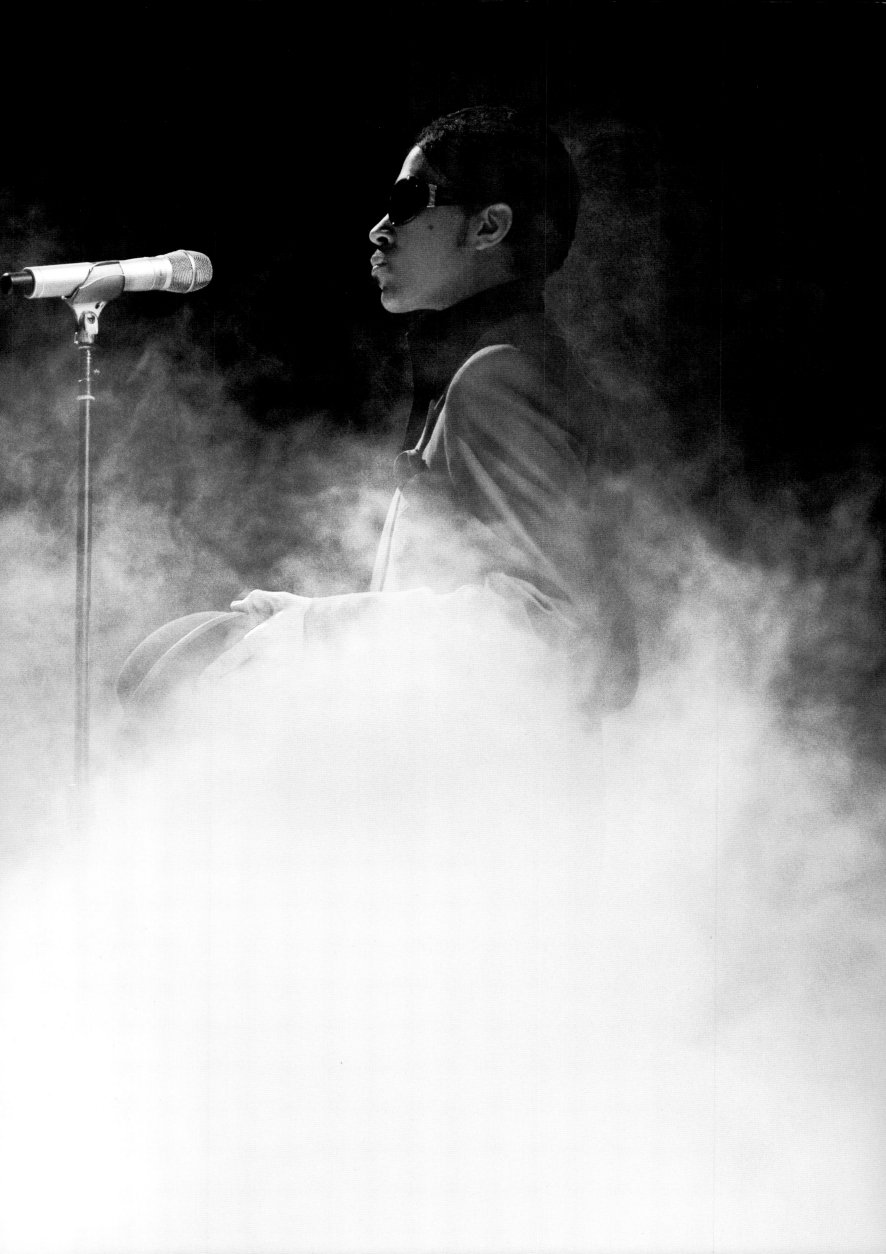

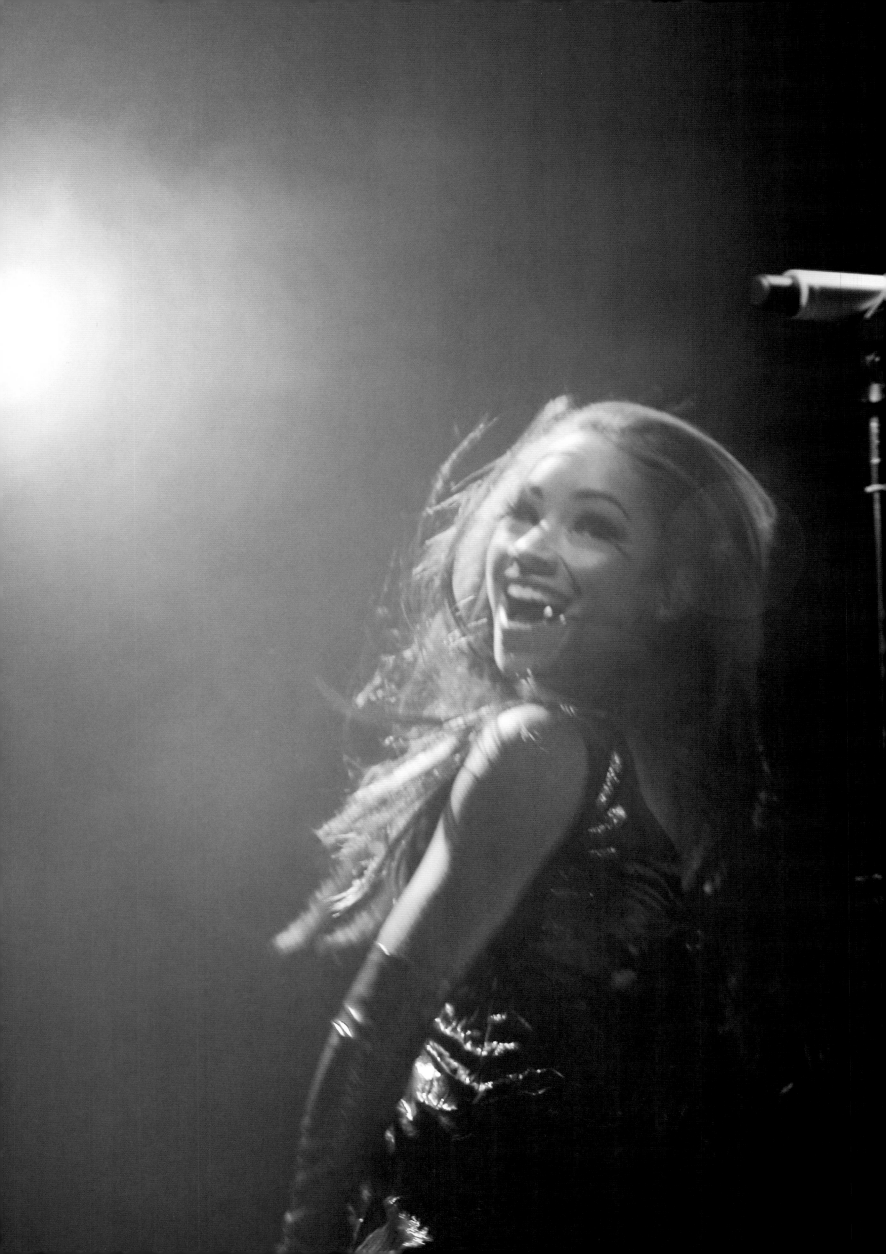

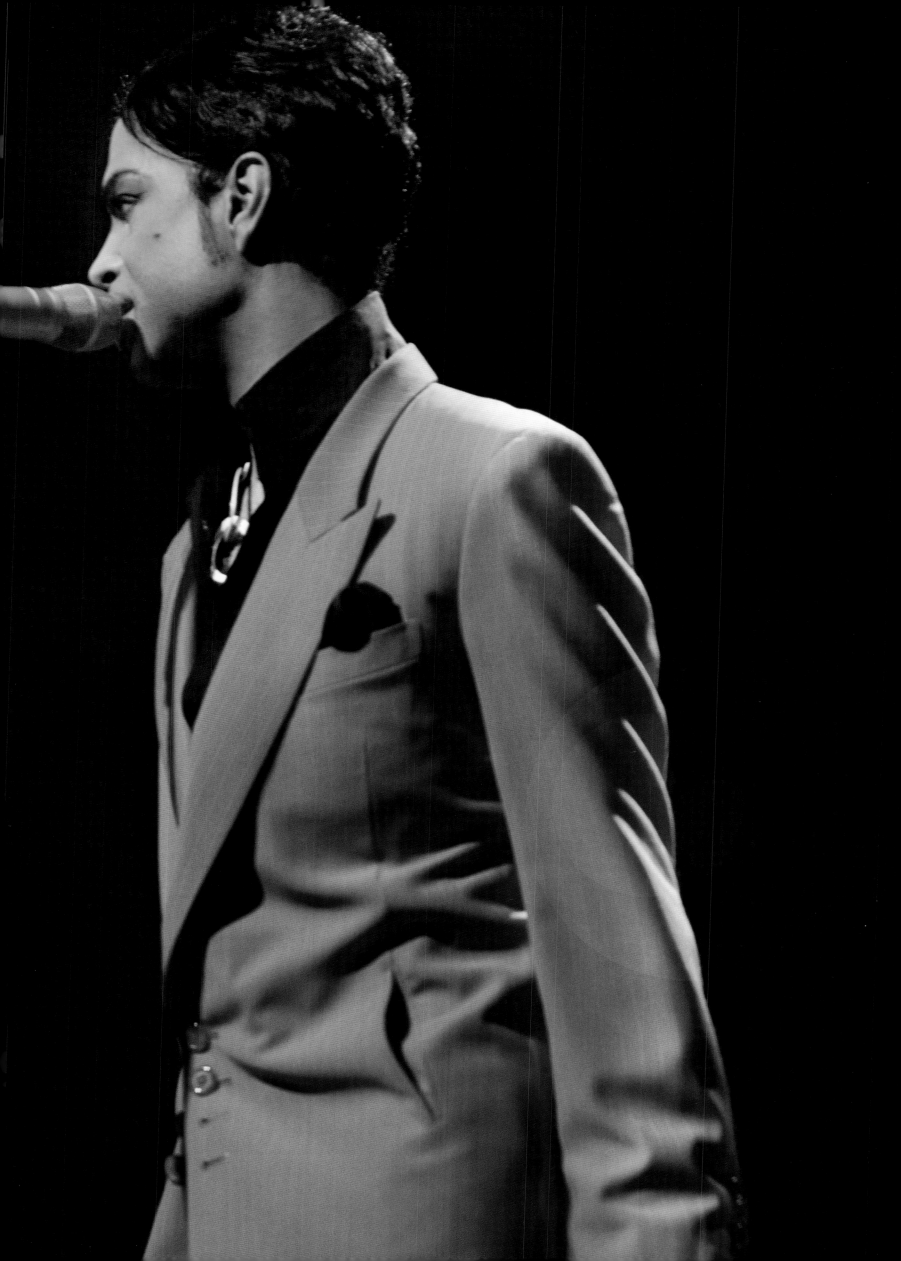

MOVE DA CRC

WD

MOVE DA CROWD, MOVE DA CROWD
THAT'S WHAT EYE DO 4 A LIVING AND EYE'M PROUD OF IT
ALL THE HEADZ HEAR ME AND JUST SAY "WOW"
THEY NEVER HEARD APPLAUSE SO LOUD
WHO DA COMPETITION SAY BEST?
WHO DAT NEVER SETTLE 4 LESS
THAN 2 STIX GOING THRU THE S?
THE WINNER IS—OOH, LEMME GUESS
WALK UP ANY HOT GHETTO MESS
ASK U 4 UR NUMBER U SAY YES
GIVE U MINE, TUCK IT IN THE MIDDLE OF UR CHEST
HOPE IT DON'T SLIP DOWN UR DRESS
PROBABLY WON'T CALL, EYE MUST CONFESS
HOLLA WHEN U C ME NEVERTHELESS

NIGHT 12 OF 21

WHAT COMES OUT

IS THE TRUTH

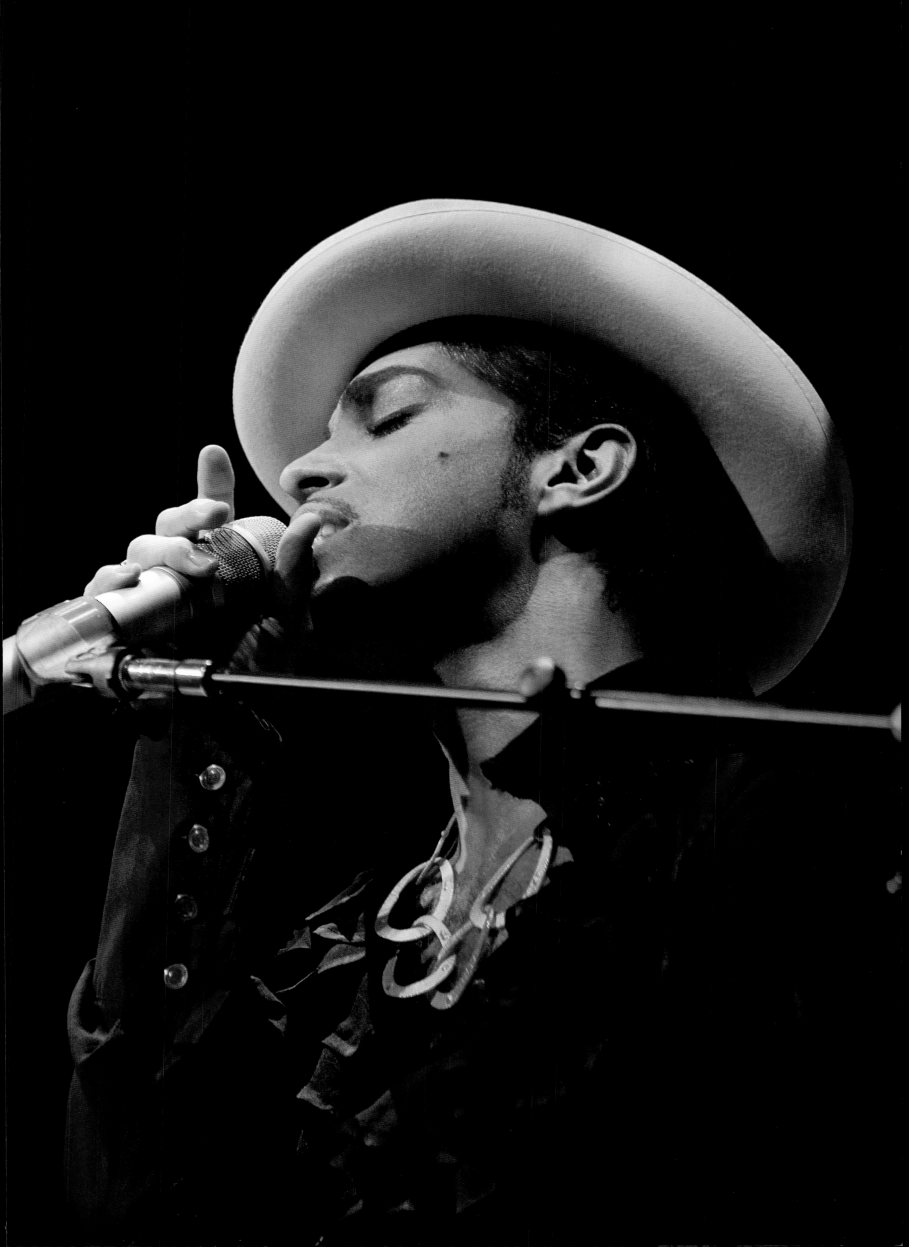

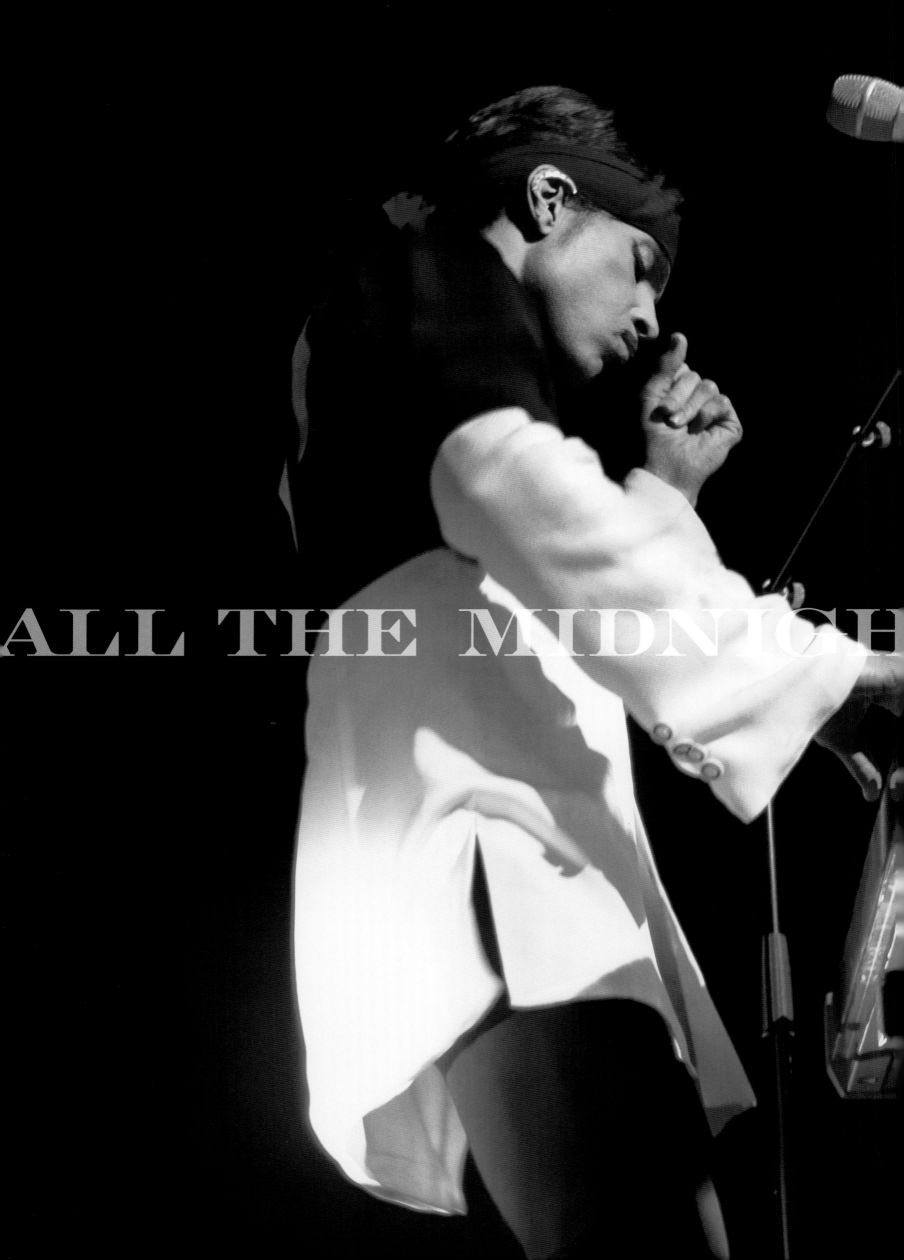

4 ALL THE MIDNIGHTS IN THE WORLD
THIS ONE WILL SERVE US BETTER IF U CHOOSE 2 B MY GIRL

LIKE ZUZU'S PETALS, A WONDERFUL LIFE THE TWO OF US SHALL LEAD
THE CHILDREN OF THE FUTURE WITH ALL THE SPIRITUAL FOOD THEY NEED
THE SECRETS THAT THE ONES B4 US WITH GRACE HAVE COME AND SHOWN
2GETHER WITH LOVE 4 ONE ANOTHER WE SHALL MAKE THEM KNOWN

TS IN THE WORLD

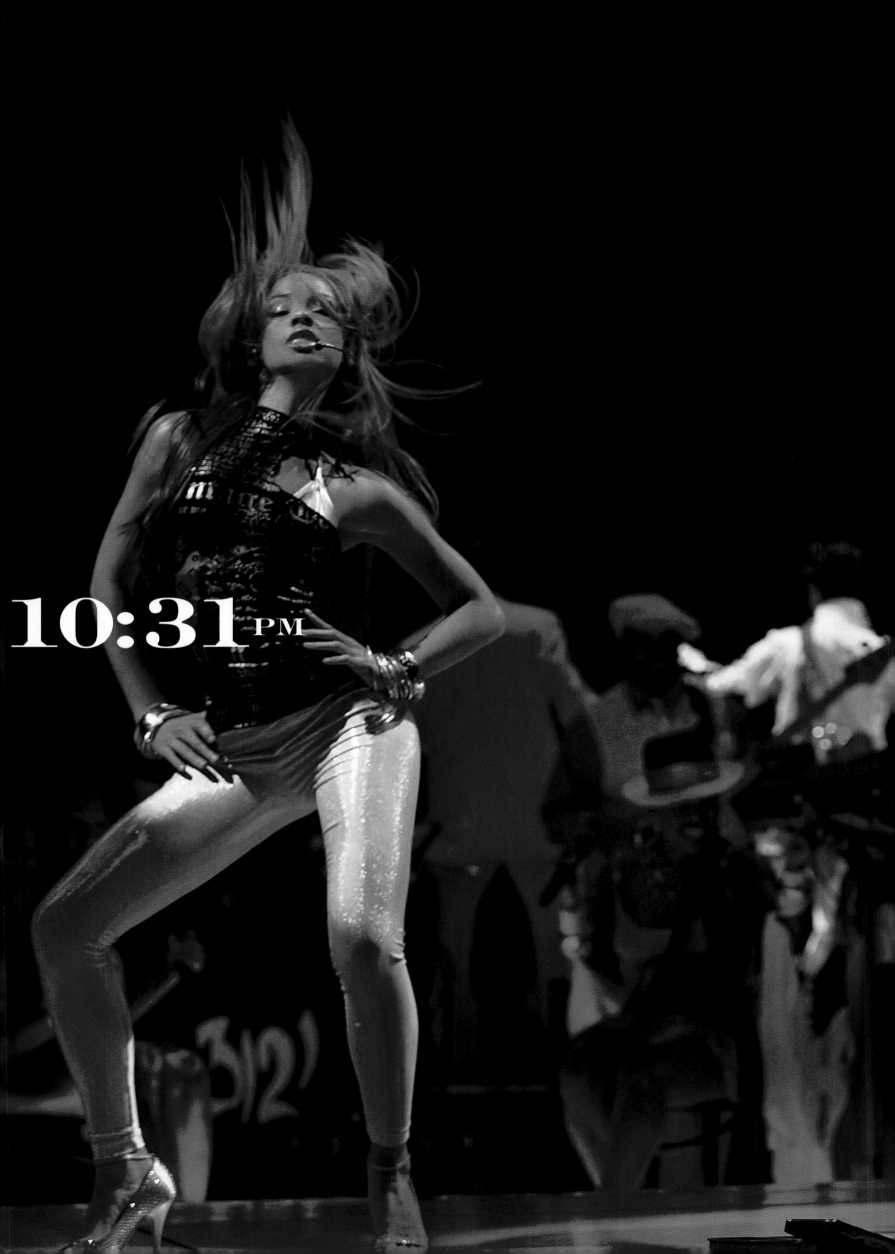

10:31 PM

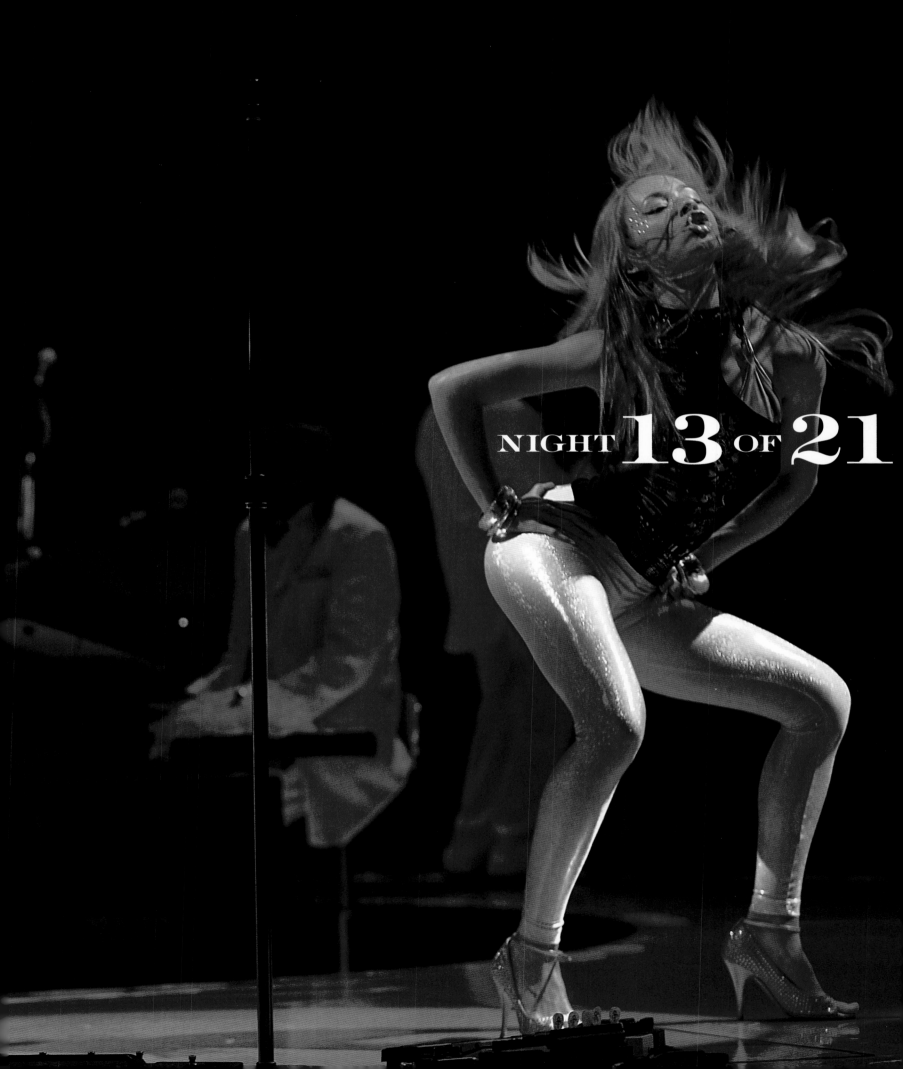

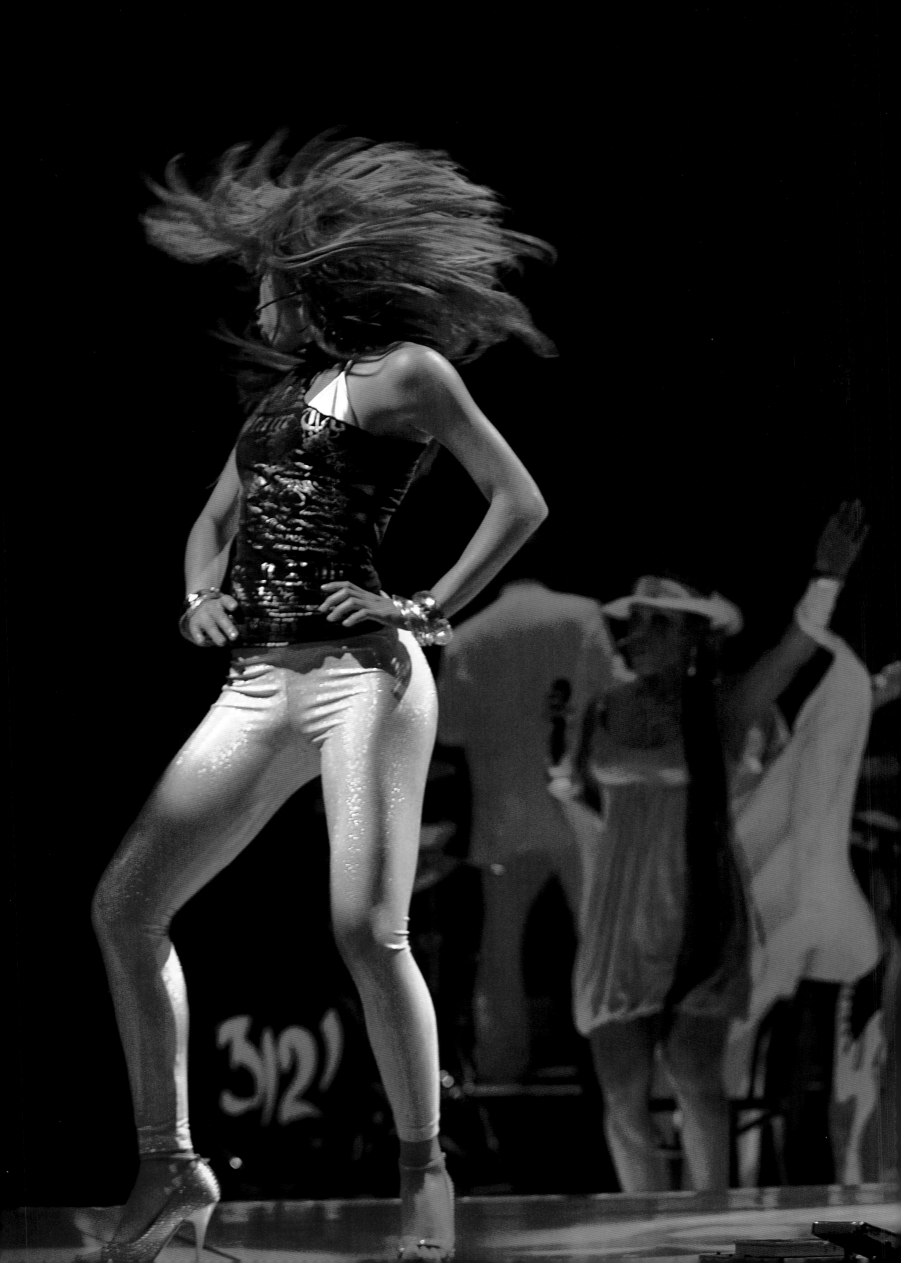

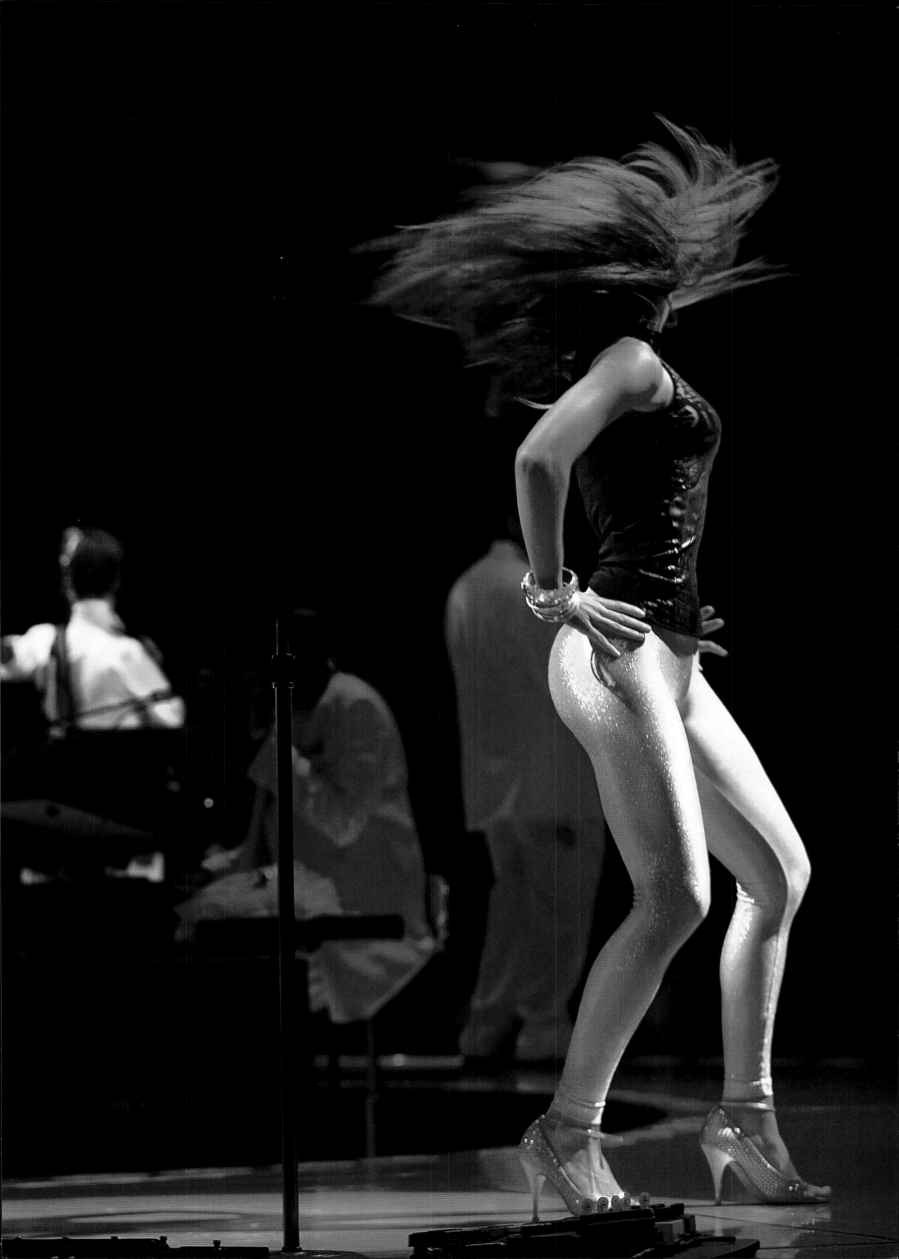

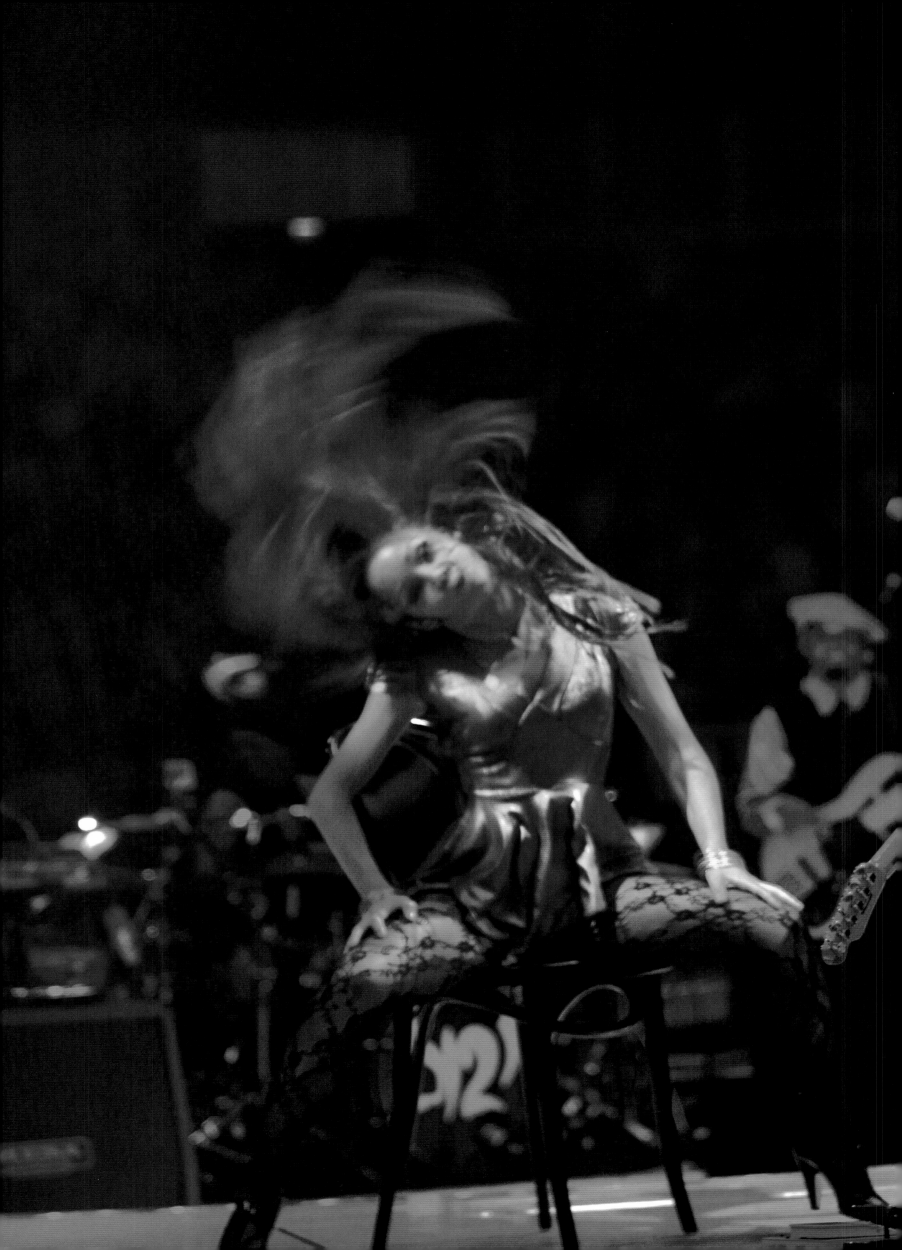

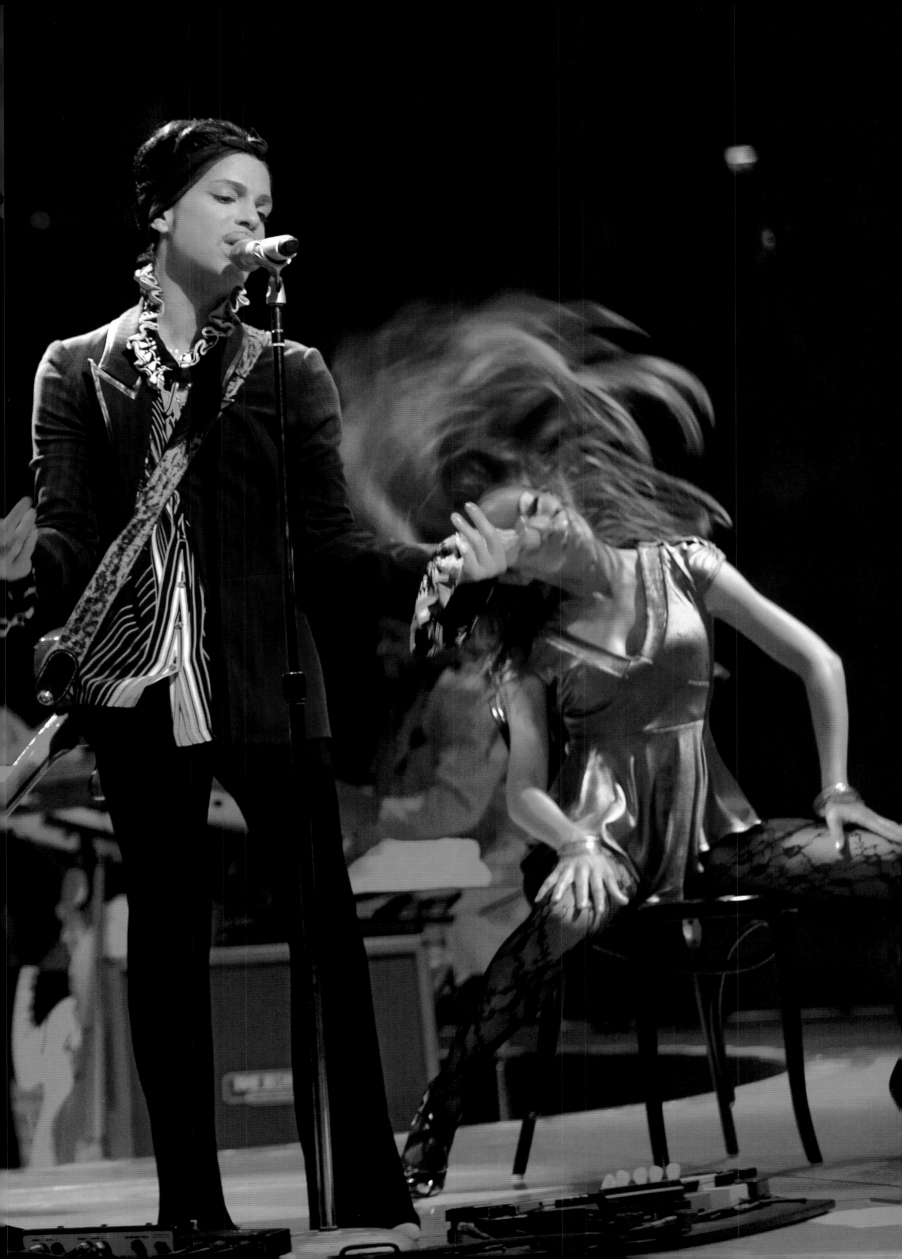

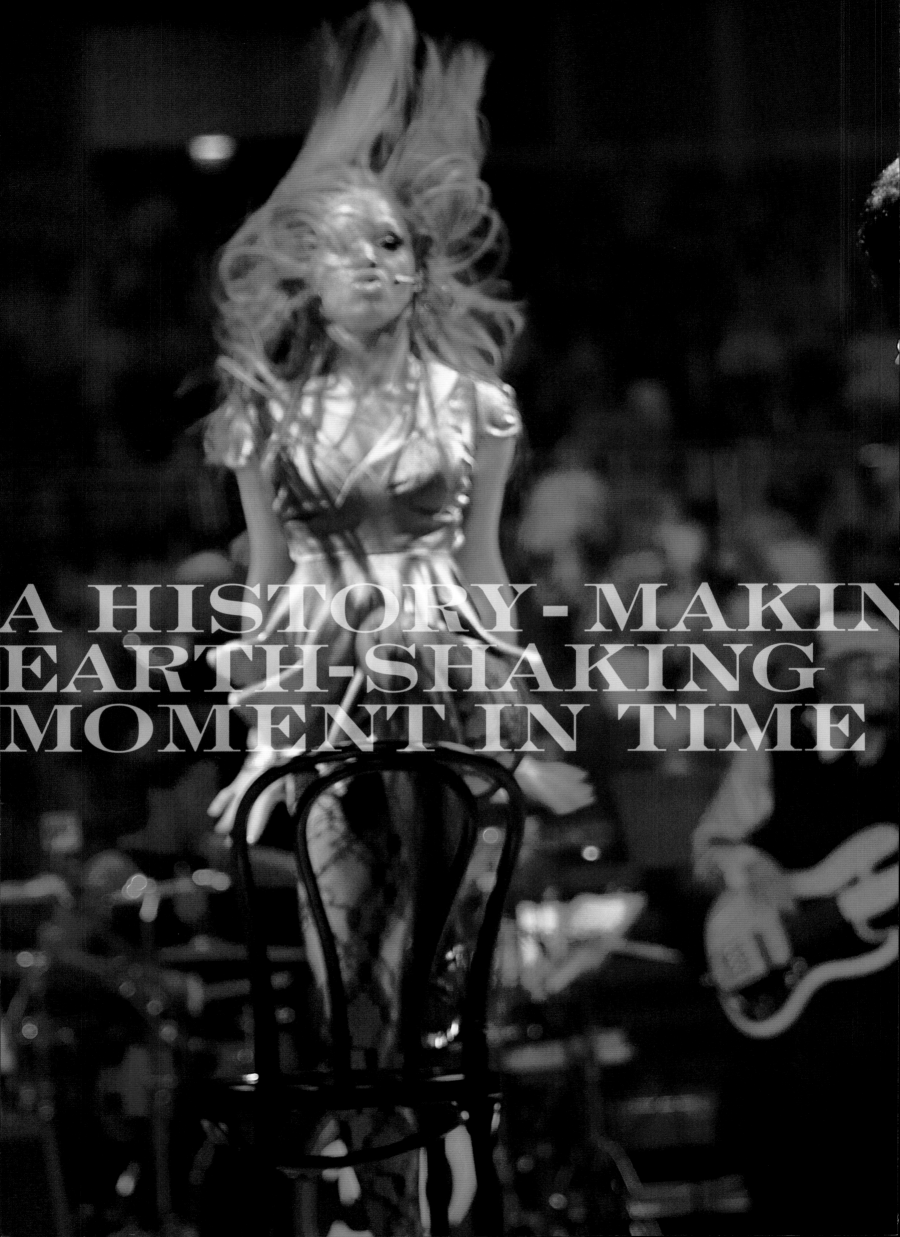

A HISTORY-MAKIN
EARTH-SHAKING
MOMENT IN TIME

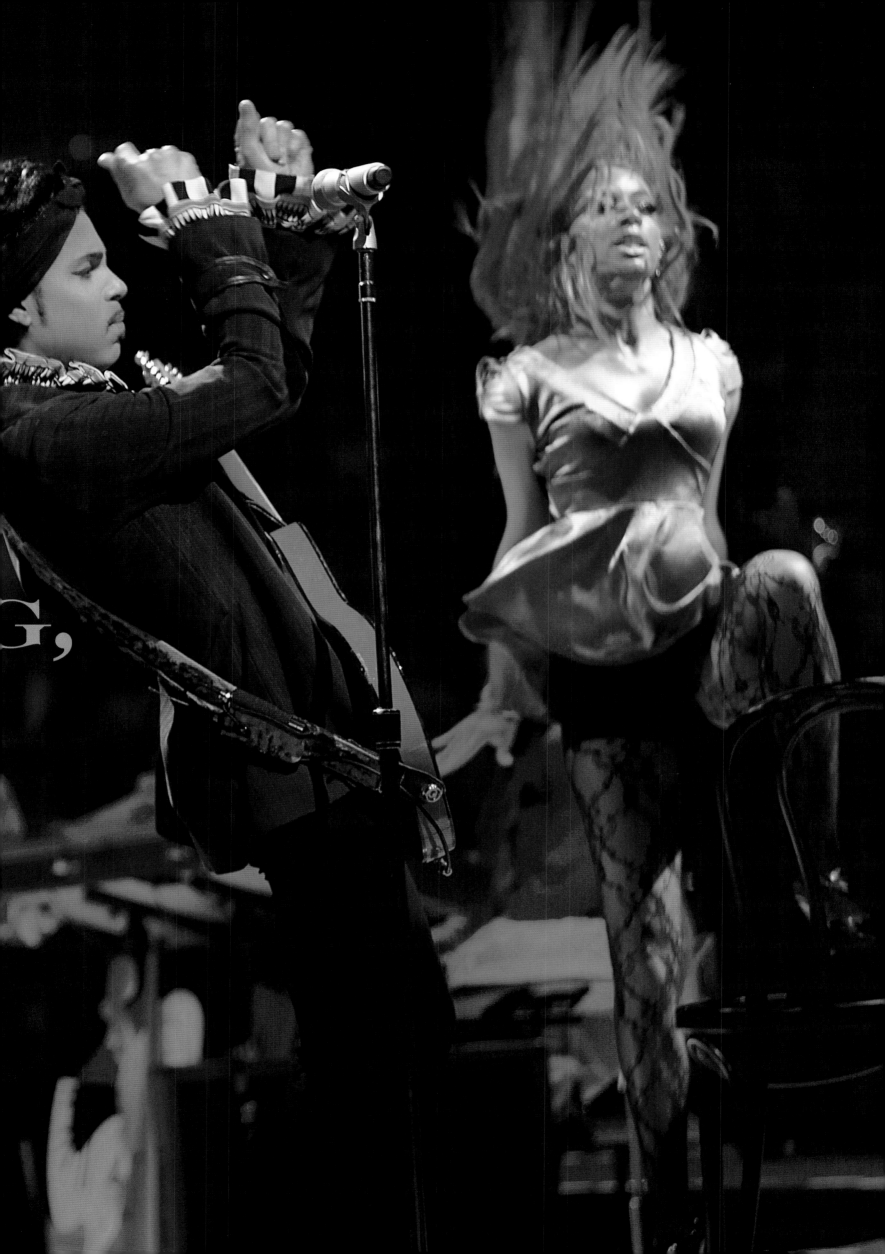

11:37 PM

"EYE JUST WANT

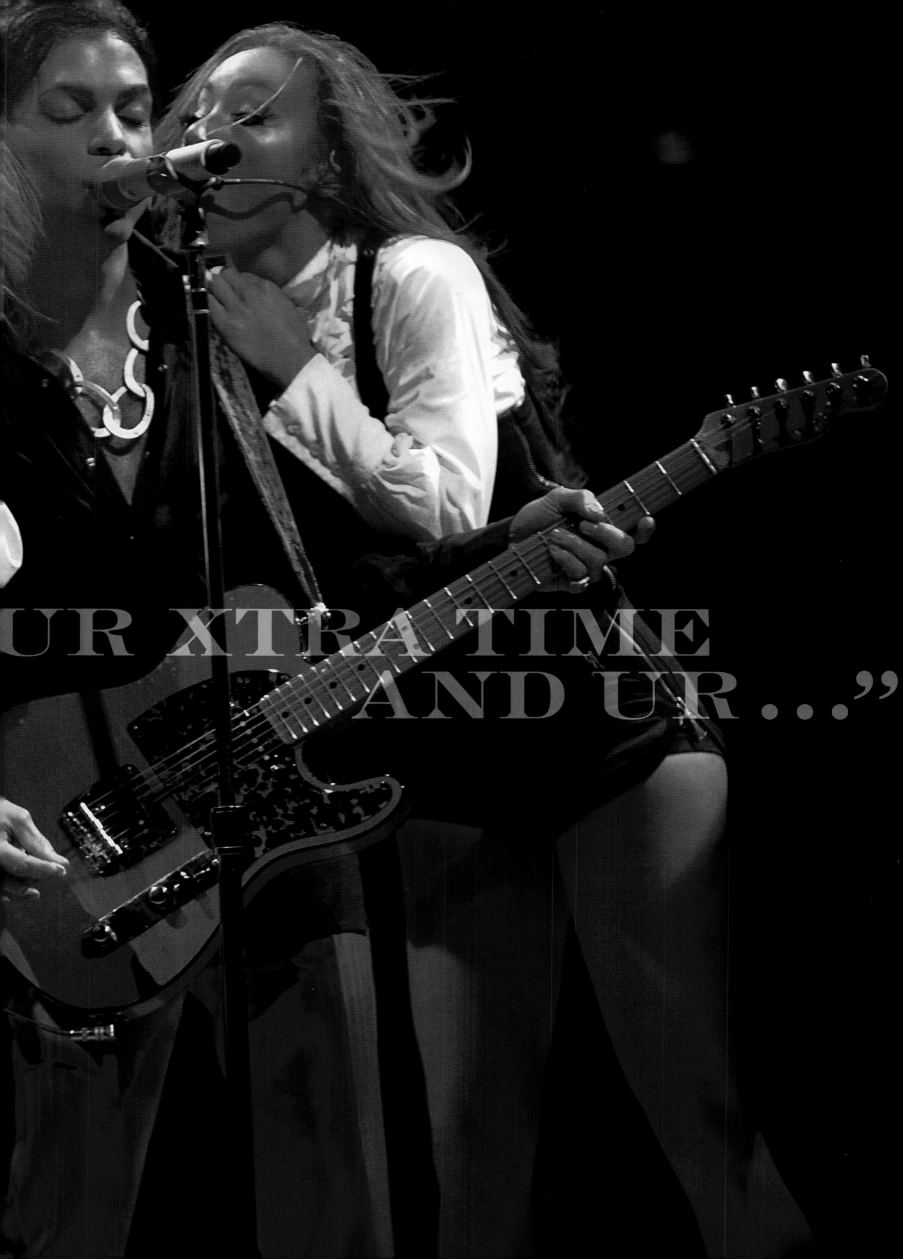

UR XTRA TIME AND UR . . ."

RESERVED 4 THE C
THAT GIVES PRAIS

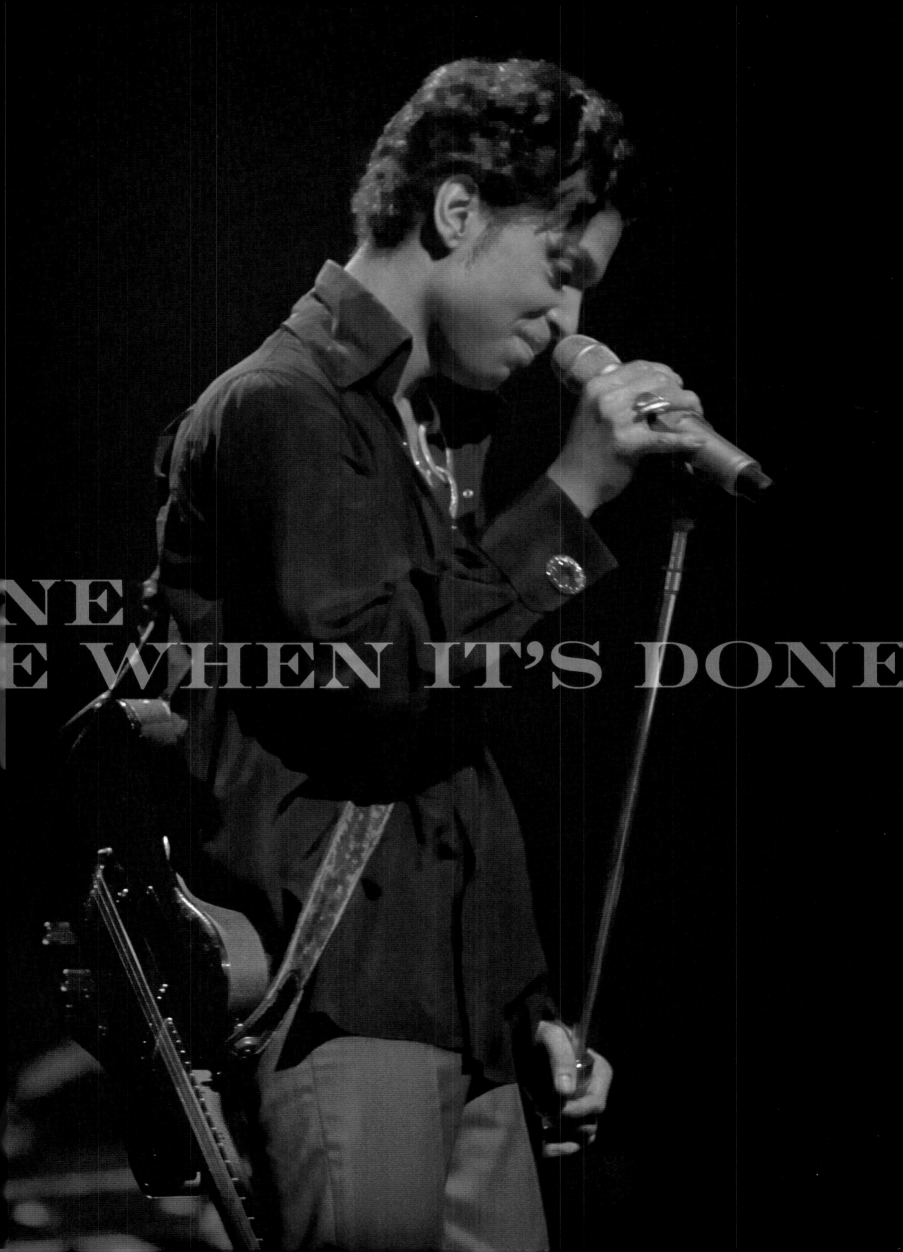

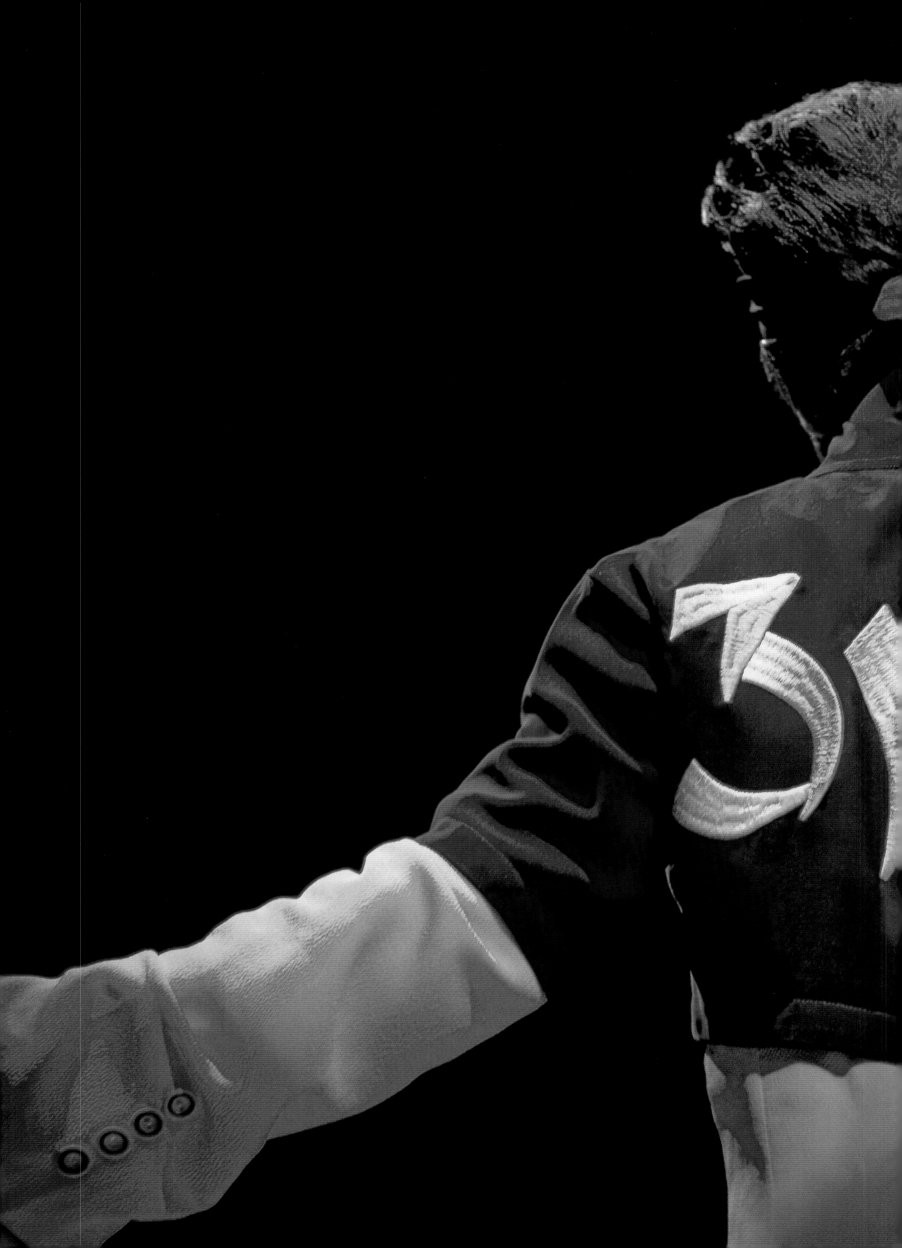

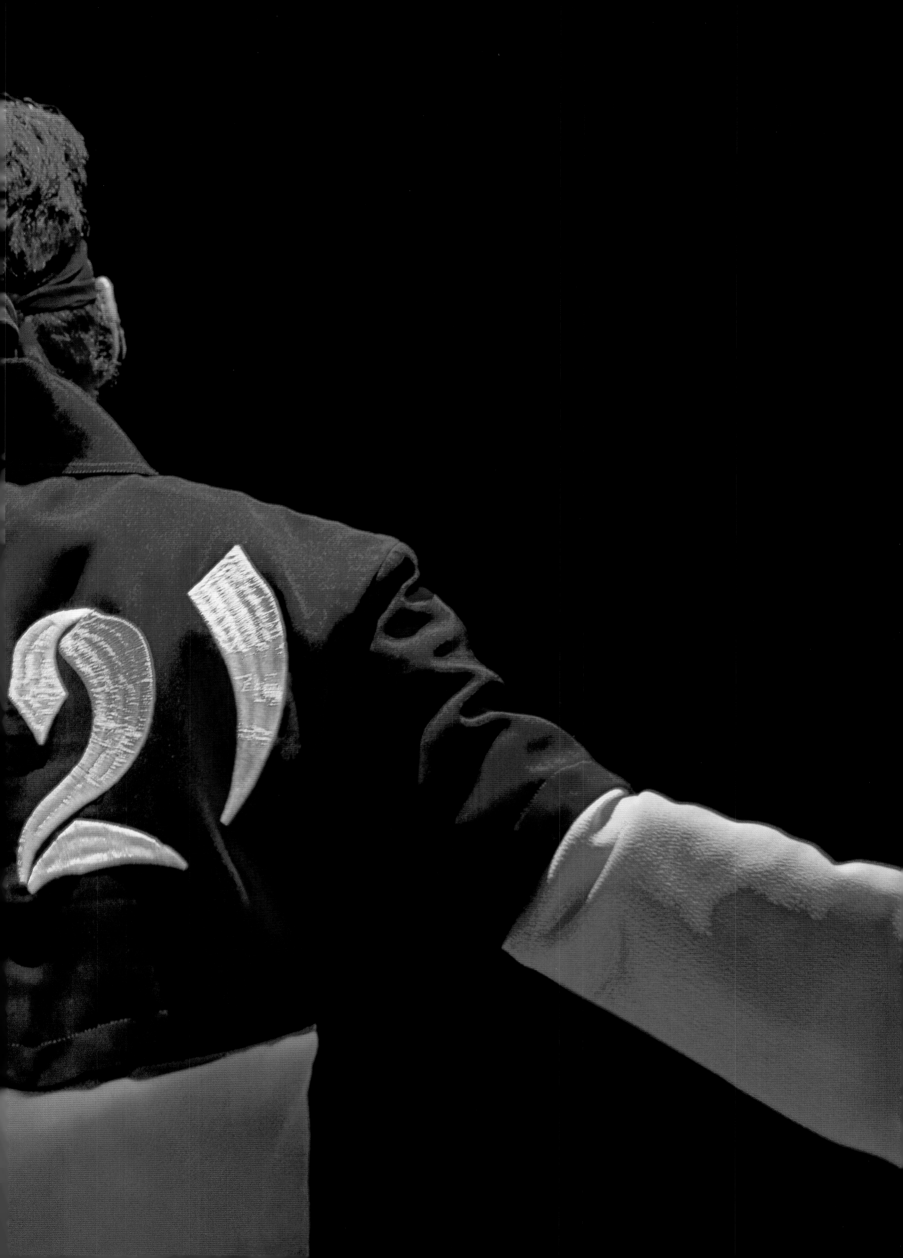

AWAKE ALI

NIGHT LONG

LOOK OVER THERE

THERE'S ANOTHER TURN ON

BUTTERFLIES SCARED THAT THEY'RE GONNA B

AWAKE ALL NIGHT LONG

DANCING IN UR BELLY LIKE A BALLERINA

IN SPITE OF UR EFFORTS 2 CALM THEM DOWN

DON'T U WANNA COME? 3121

GONNA B SO MUCH FUN. 3121

THAT'S WHERE THE PARTY B 3121

U CAN COME IF U WANT 2,

BUT U CAN NEVER LEAVE

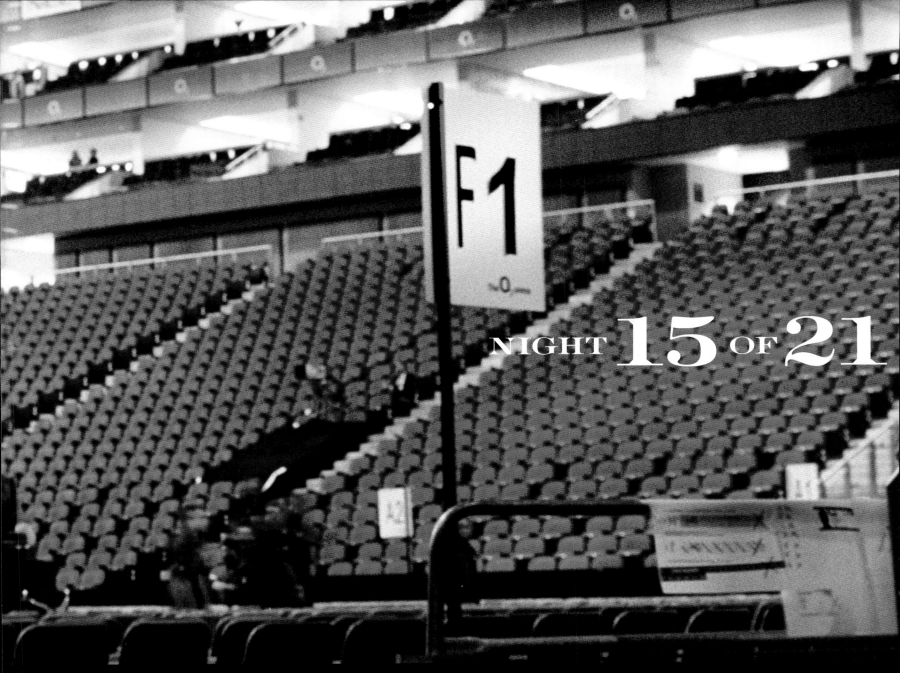

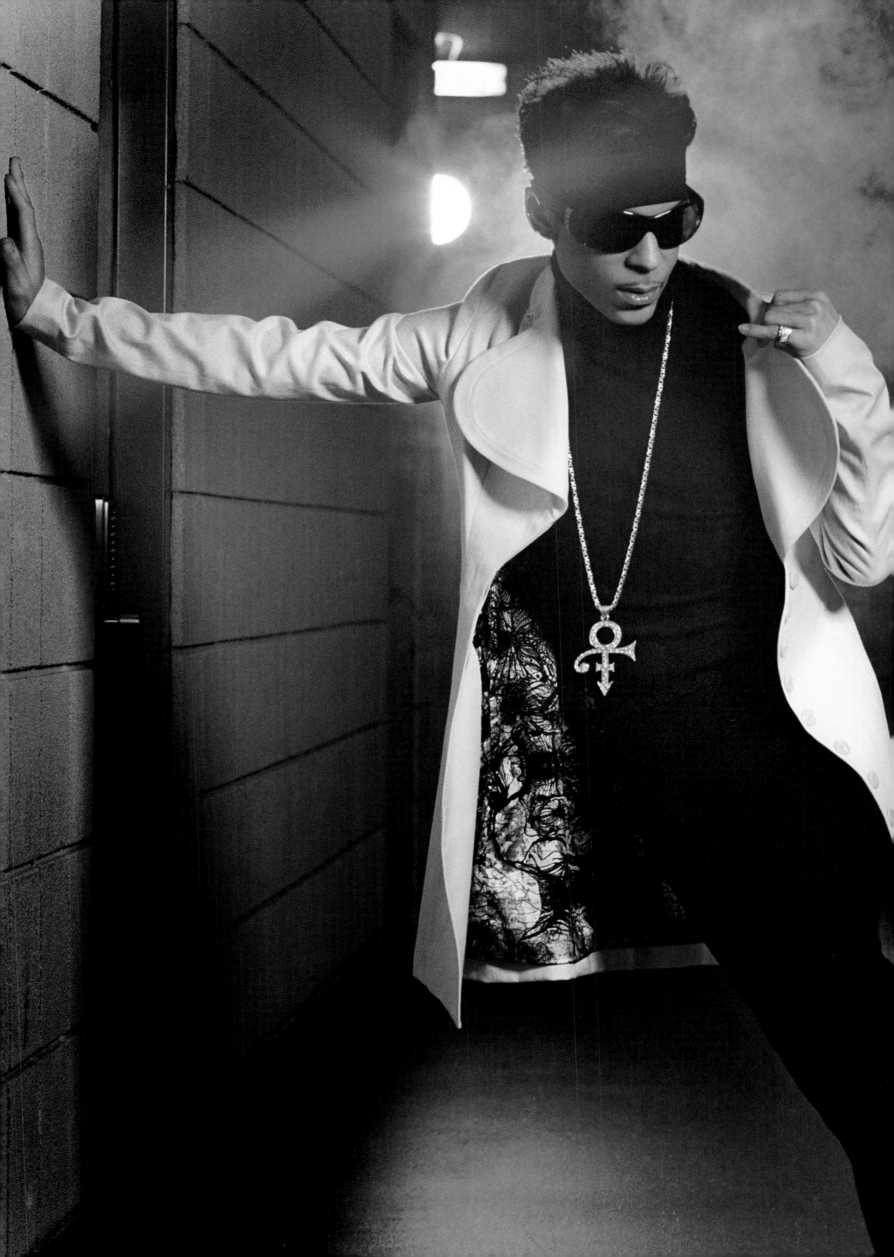

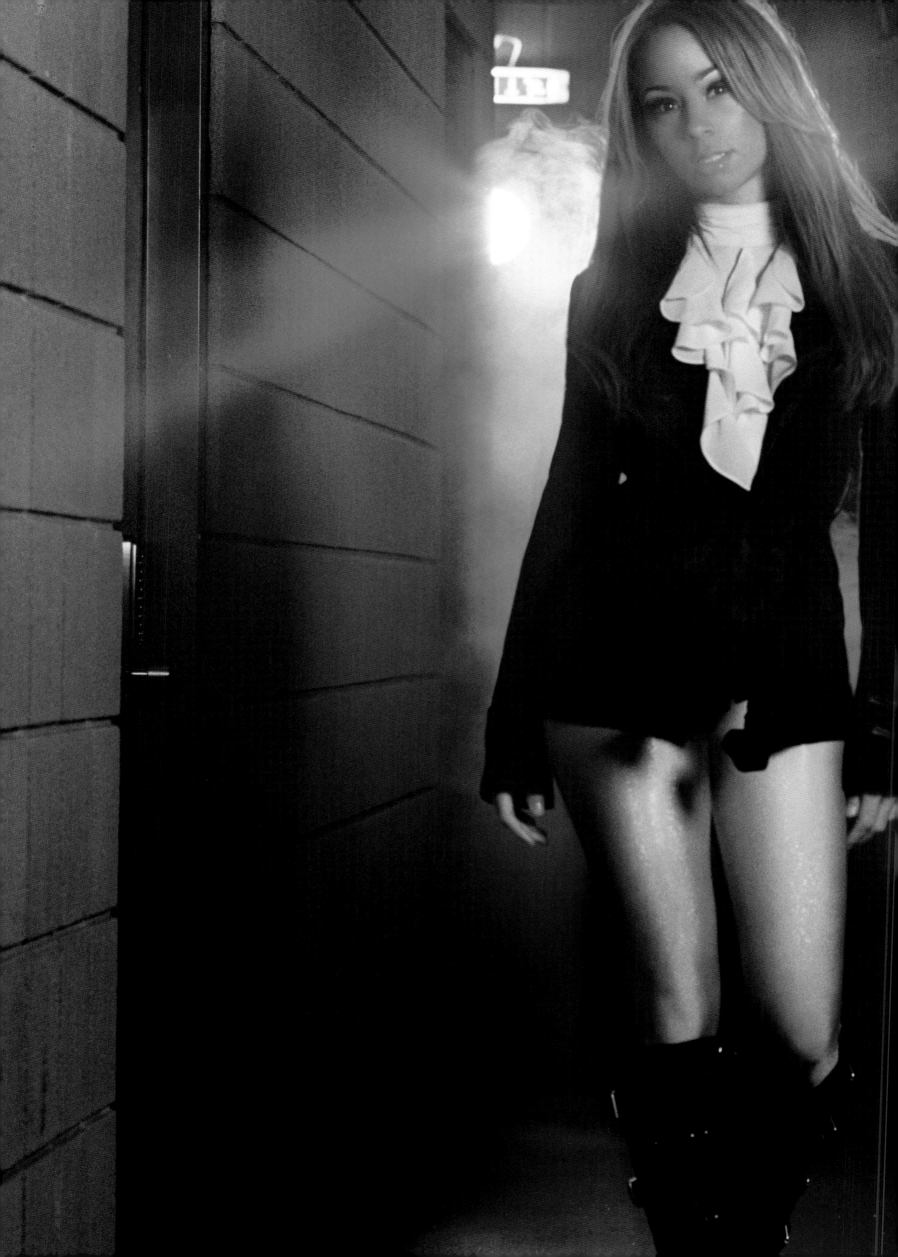

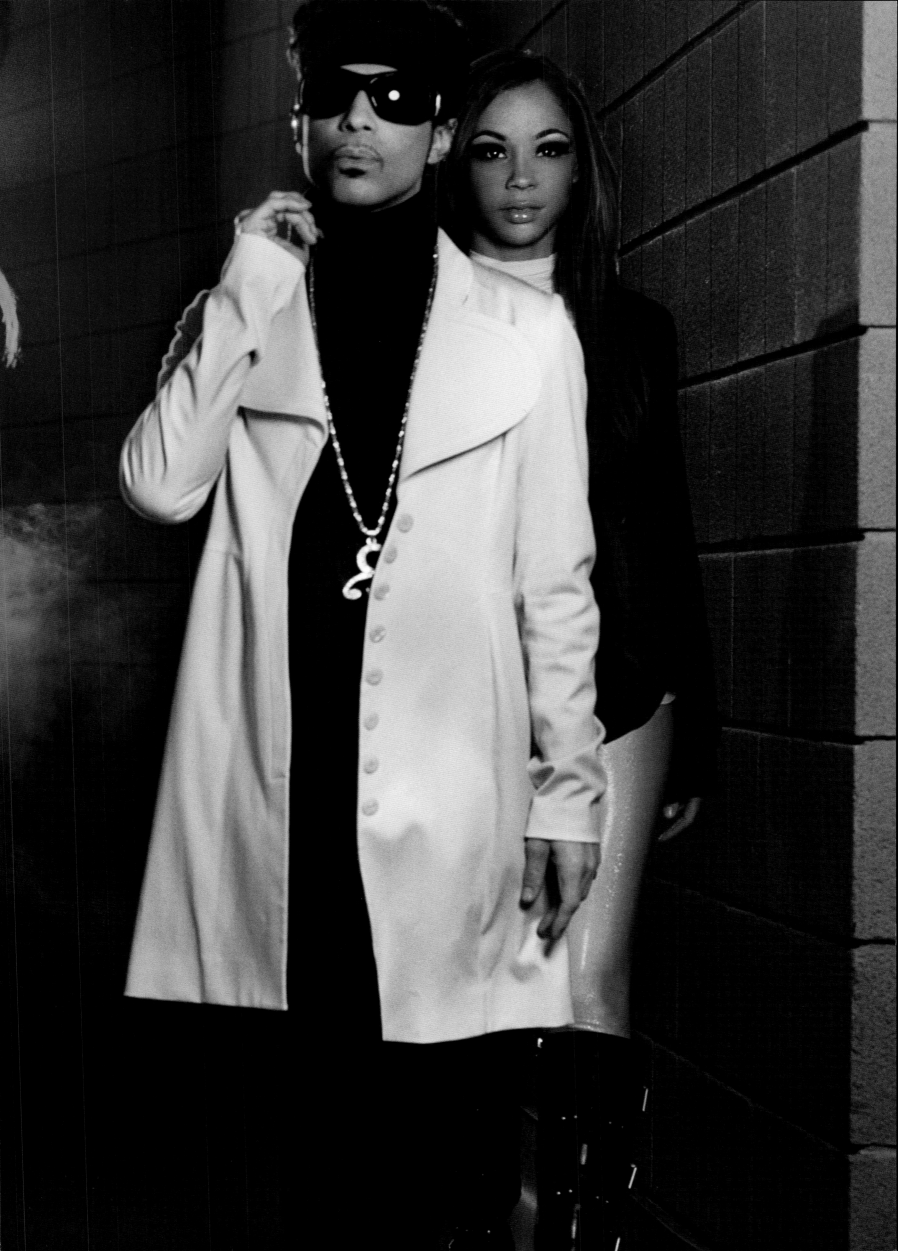

LY SHE IS THERE

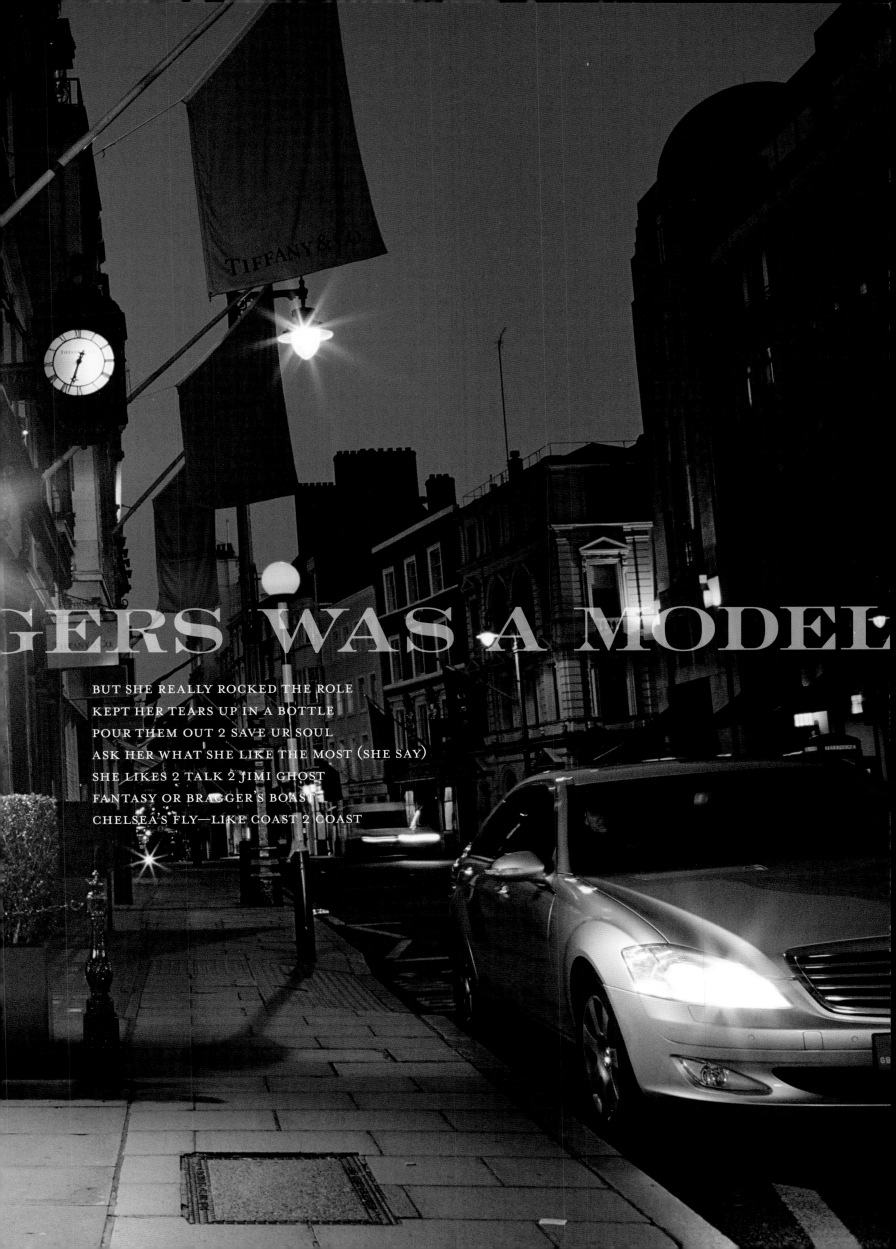

GERS WAS A MODEL

BUT SHE REALLY ROCKED THE ROLE
KEPT HER TEARS UP IN A BOTTLE
POUR THEM OUT 2 SAVE UR SOUL
ASK HER WHAT SHE LIKE THE MOST (SHE SAY)
SHE LIKES 2 TALK 2 JIMI GHOST
FANTASY OR BRAGGER'S BOAST
CHELSEA'S FLY—LIKE COAST 2 COAST

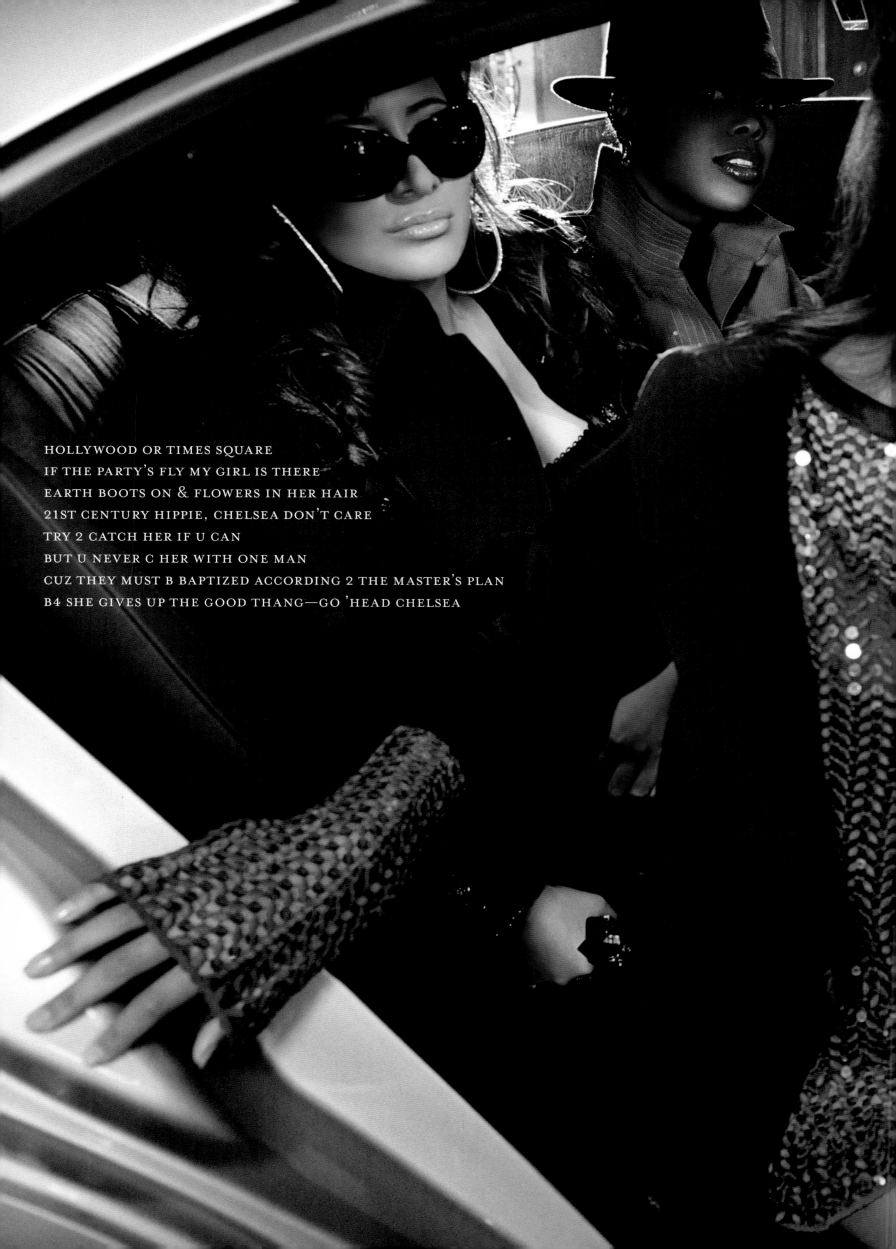

HOLLYWOOD OR TIMES SQUARE
IF THE PARTY'S FLY MY GIRL IS THERE
EARTH BOOTS ON & FLOWERS IN HER HAIR
21ST CENTURY HIPPIE, CHELSEA DON'T CARE
TRY 2 CATCH HER IF U CAN
BUT U NEVER C HER WITH ONE MAN
CUZ THEY MUST B BAPTIZED ACCORDING 2 THE MASTER'S PLAN
B4 SHE GIVES UP THE GOOD THANG—GO 'HEAD CHELSEA

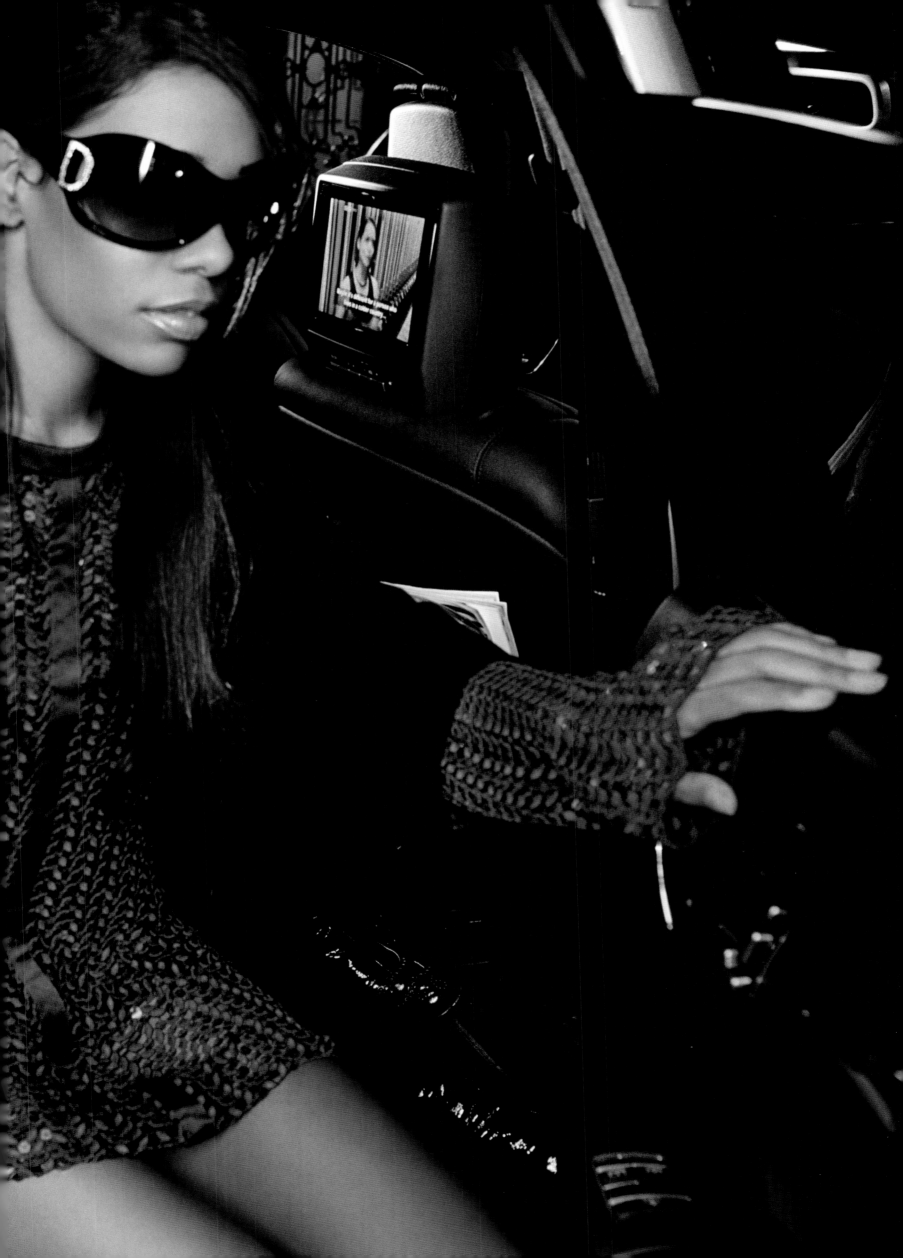

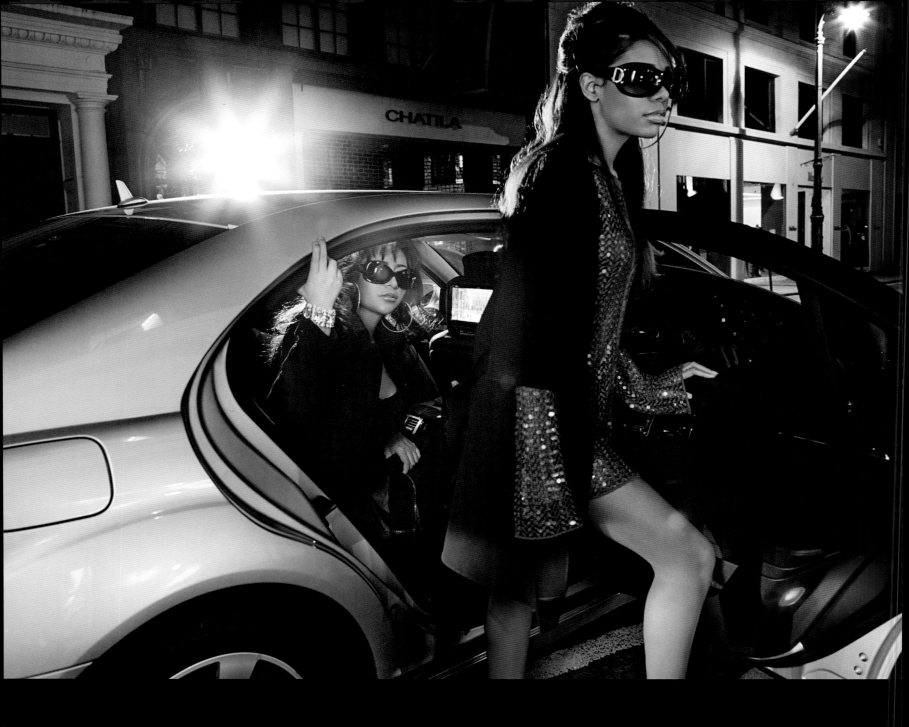

NO BLOOD DIAMONDS OR DESIGNER CHIC
CUZ SHE 2 ORIGINAL FROM HER HEAD DOWN 2 HER FEET
U CAN HATE IF U WANT 2—CHELSEA DON'T EAT NO MEAT
STILL GOT BUTT LIKE A LETTER C—GO 'HEAD CHELSEA

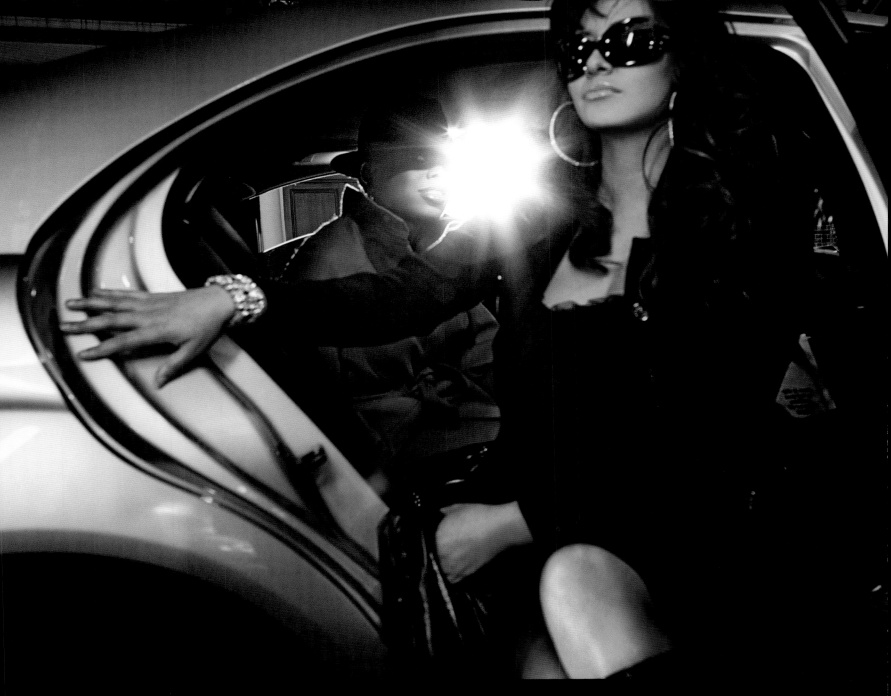

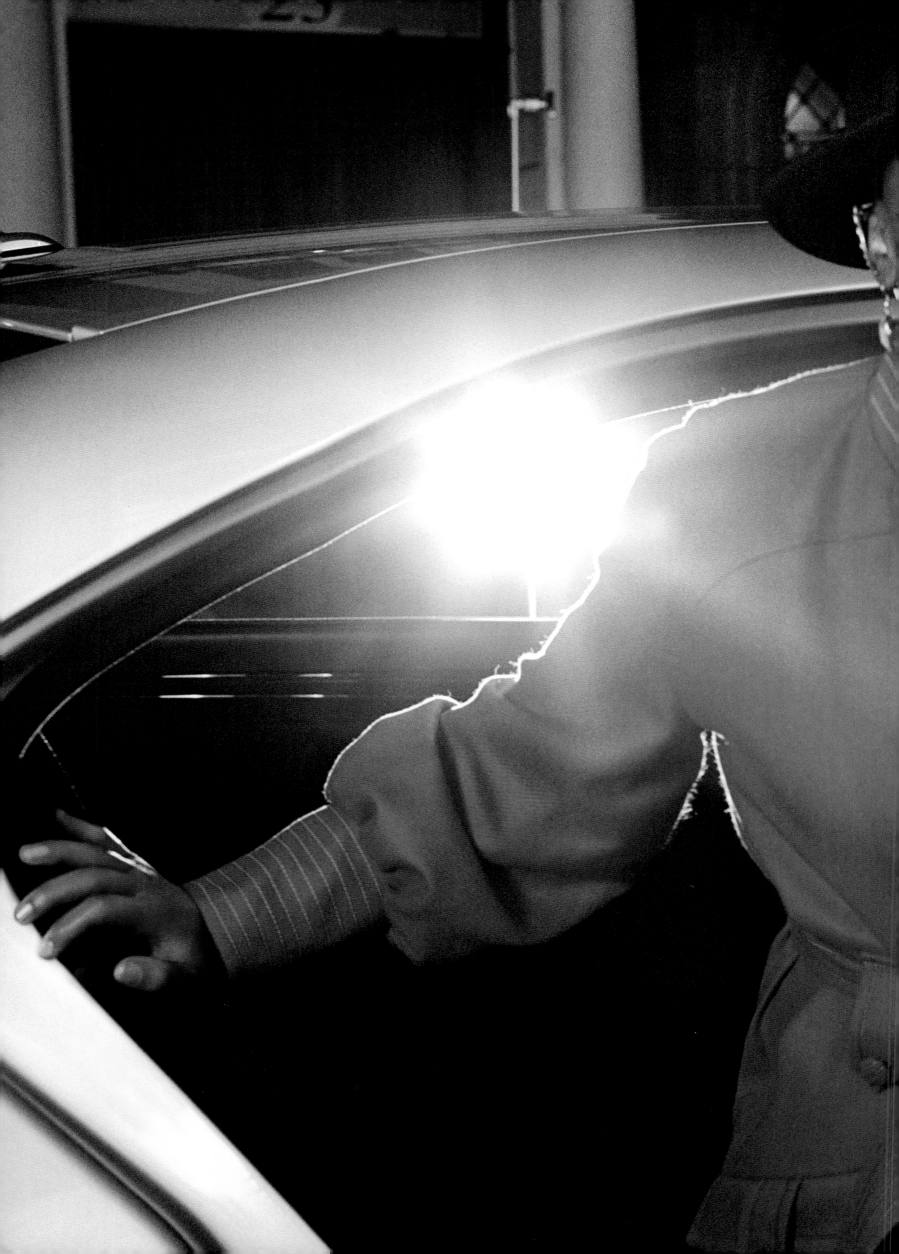

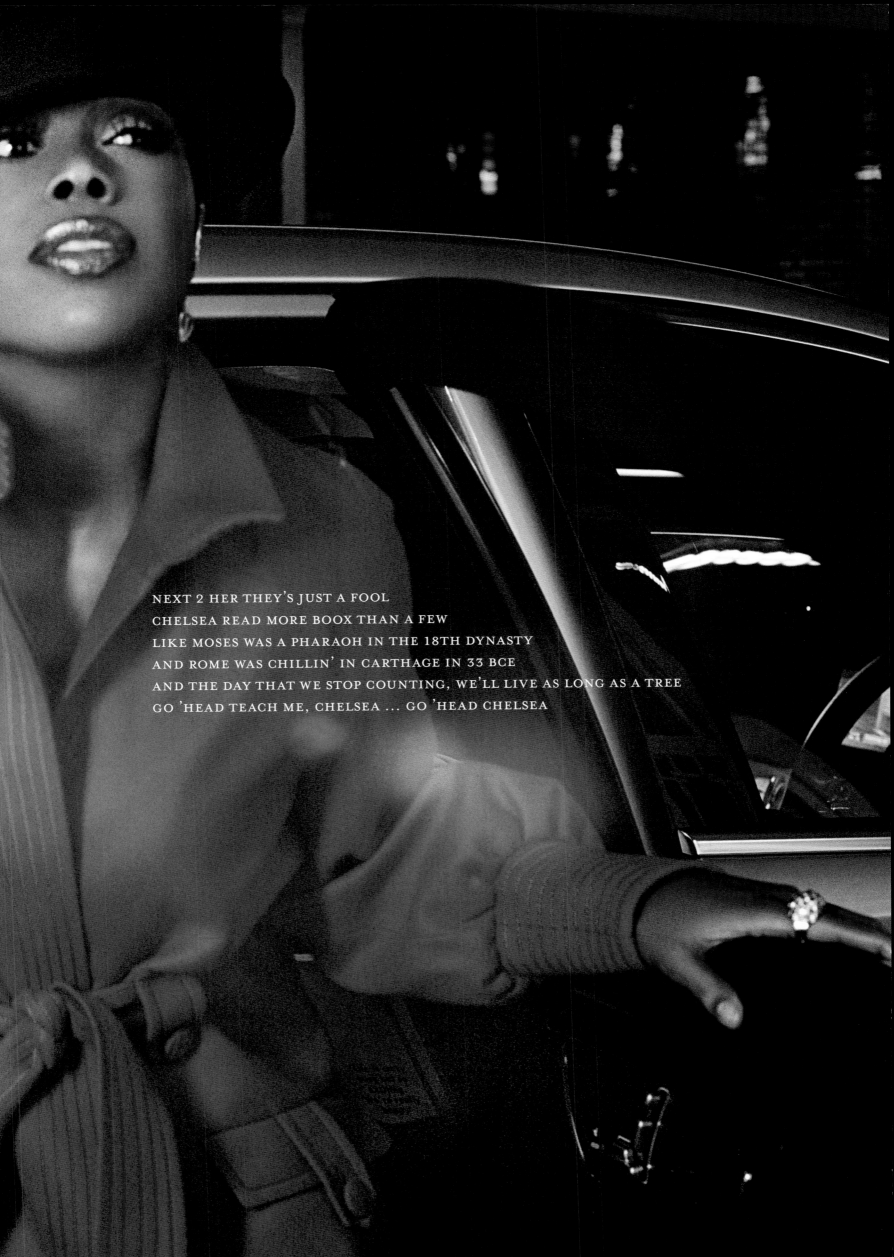

NEXT 2 HER THEY'S JUST A FOOL
CHELSEA READ MORE BOOX THAN A FEW
LIKE MOSES WAS A PHARAOH IN THE 18TH DYNASTY
AND ROME WAS CHILLIN' IN CARTHAGE IN 33 BCE
AND THE DAY THAT WE STOP COUNTING, WE'LL LIVE AS LONG AS A TREE
GO 'HEAD TEACH ME, CHELSEA … GO 'HEAD CHELSEA

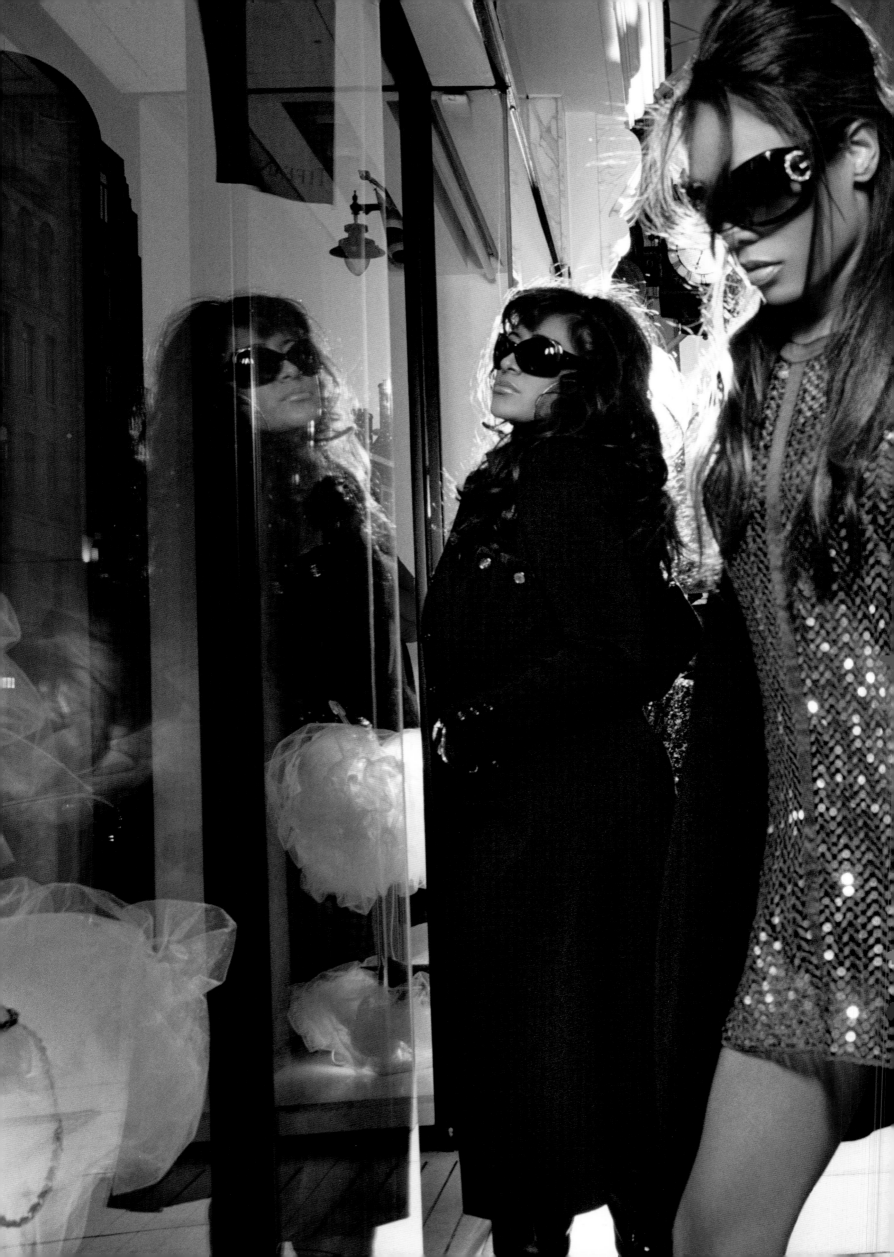

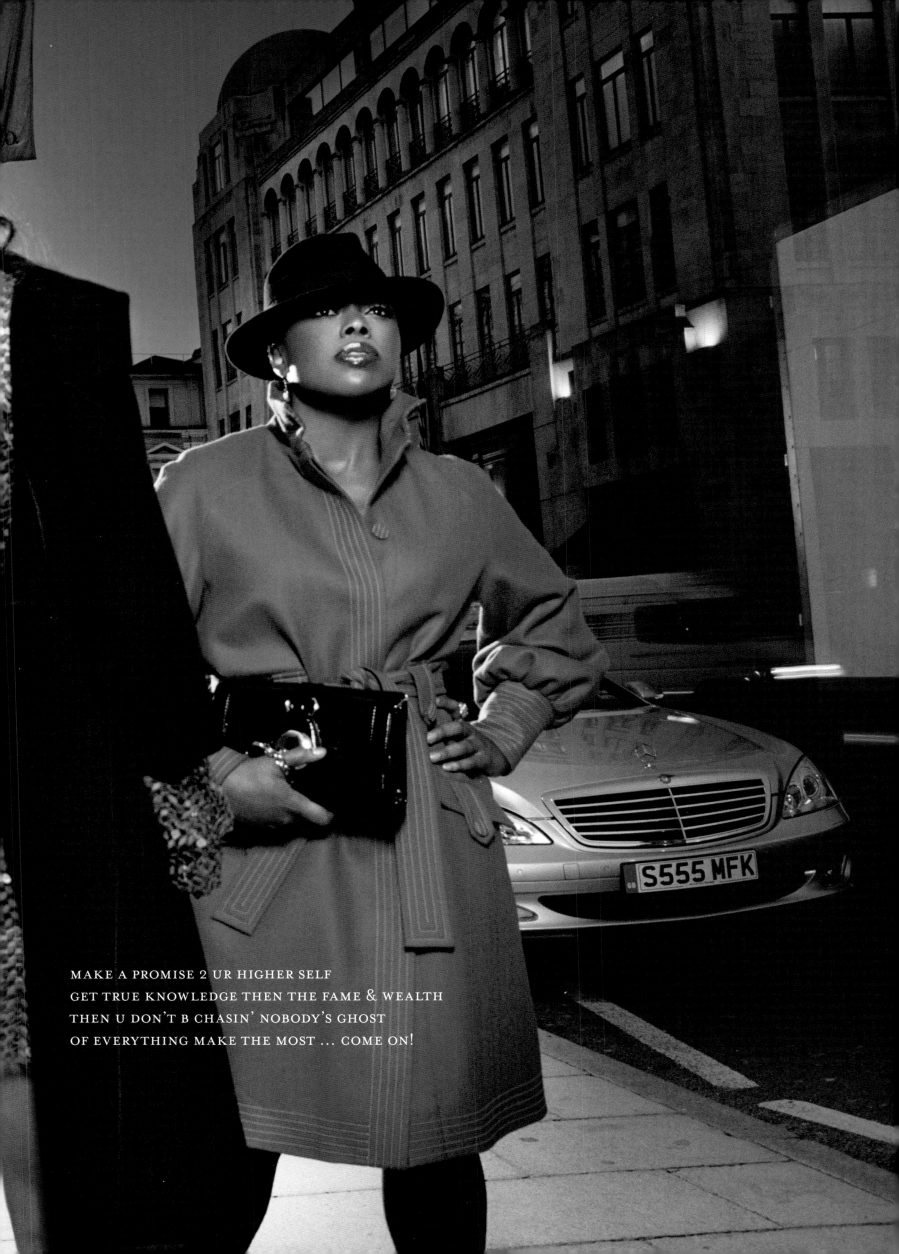

MAKE A PROMISE 2 UR HIGHER SELF
GET TRUE KNOWLEDGE THEN THE FAME & WEALTH
THEN U DON'T B CHASIN' NOBODY'S GHOST
OF EVERYTHING MAKE THE MOST … COME ON!

LION

SITTING ON THE FLOOR OF AN ALL-WHITE ROOM
FEELING LIKE THE COLOR BLUE
THINKIN' 'BOUT THE WORDS THAT EYE CAN USE 2 GET THIS THRU 2 U
A MILLION MISTAKES AND THEN SOME EYE'VE MADE WITH THE ONES B4
EYE'VE PROBABLY PASSED MY XPIRATION DATE BUT STILL EYE ADORE U

LOOKING 4 THE NRG 2 TAKE U THERE
PLACES THAT U WANNA GO
KNOWING IF EYE DO U'RE FULLY AWARE THE PRESS WILL TURN IT IN2 A SHOW
EVERYONE XPECTED THIS OUTCOME … STILL THEY JUMP AROUND WITH GLEE
EYE GUESS EYE SHOULD B HAPPY BUT EYE'M STILL NOT SURE THAT U REALLY LOVE ME
U LOVE ME

OF JUDAH

DRIVING AWAY WITH A SMILE ON MY FACE
THE WIND BLOWING THROUGH MY HAIR
WONDERING HOW U'LL FEEL WHEN U FIND OUT HOW MUCH EYE REALLY CARE
HOPING THAT THE TEARS ROLL DOWN UR FACE WHEN U FINALLY GRASP WHO WE R
2 GYPSY BANDITS WHO ONLY BY GRACE CAME 2 B A STAR
A SUPERSTAR—THAT'S WHAT WE R

LIKE THE LION OF JUDAH,
EYE STRIKE MY ENEMIES DOWN
AS MY GOD IS LIVING SURELY THE TRUMPET WILL SOUND
LIKE THE LION OF JUDAH

5:33 AM

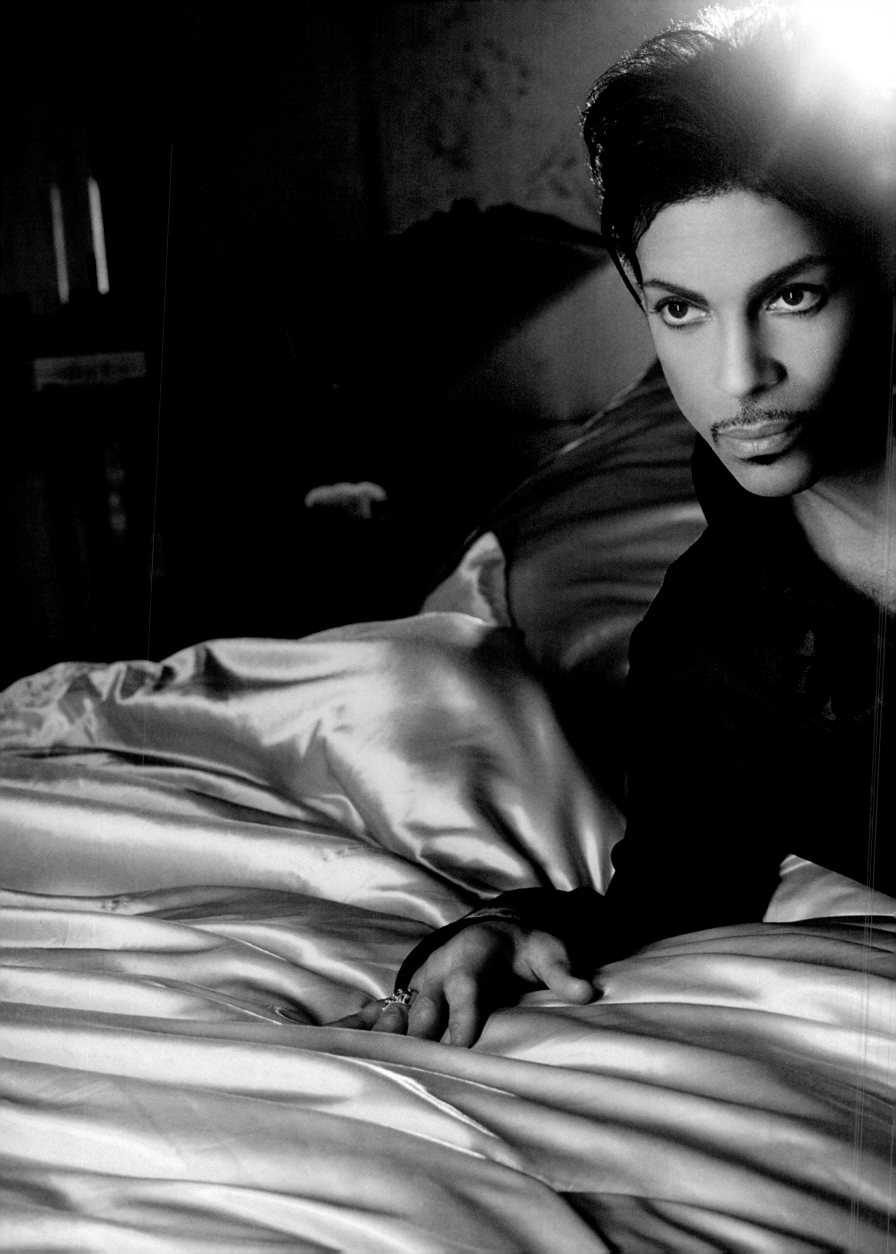

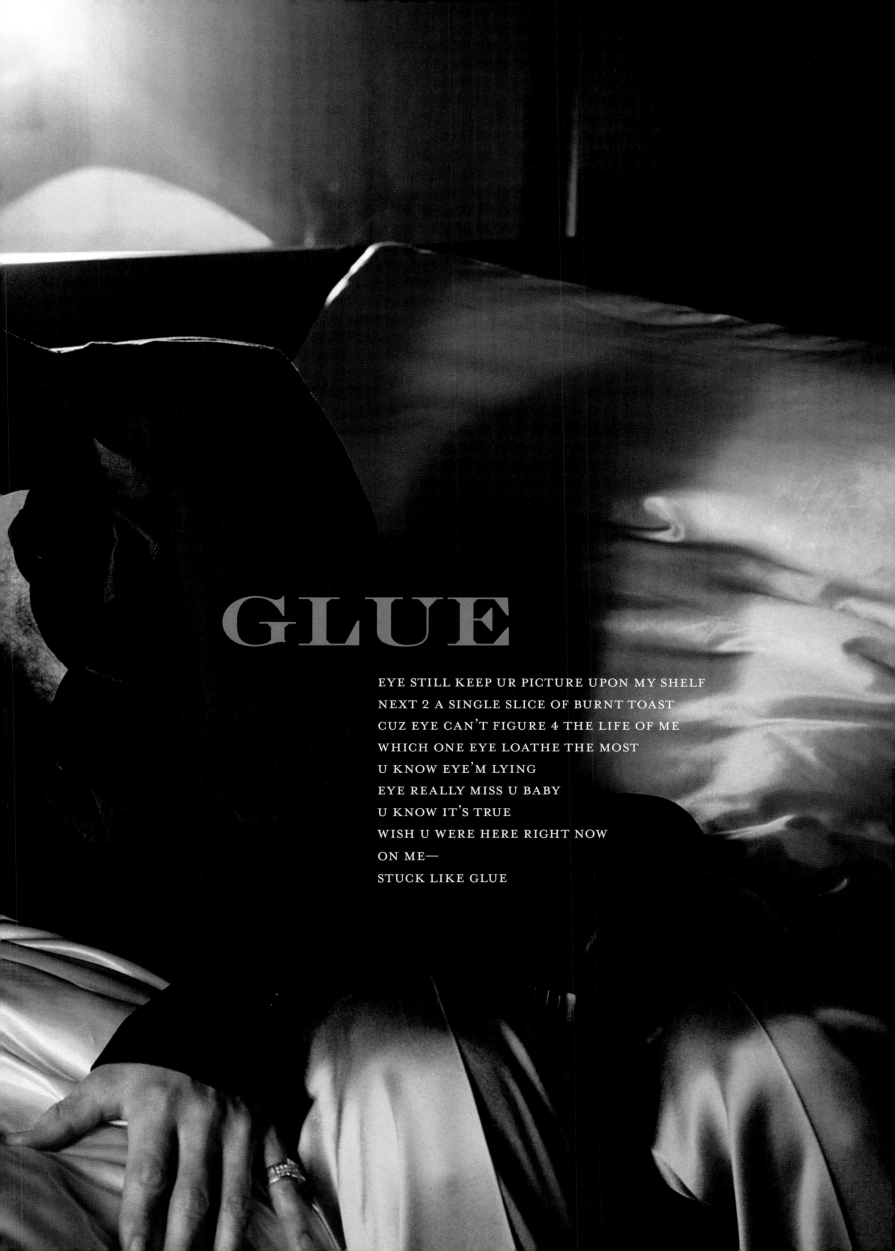

GLUE

EYE STILL KEEP UR PICTURE UPON MY SHELF
NEXT 2 A SINGLE SLICE OF BURNT TOAST
CUZ EYE CAN'T FIGURE 4 THE LIFE OF ME
WHICH ONE EYE LOATHE THE MOST
U KNOW EYE'M LYING
EYE REALLY MISS U BABY
U KNOW IT'S TRUE
WISH U WERE HERE RIGHT NOW
ON ME—
STUCK LIKE GLUE

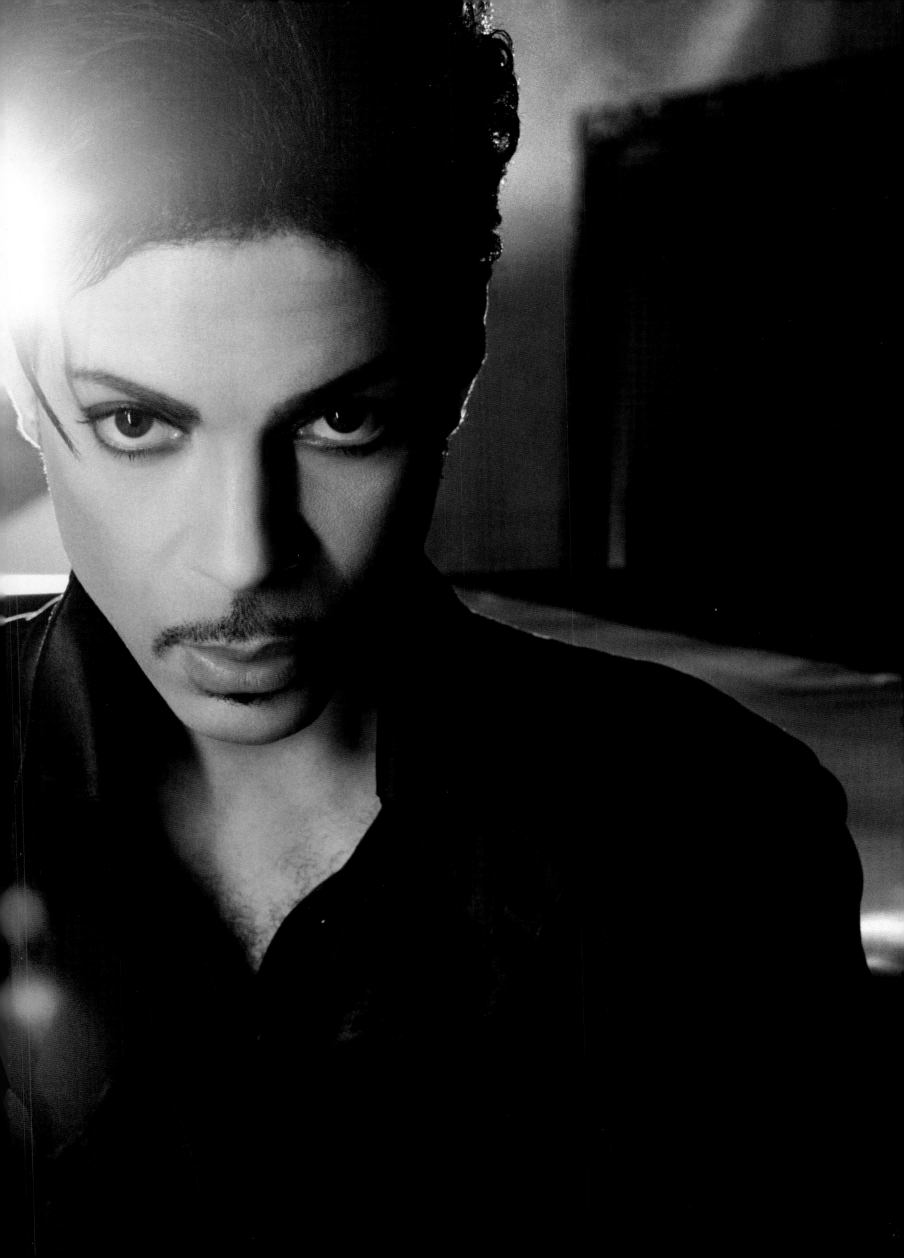

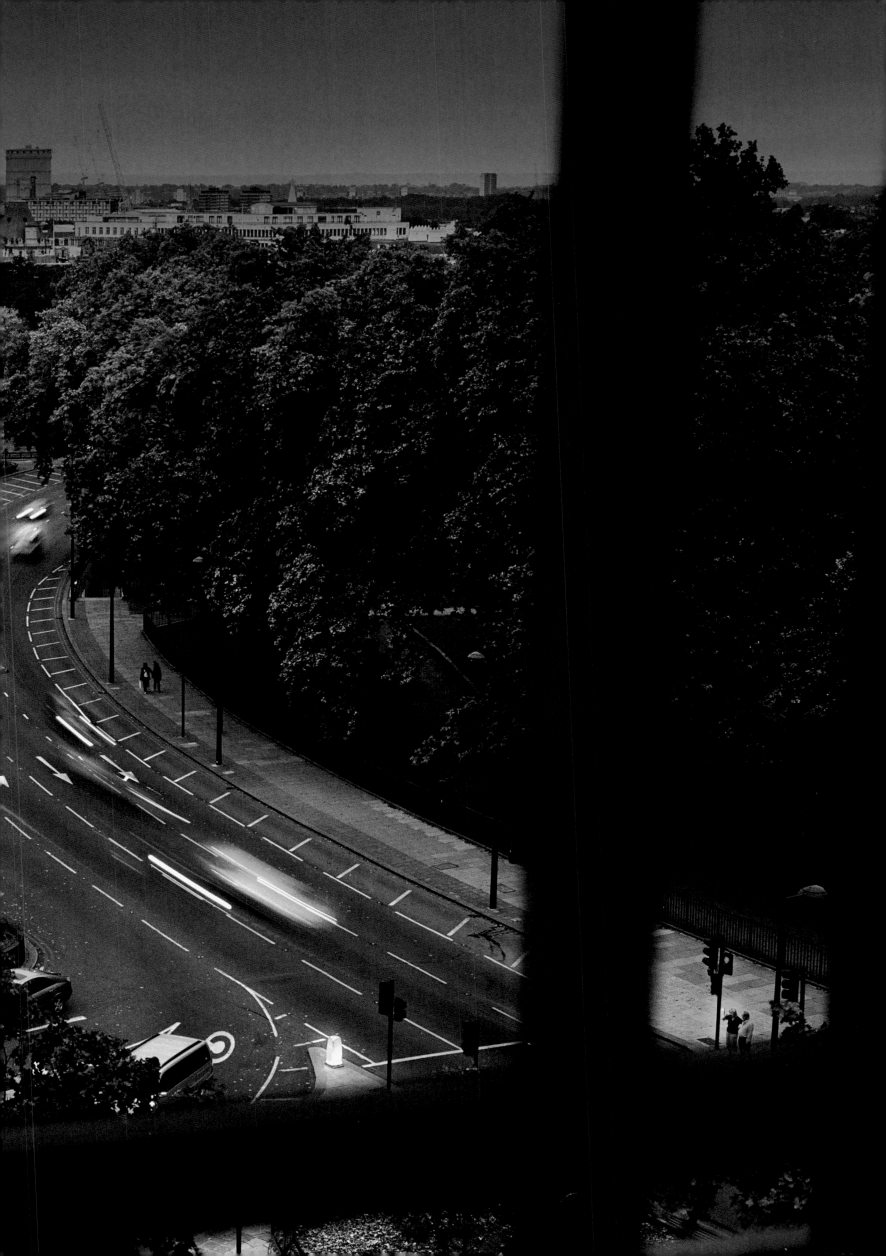

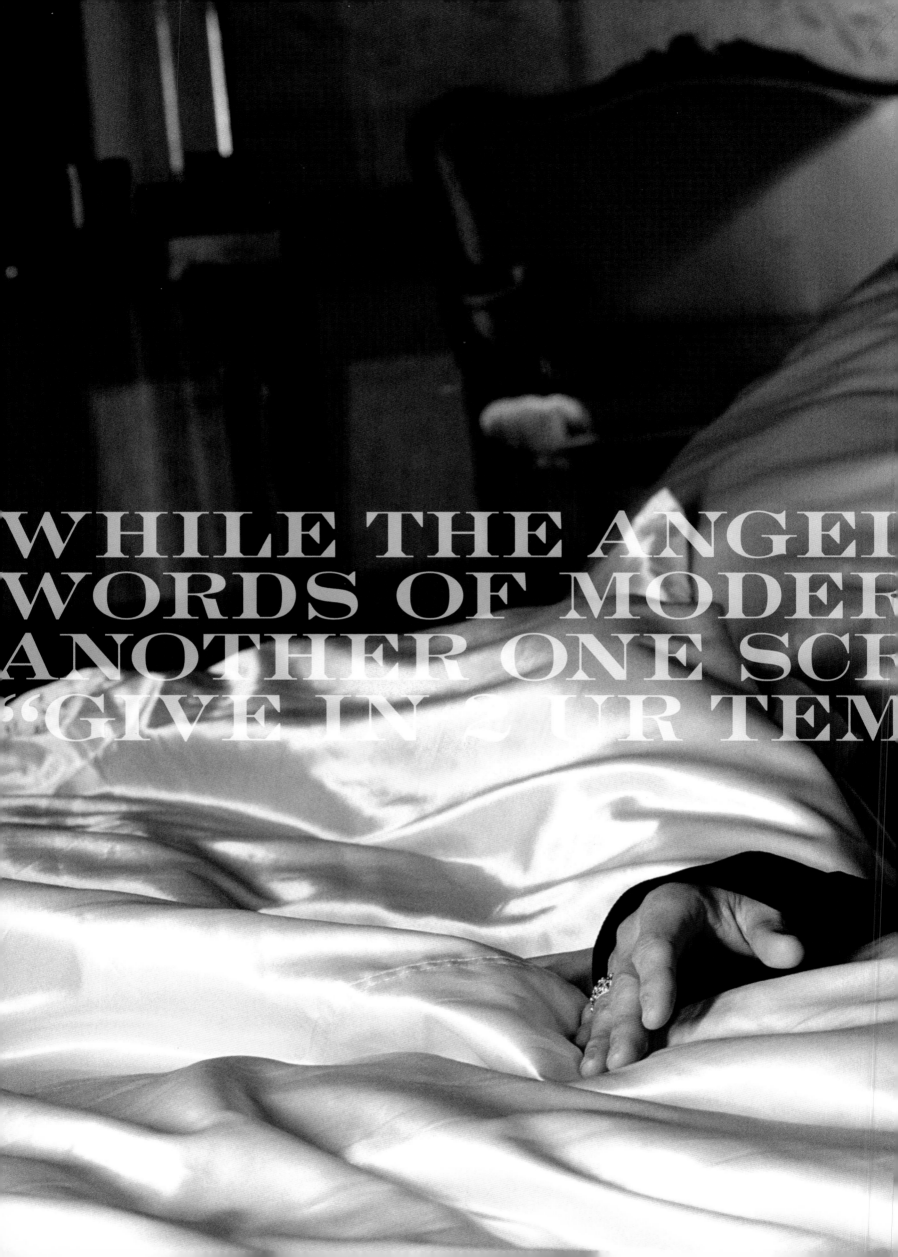

WHISPERS
ATION,
EAMS:
PTATION"

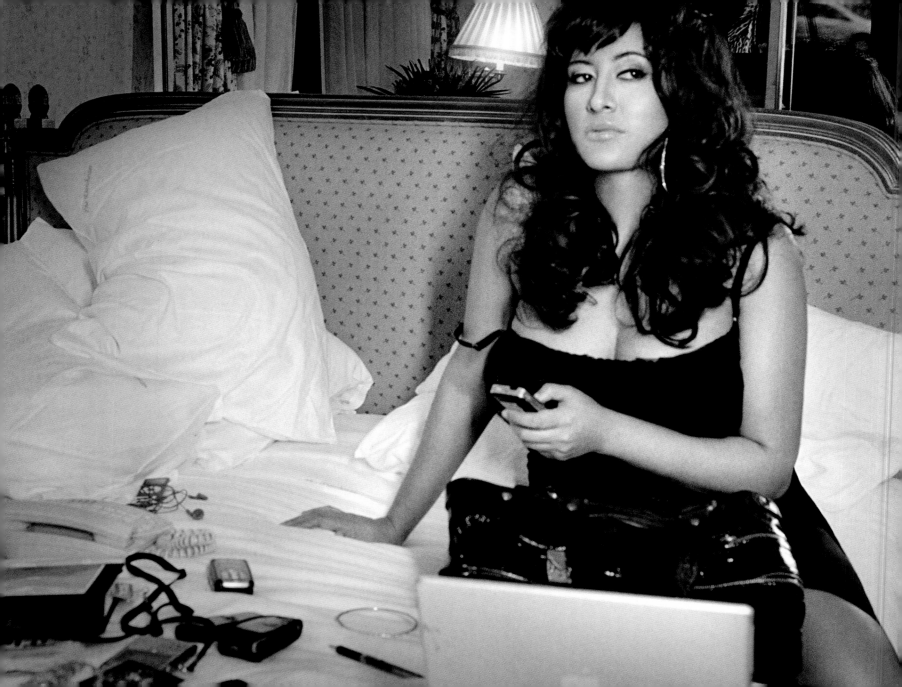

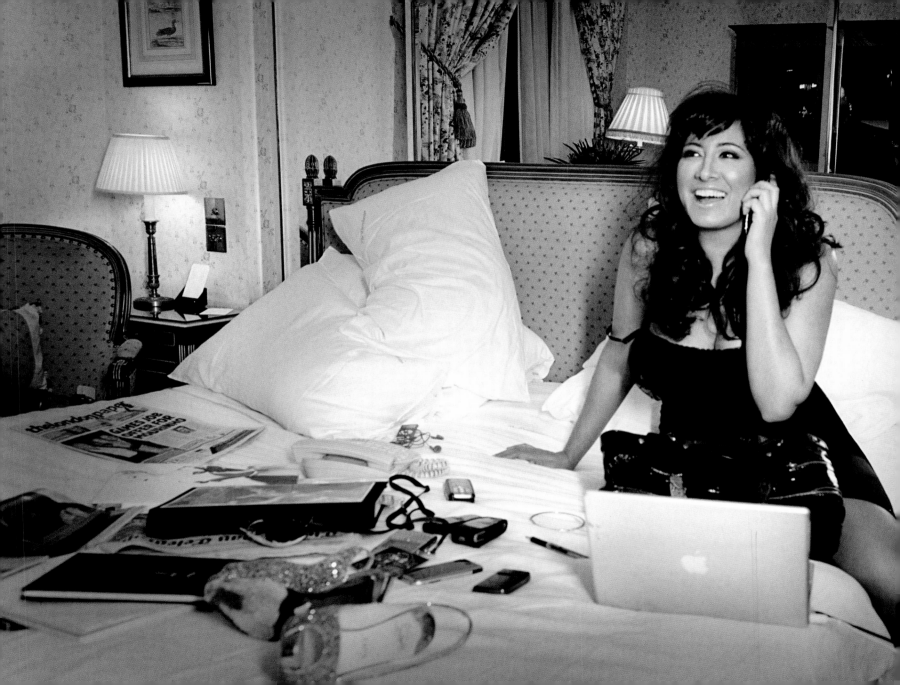

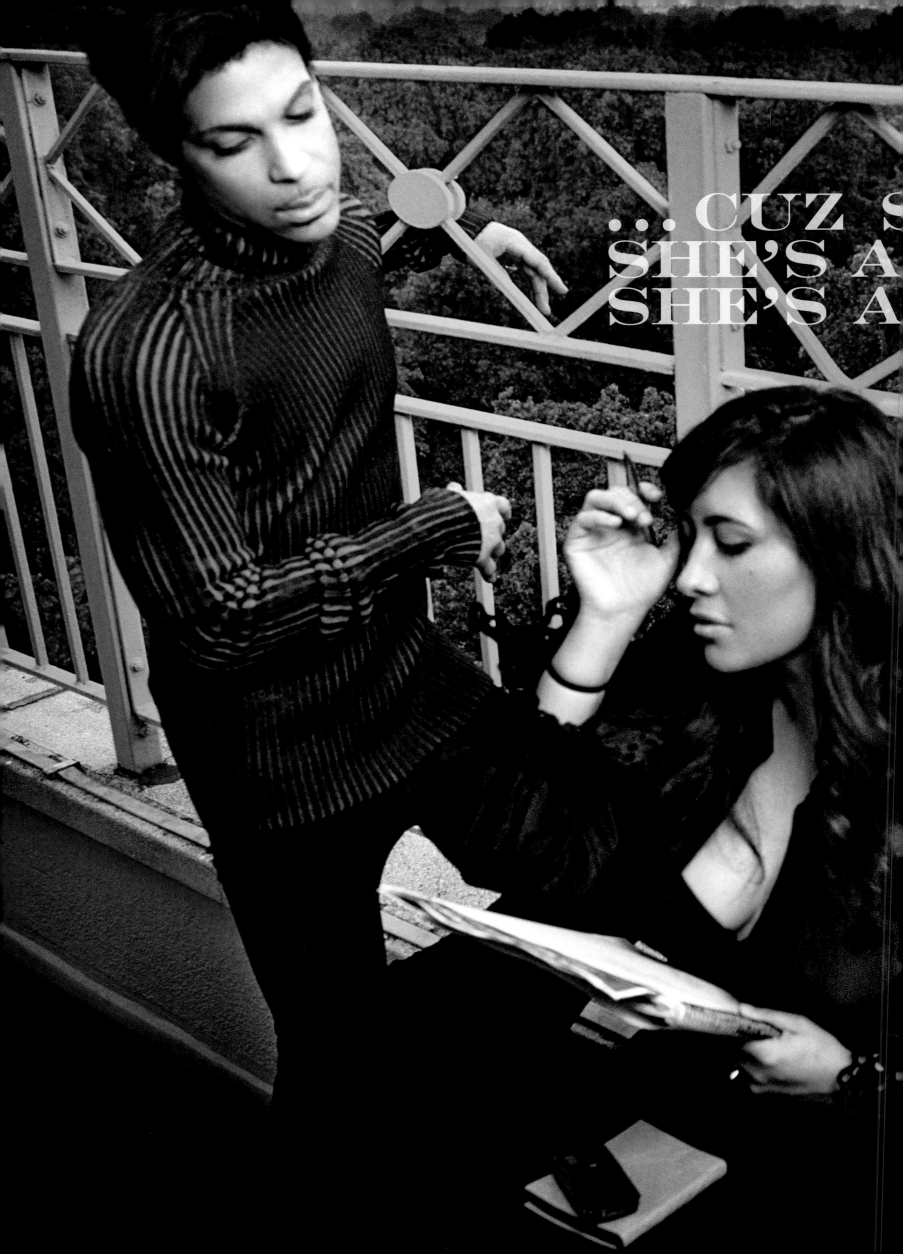

... CUZ S
SHE'S A
SHE'S A

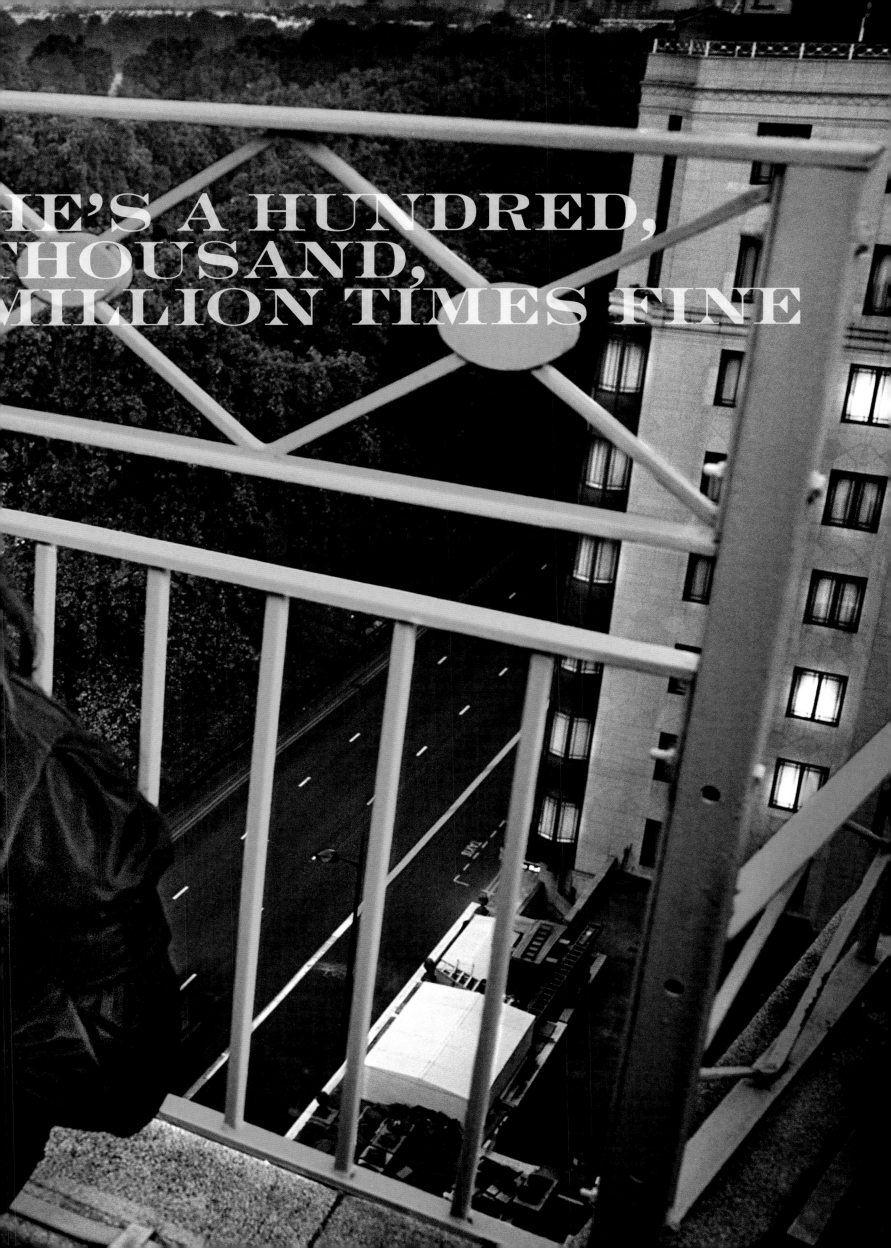

REAK IT DOWN...

AMID THE SOUND OF CITY NOISE
THEY LAY XPOSED
NAKED GIRL, NAKED BOY FULLY CLOTHED
WITH HIS PEN INK IN TONGUE HE WRITES IT THERE
A SINGLE WORD BENEATH HER HAIR
IT'S EARLY IN THE DAY 4 THEIR RELATIONSHIP
IN TRUTH HE HARDLY KNOWS HER XCEPT 4 HER LIPS

10:34 PM

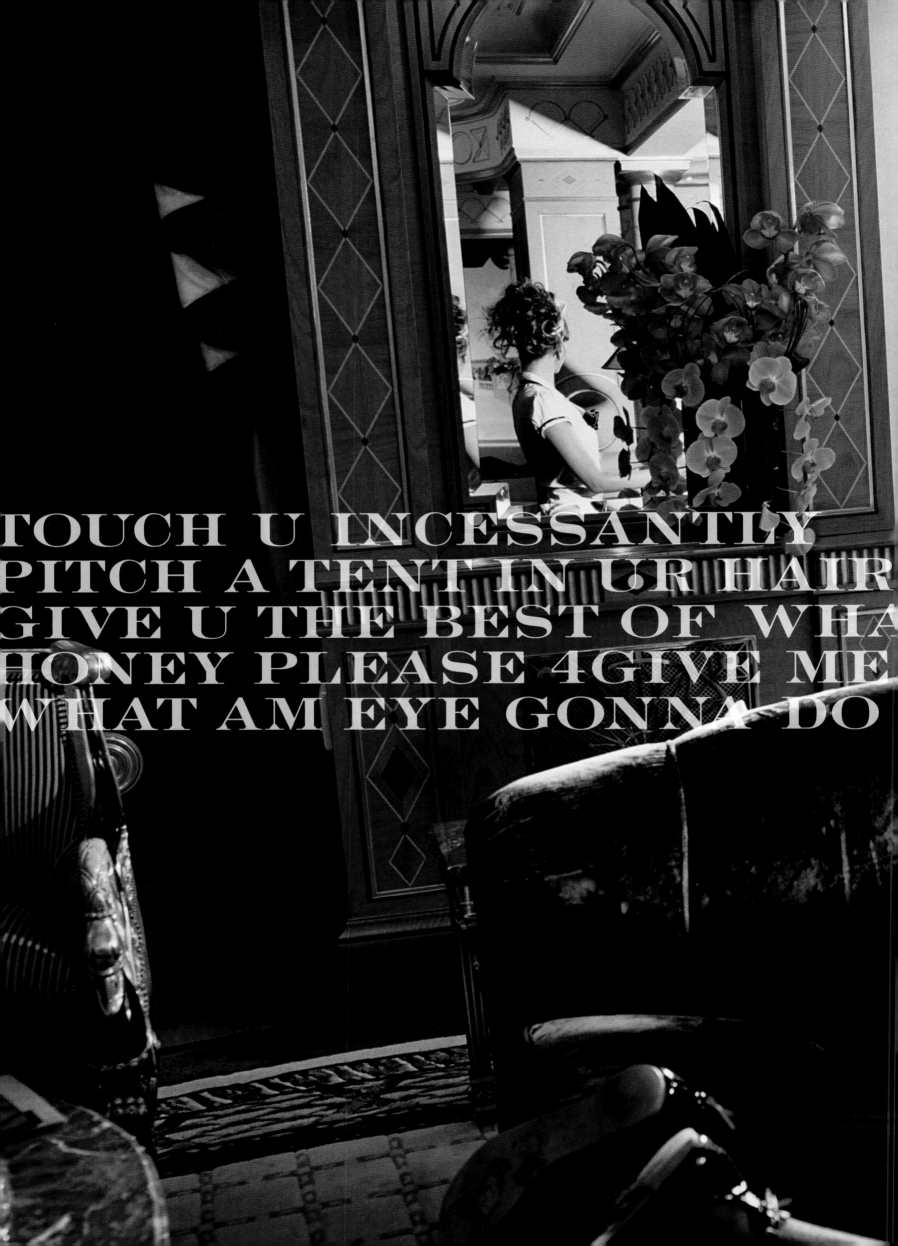

TOUCH U INCESSANTLY
PITCH A TENT IN UR HAIR
GIVE U THE BEST OF WHA
HONEY PLEASE 4GIVE ME
WHAT AM EYE GONNA DO

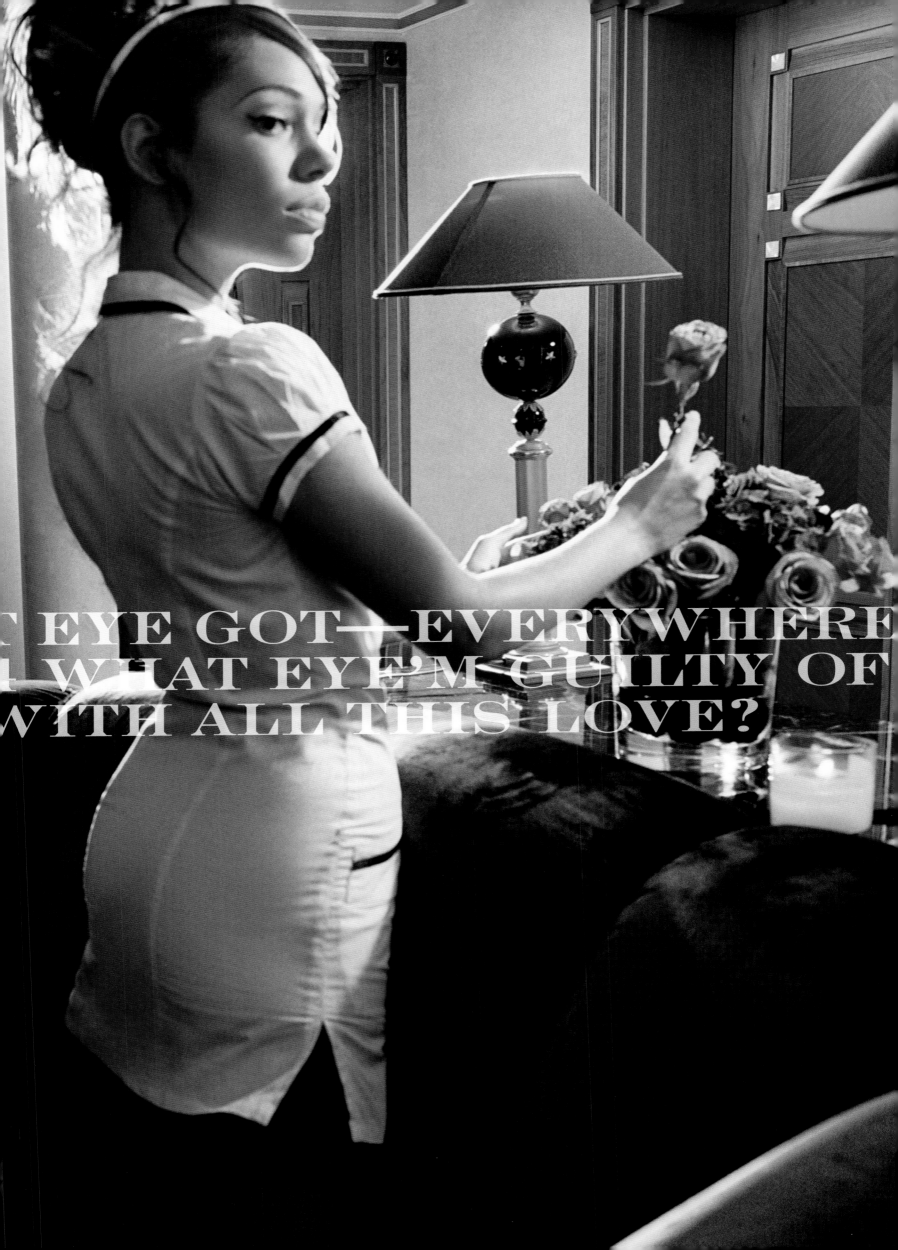

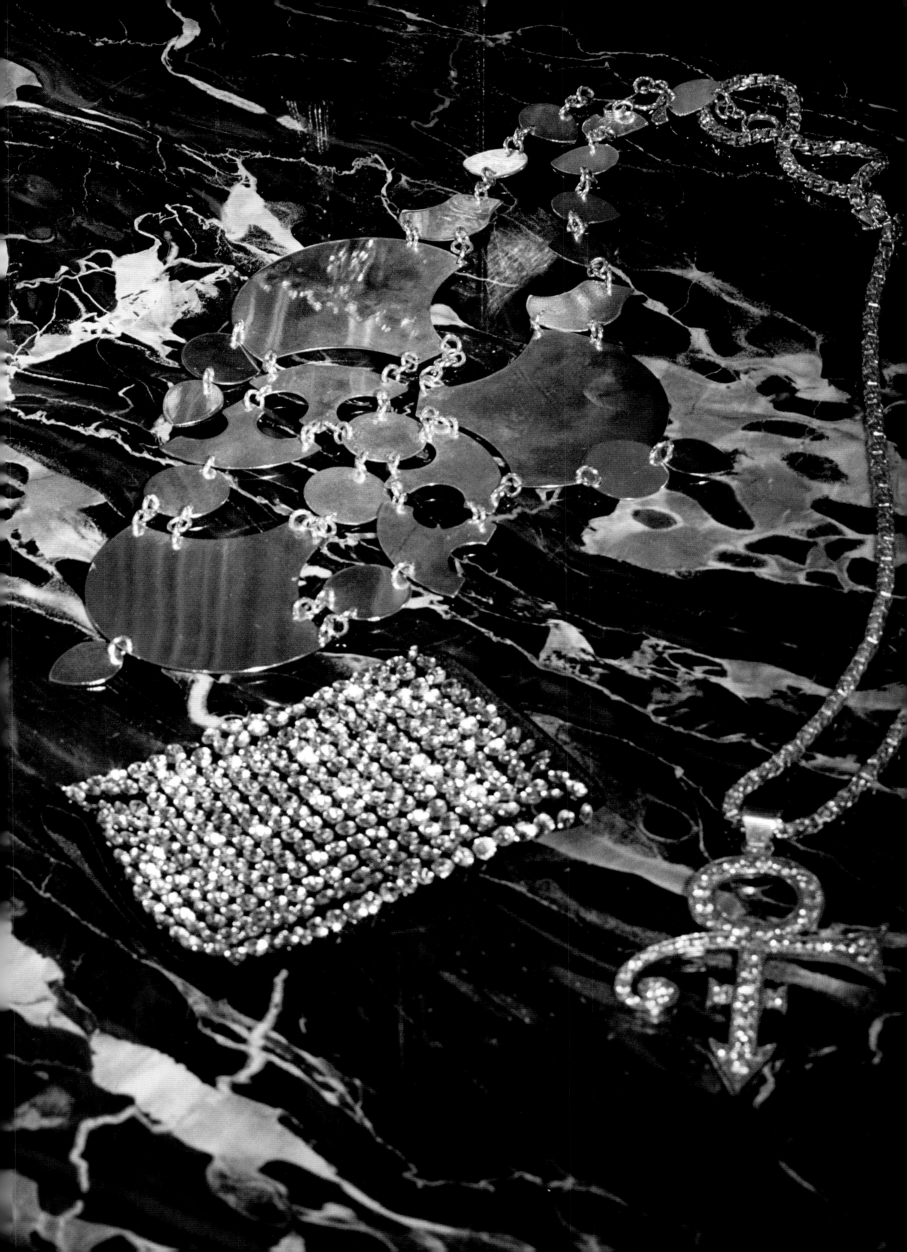

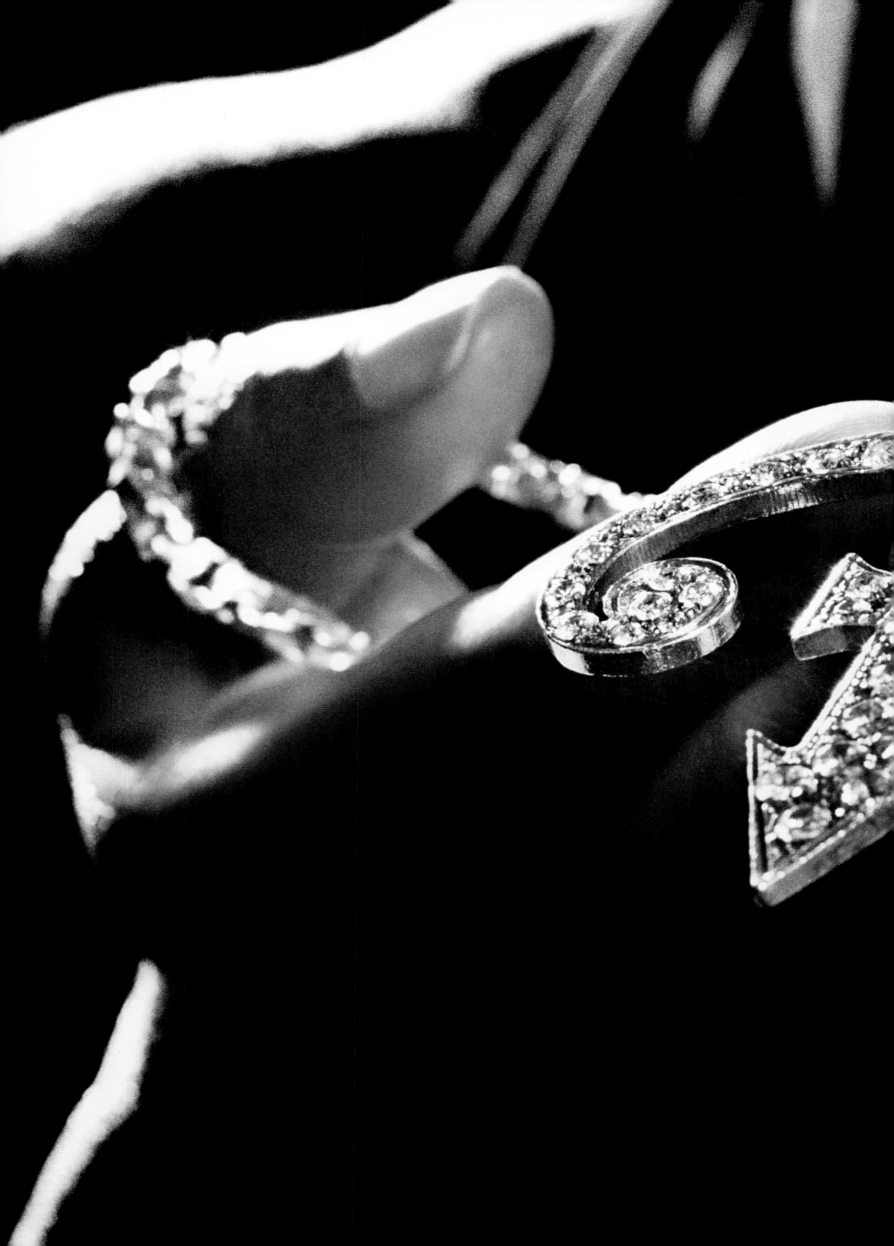

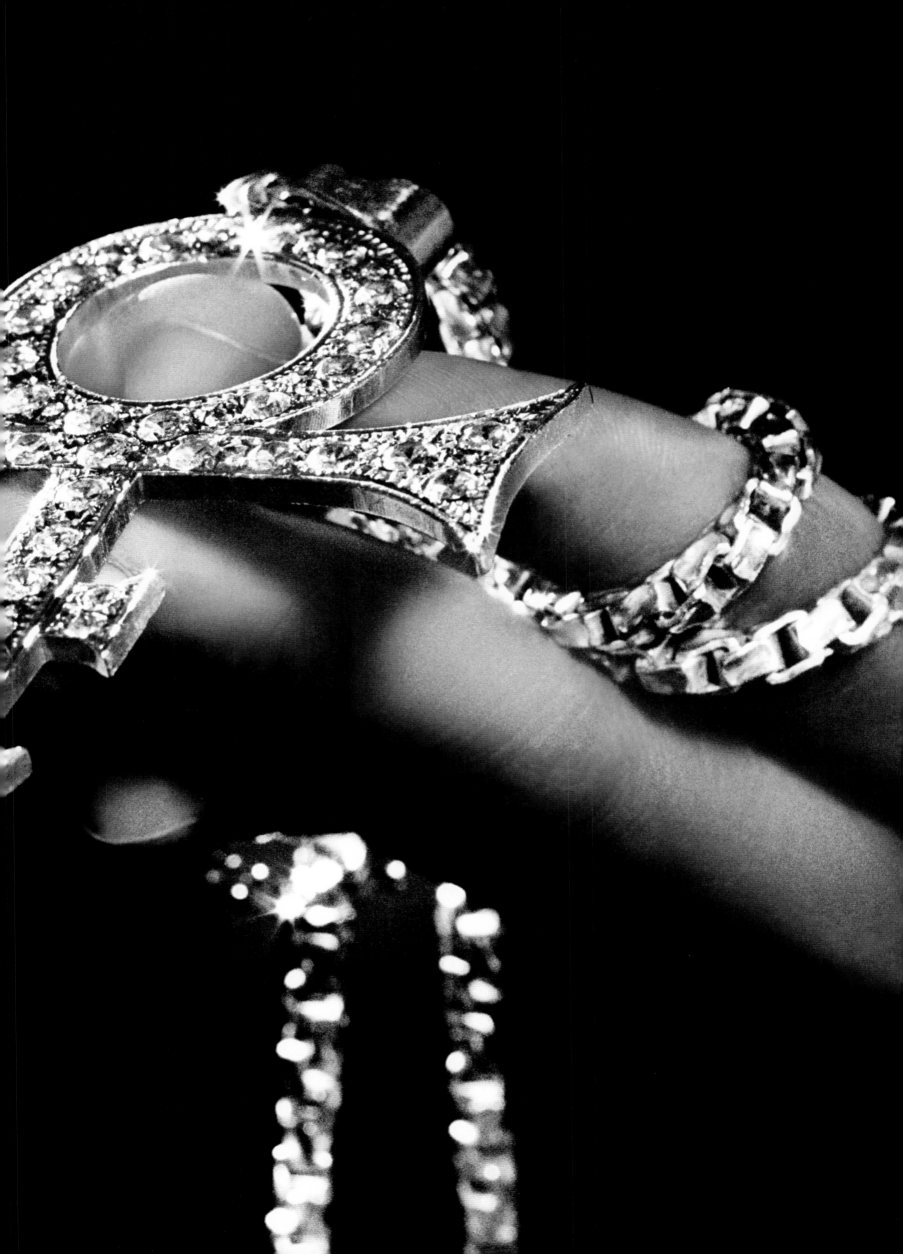

CHAKRA TRANSFER I
EYE'MA TAKE IT EASY.
EYE'M AROUND U LIK
DON'T WORRY BABY, U

SIDE LOOKING OUT
NO NEED 2 POUT
WA HAND IN GLOVE
RE DEEP ENOUGH

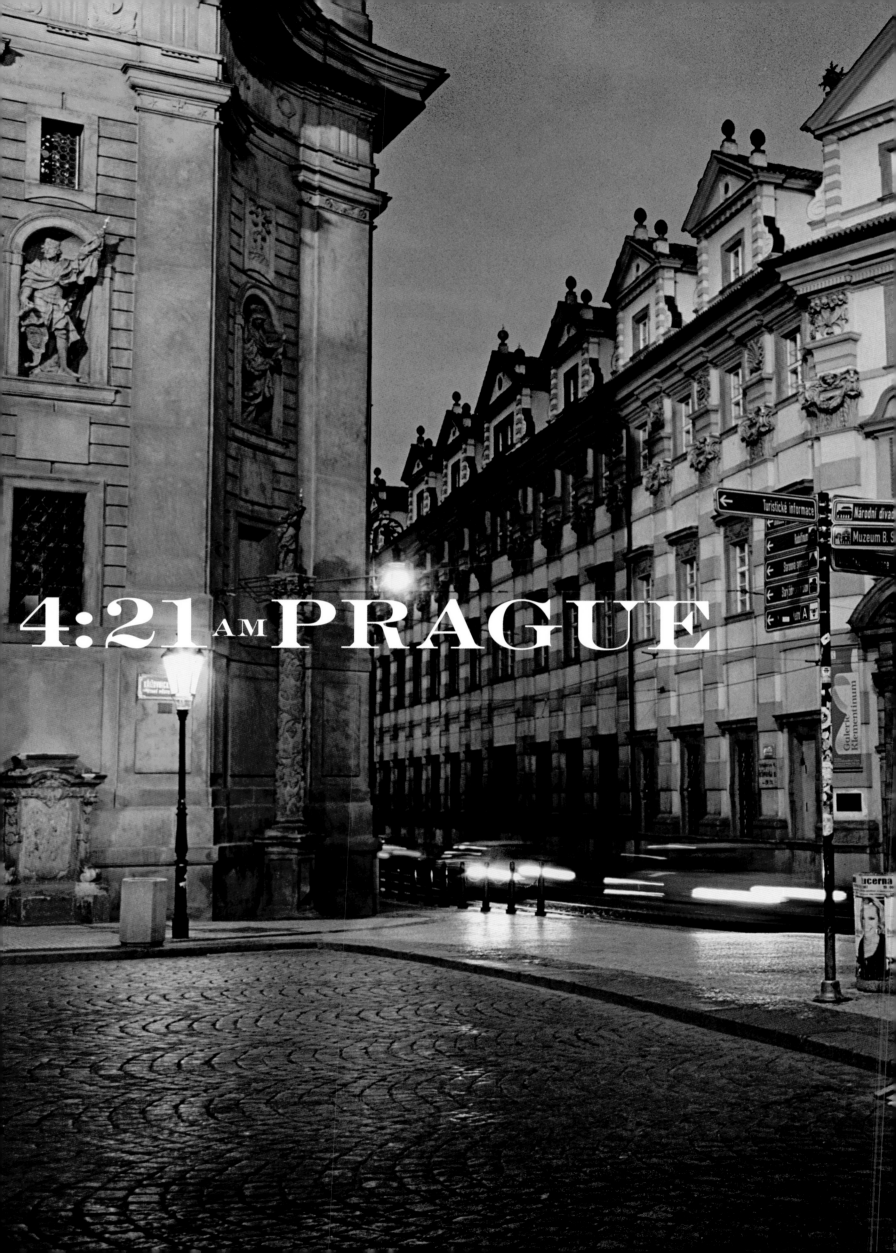

4:21 AM PRAGUE

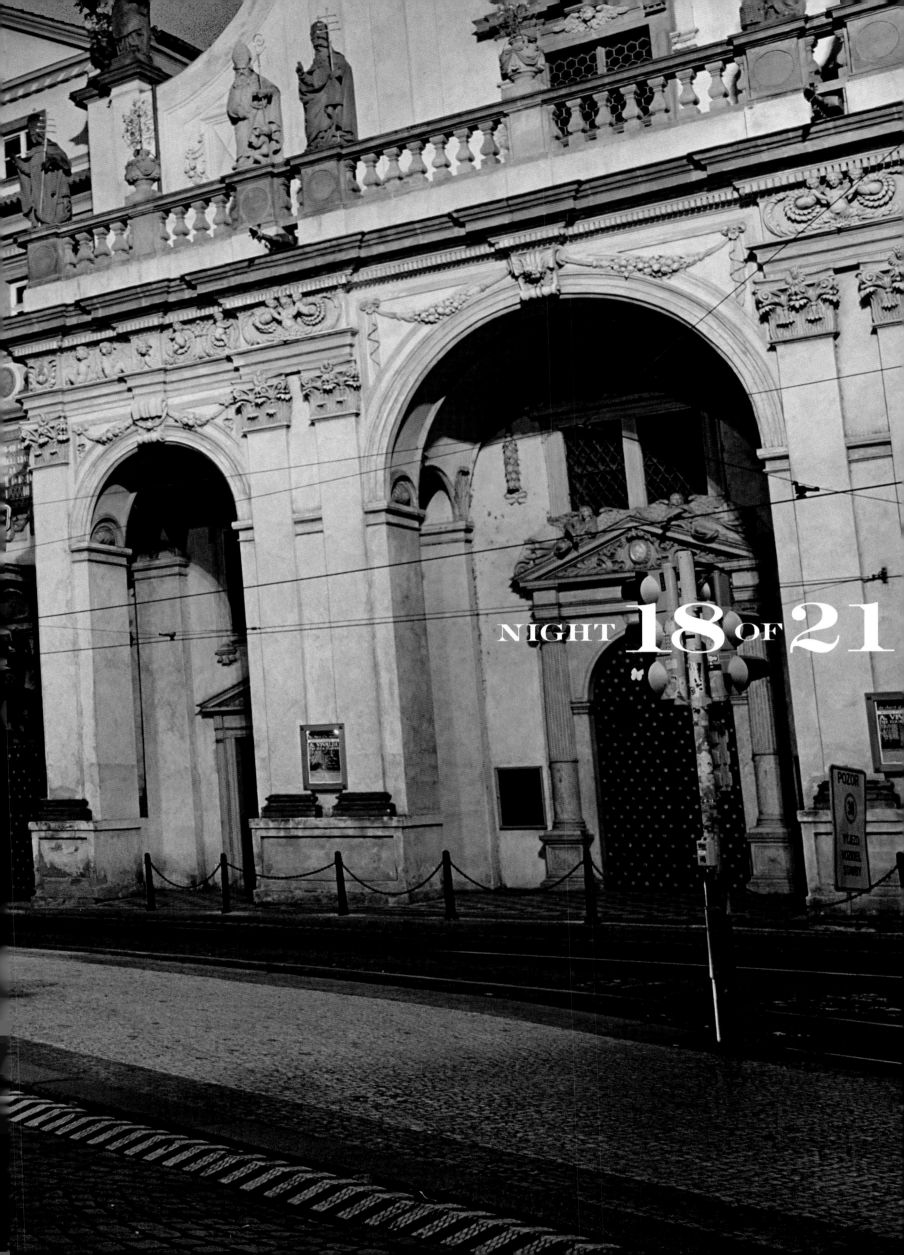

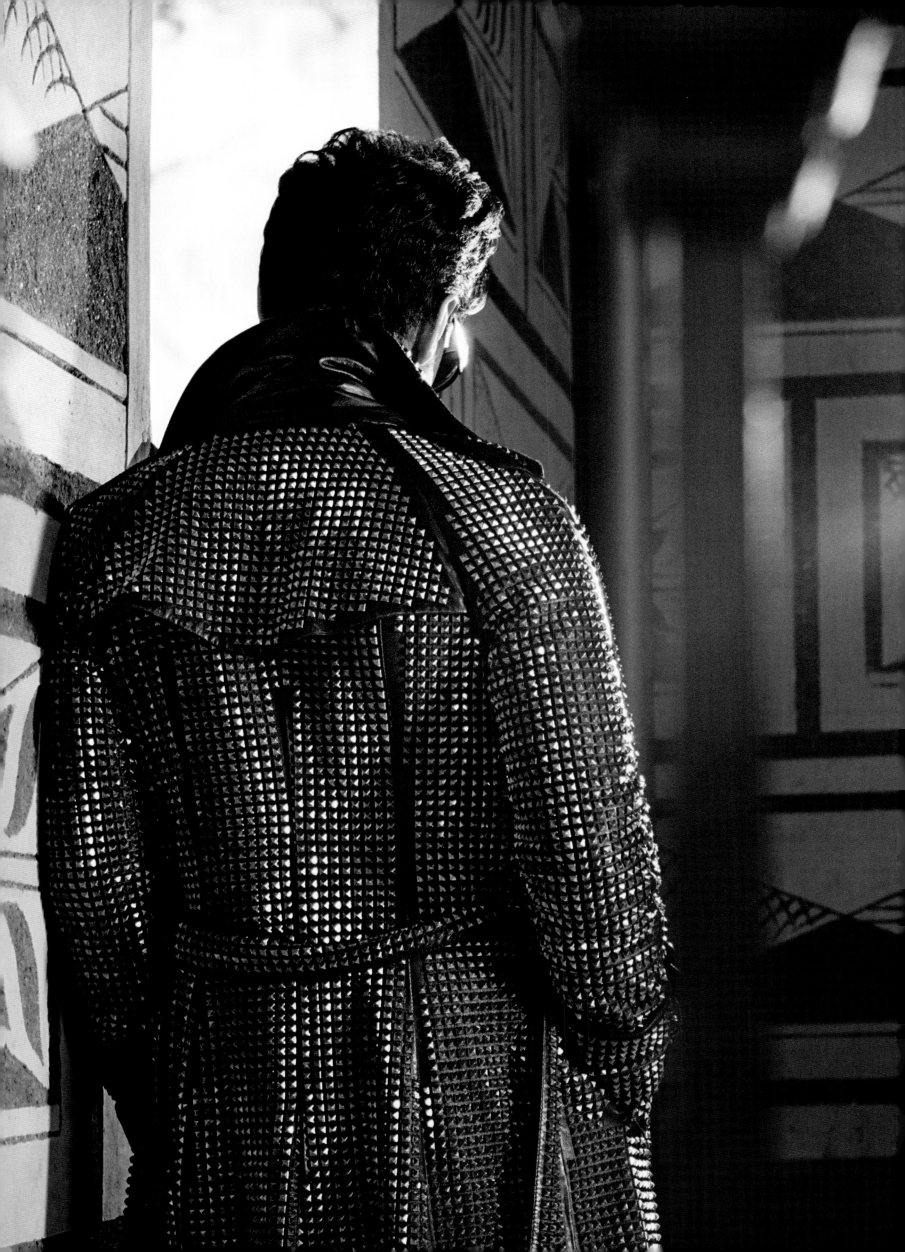

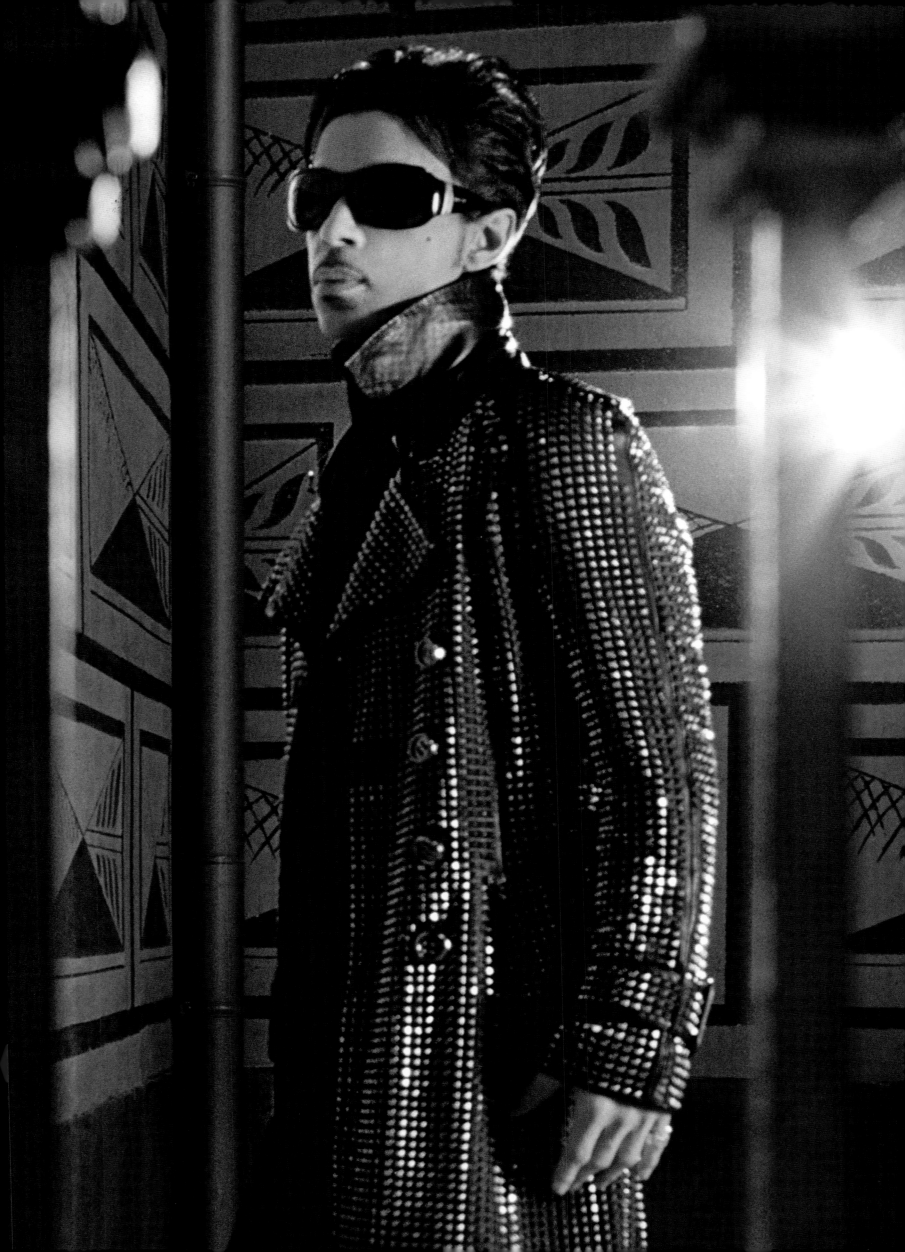

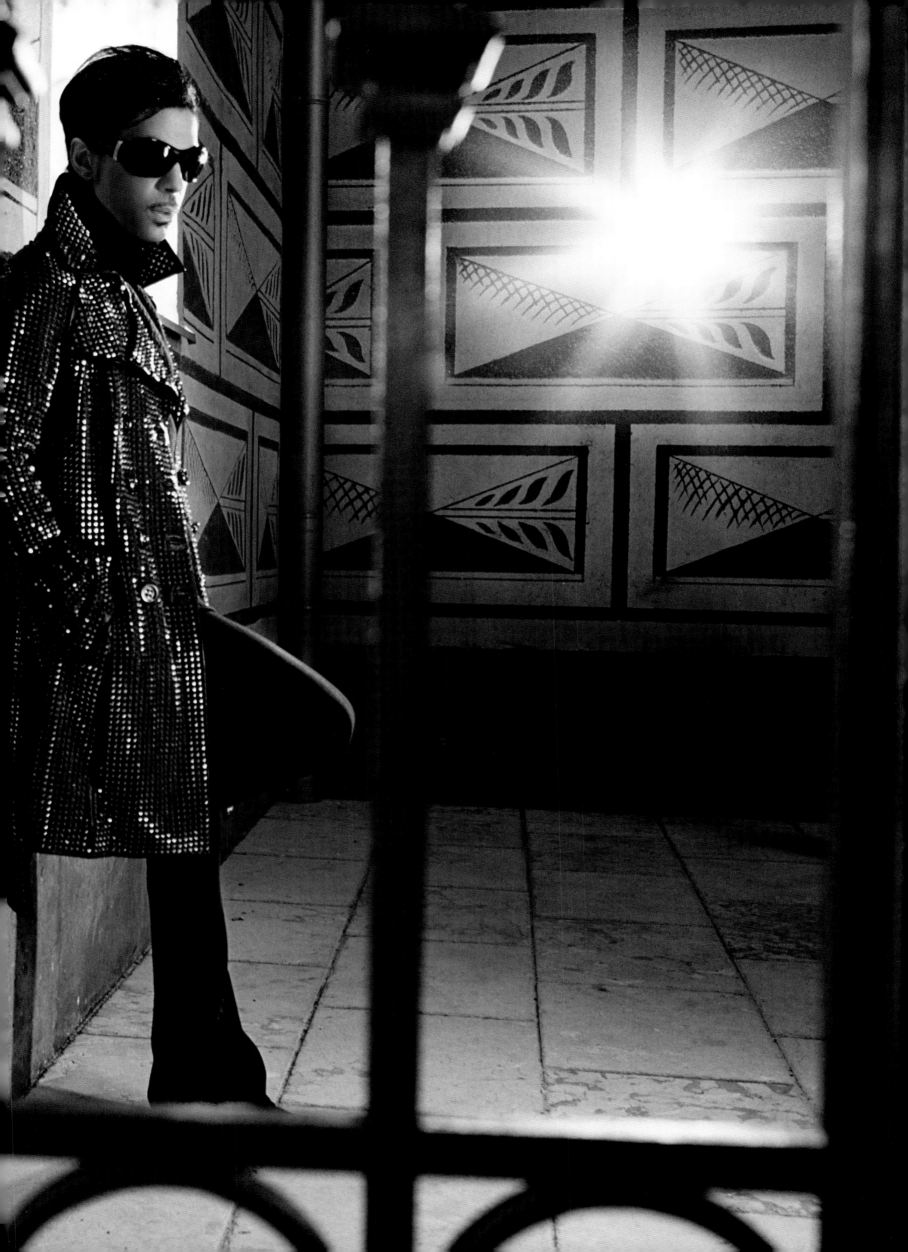

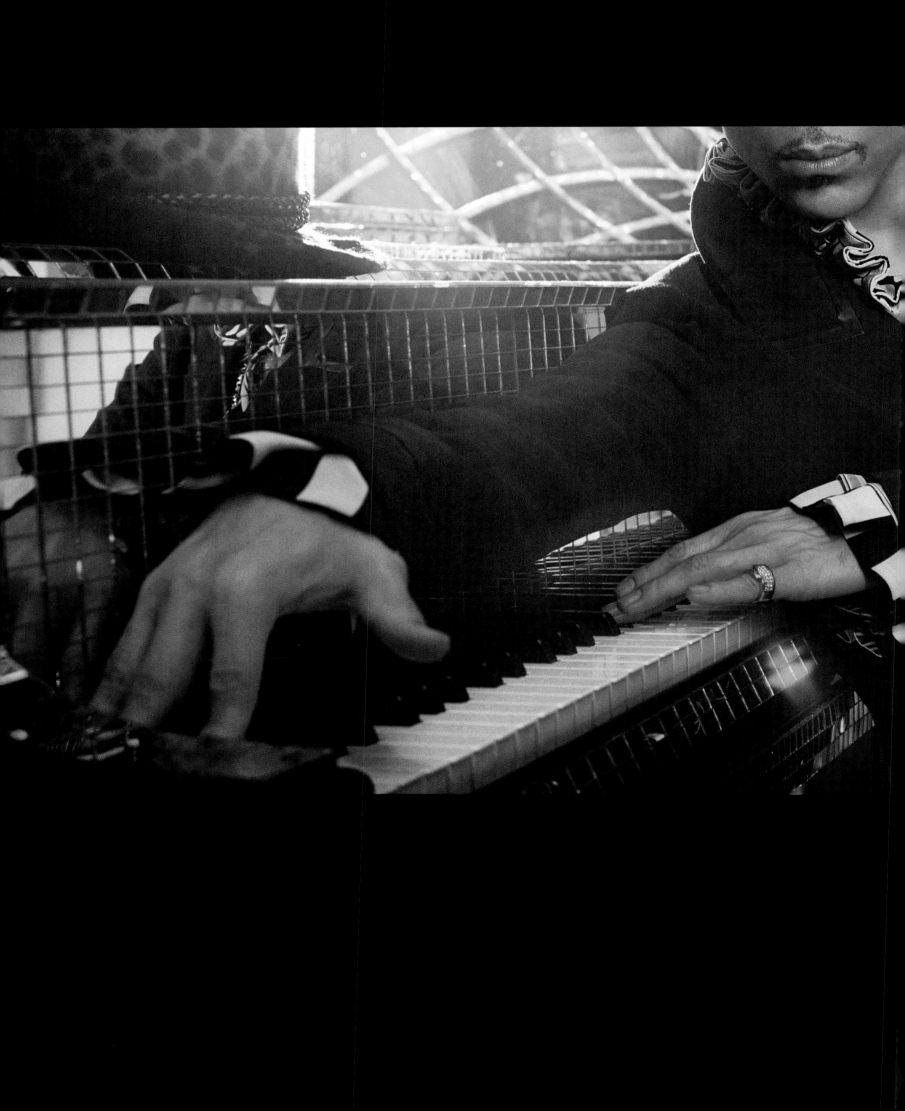

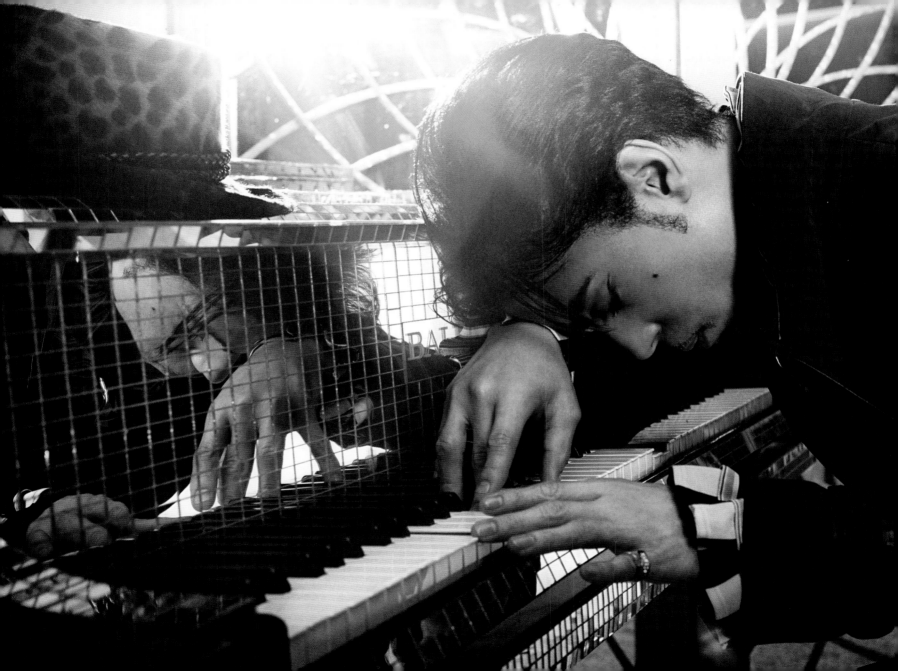

SOMEWI

EYE KNOW U'RE OUT THERE
EYE CAN FEEL UR EYES ON ME
EYE'VE SEEN THAT FACE A THOUSAND TIMES
IF ONLY IN MY DREAMS
EYE KNOW U REALLY WANT ME
EYE REALLY WANT 2 TOUCH U 2
IN A WAY EYE AM ALL ALONE
4 WHAT IT'S WORTH
U'RE SOMEWHERE HERE ON EARTH
EYE KNOW U'RE OUT THERE
EYE FEEL U GETTING CLOSER 2 ME
EYE'M JUST WONDERING WHAT U'RE WAITING 4
U KNOW EYE AM FREE
IN THIS DIGITAL AGE—U COULD JUST PAGE ME
EYE KNOW IT'S THE RAGE BUT IT JUST DON'T ENGAGE ME
LIKE THE FACE 2 FACE … U WANNA DO THIS AT URS OR MY PLACE?
& IT'S BEEN SO LONG SINCE EYE BEEN WITH SOMEBODY
LIKE A MILLION YEARS
BUT NOW U'RE HERE ON EARTH
EYE KNOW U HEAR ME
LIKE A WHISPER IN UR EAR

HERE ON EA

U DON'T HAVE 2 FEAR ME
U'RE EVERYTHING EYE HOLD SO DEAR
EYE KNOW U ALREADY LOVE ME
U'RE PROBABLY JUST 2 COOL 2 SAY
SOMEBODY, SOMEWHERE PUT U DOWN BUT THAT'S OKAY
CUZ WHATEVER U FEEL IT'S TIME 2 HEAL
NO MORE HURT AS LONG AS EYE'M HERE ON EARTH

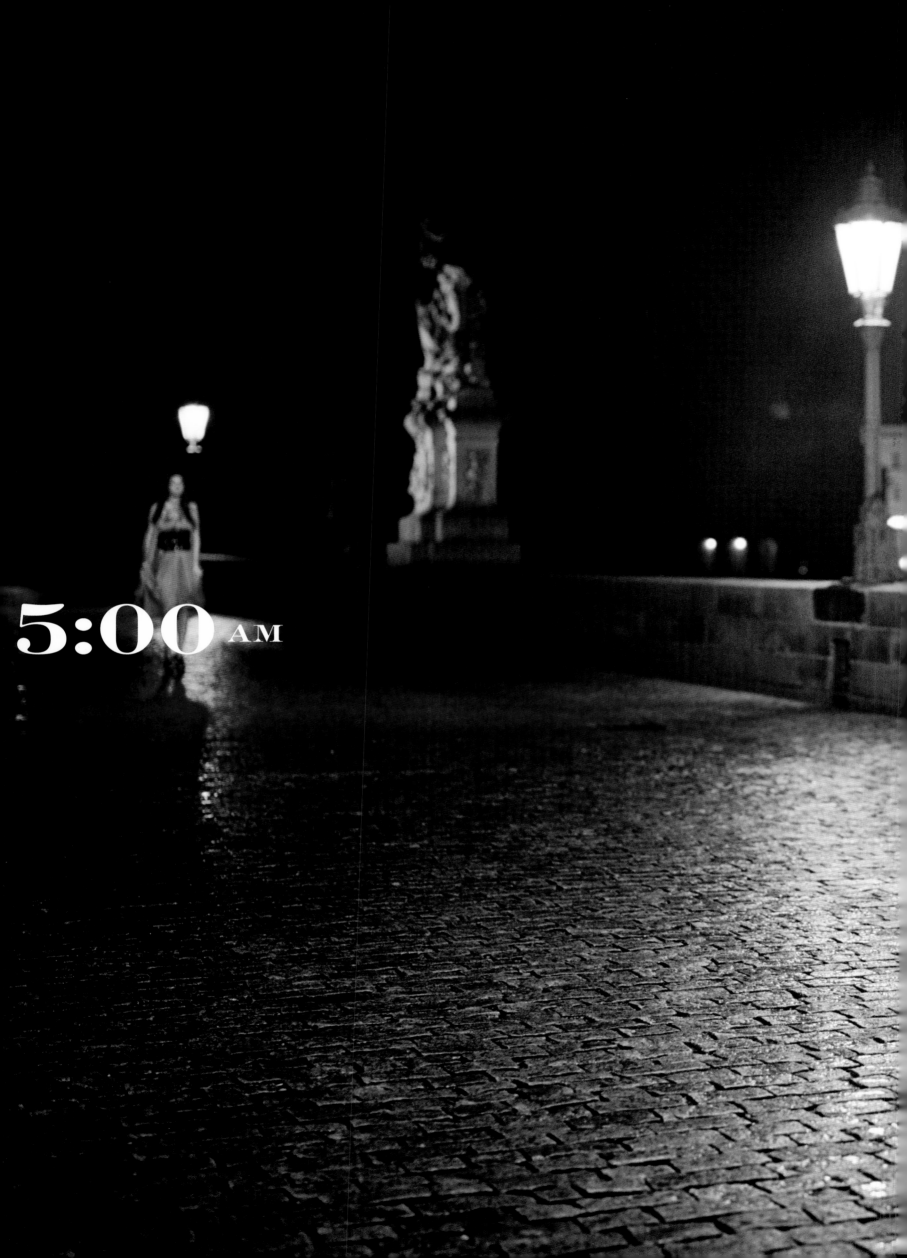

5:00 AM

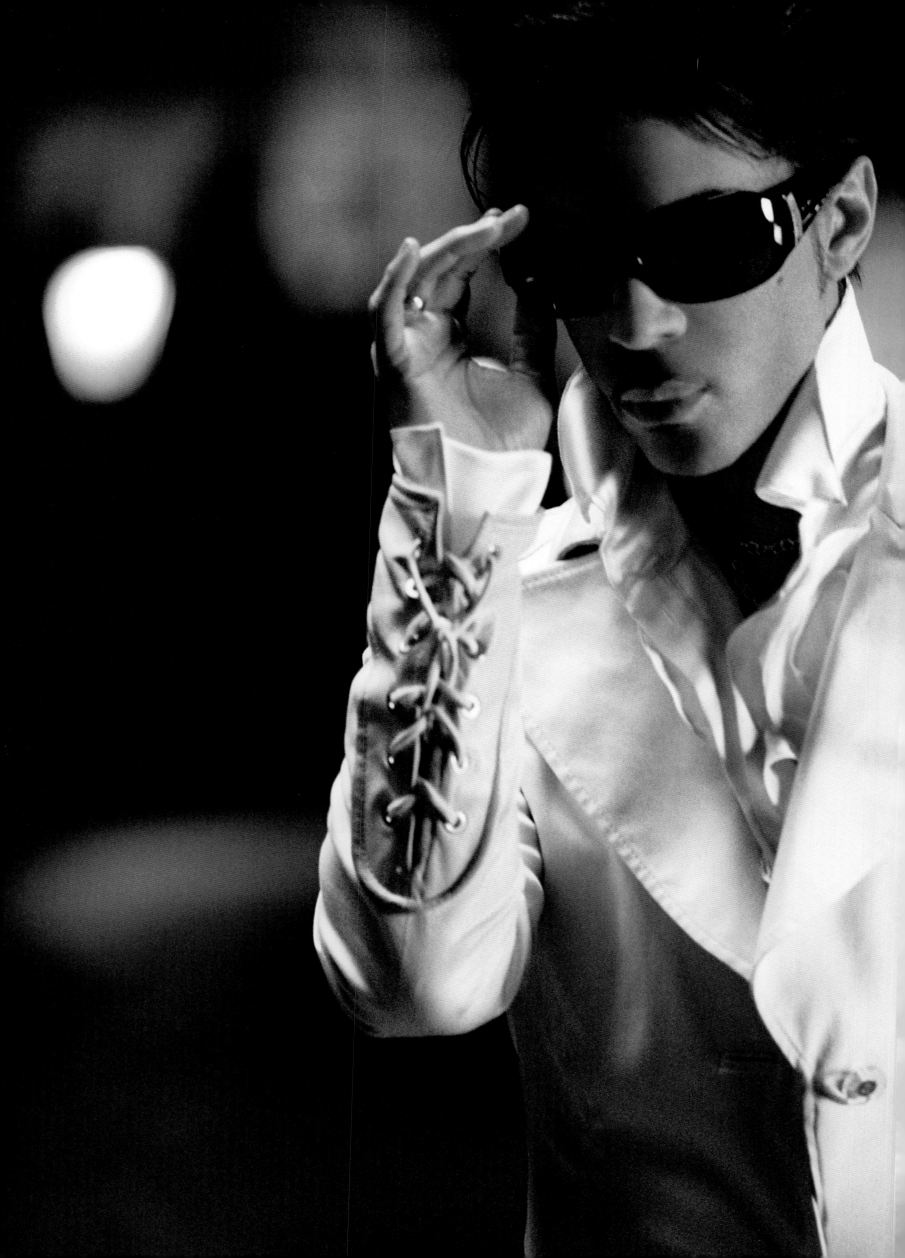

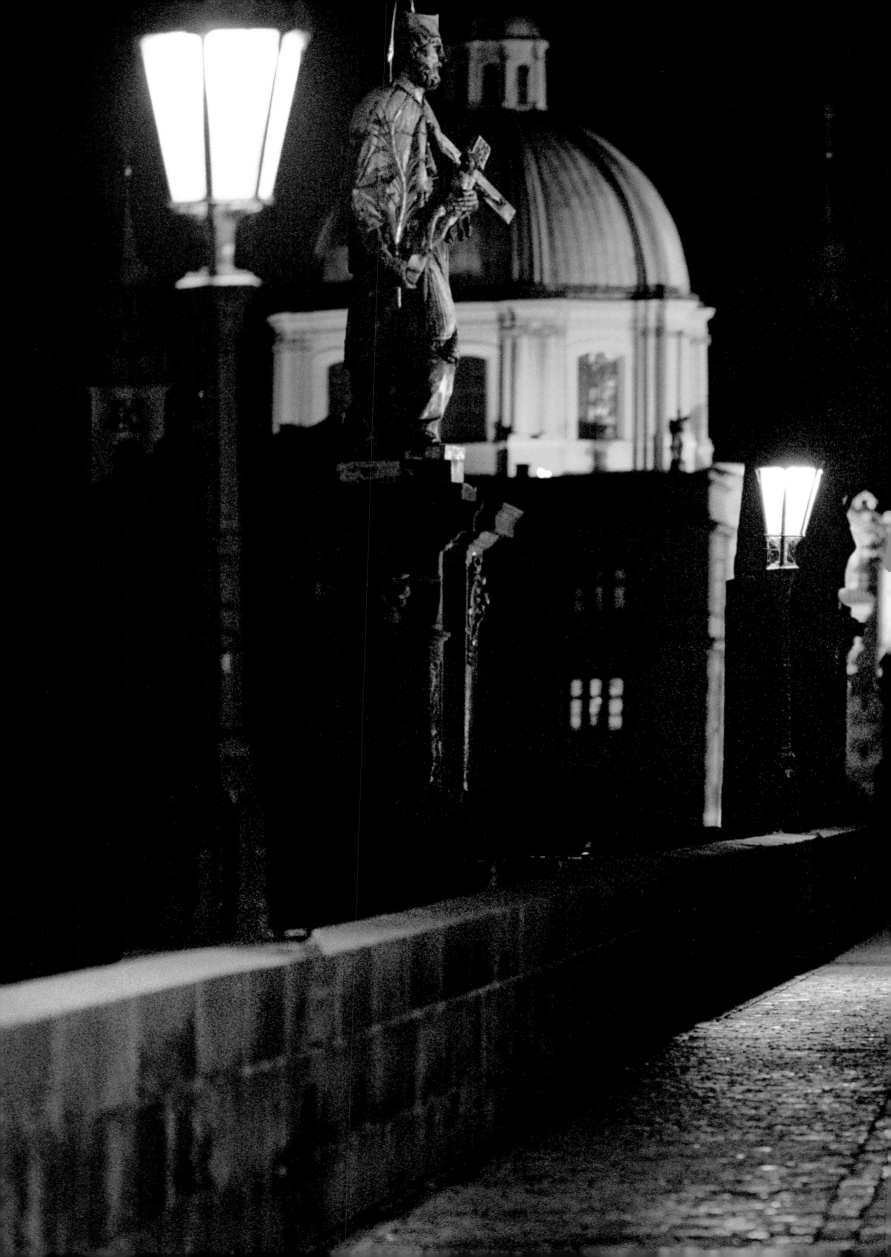

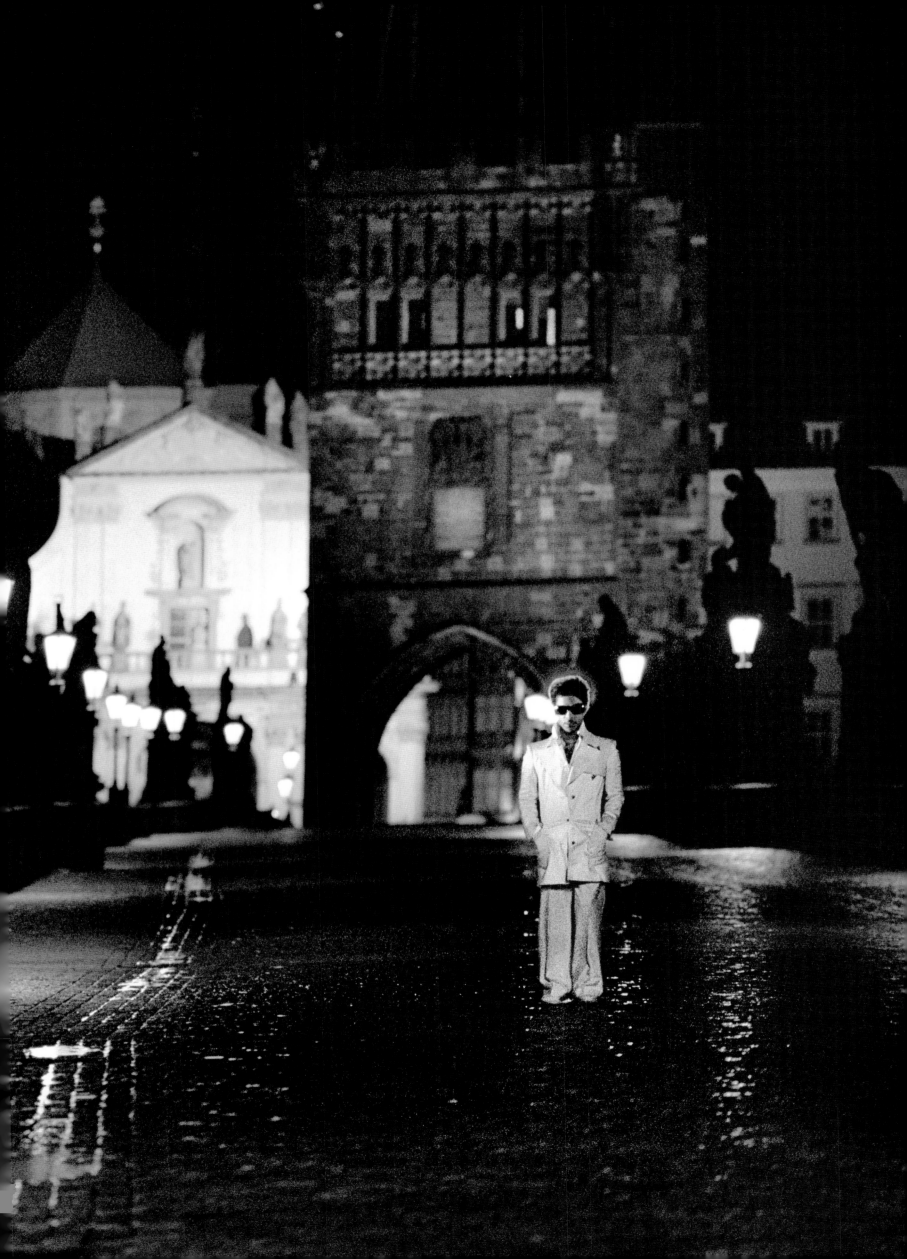

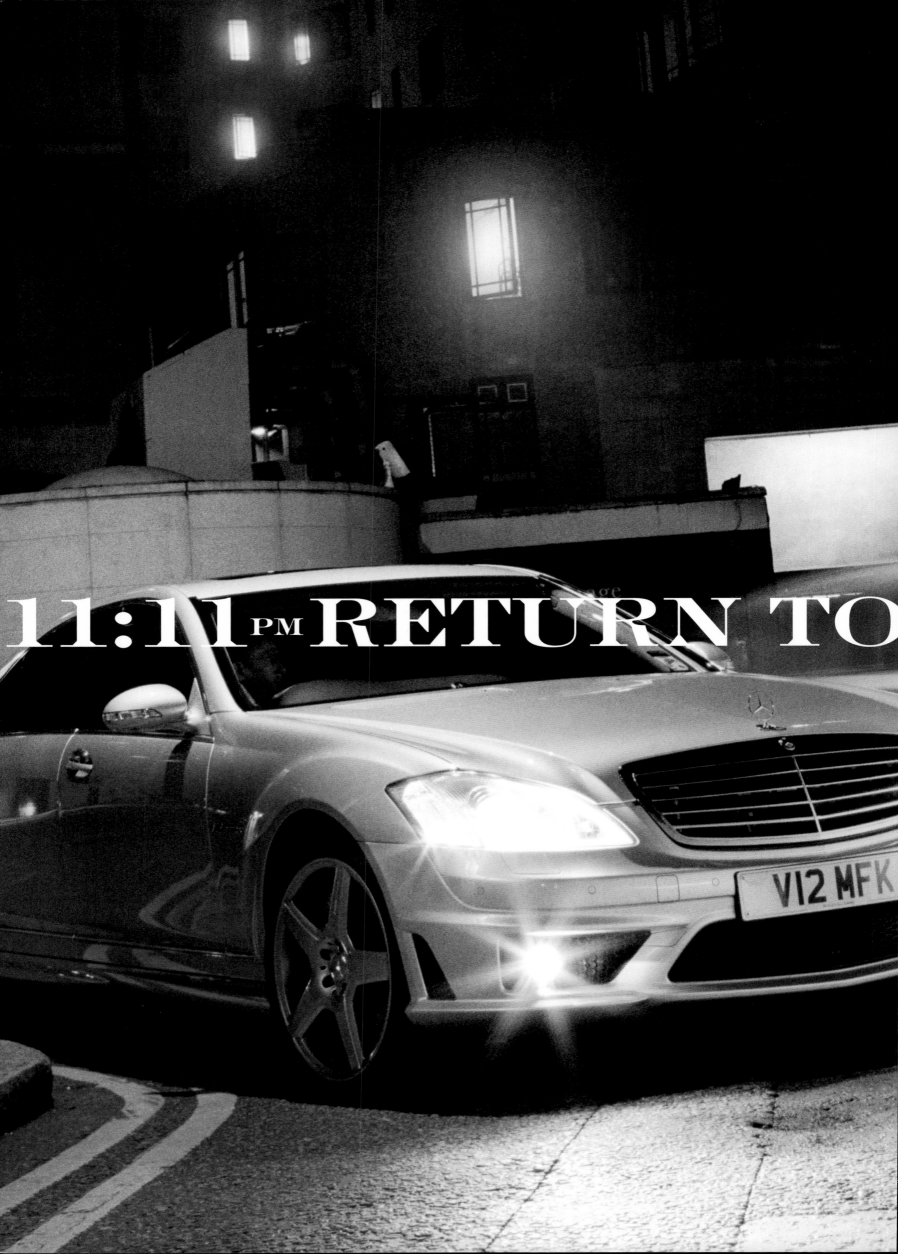

EYE KNOW EYE AIN'T THE FIRST 2 TELL YA
EYE SURE BET EYE WON'T B THE LAST
EYE KNOW U'RE IN A HURRY BABY
SO LET ME MAKE THIS FAST

EYE GOT A LOT OF MONEY
EYE DON'T WANT 2 SPEND IT ON ME
EYE LIKE PRETTY THINGS AND U'RE JUST AS PRETTY AS U CAN B
SO IF U AIN'T BUSY LATER
AND U WANT SOME COMPANY
EYE AIN'T TRYIN 2 B A HATER
EYE'M THE ONE … EYE'M THE ONE …
THE ONE U WANNA C … U WANNA C

LOOK AROUND U BABY
EYE KNOW U'VE SEEN IT ALL B4
EVERY NICKEL IN THIS CLUB LOOKIN' 4 A DIME
NOTHING LESS, NOTHING MORE

2 TALL 2 B TALKED DOWN 2
2 OVER IT 2 B PUT UNDER
ANY SPELL THE BLIND FISHERMAN COULD CAST
THAT'S Y EYE COME LIKE THUNDER

THE ONE U WANNA

U DON'T NEED 2 FIX UR HAIR
4 SOMEBODY U DON'T CARE 4
U DON'T NEED 2 SHAVE UR LEGS
IF EYE AIN'T THE ONE THAT'S KNOCKING AT UR DOOR … OH

EYE KNOW U AIN'T A CONCUBINE
EYE KNOW U AIN'T A ONE-NIGHT STAND
EYE DON'T WANNA WASTE UR TIME
IF U WANNA GET CREAMY
EYE'M THE ONE U WANNA C
OOH, THE ONE U WANNA C, BABY
OH THE ONE U WANNA C
WANNA C, WANNA C … BABY PLEASE

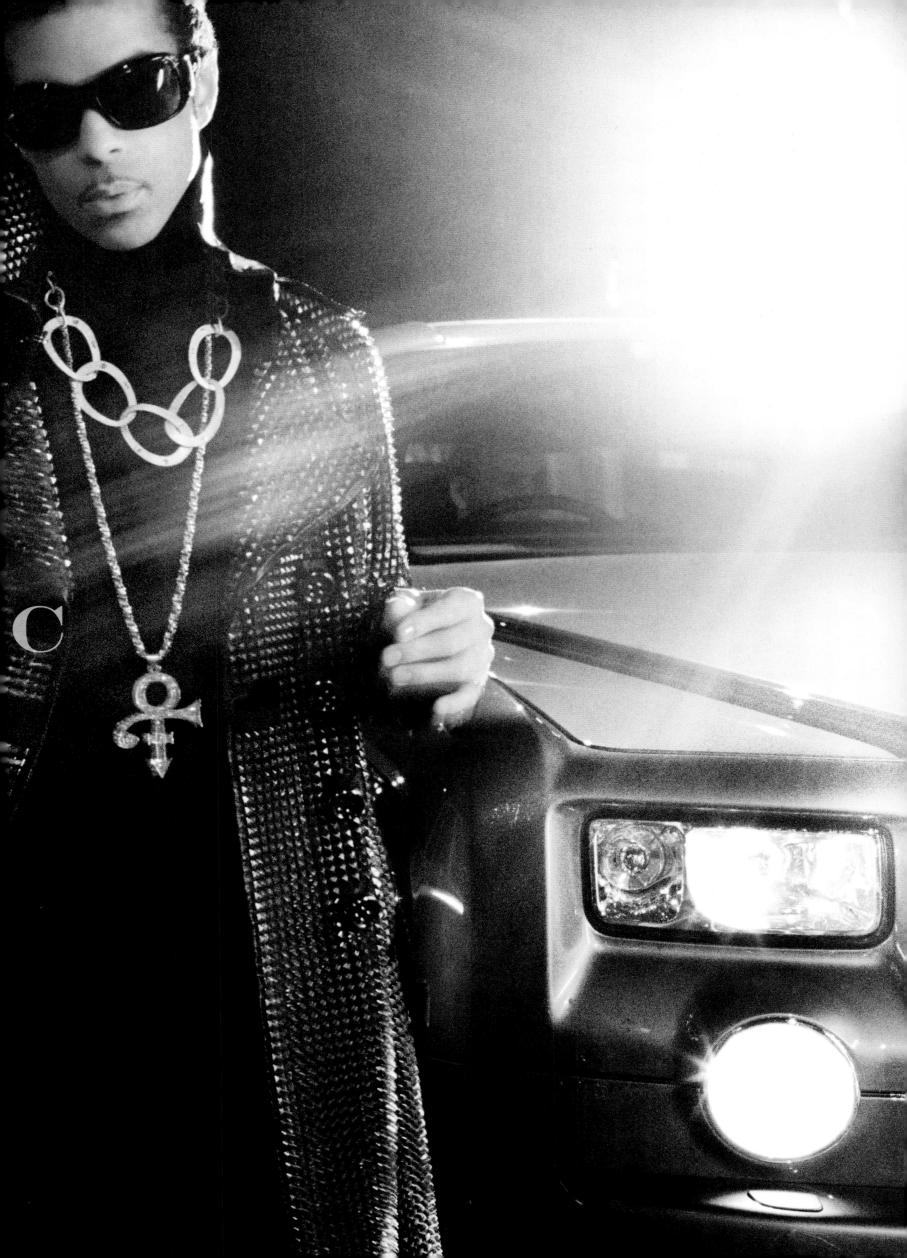

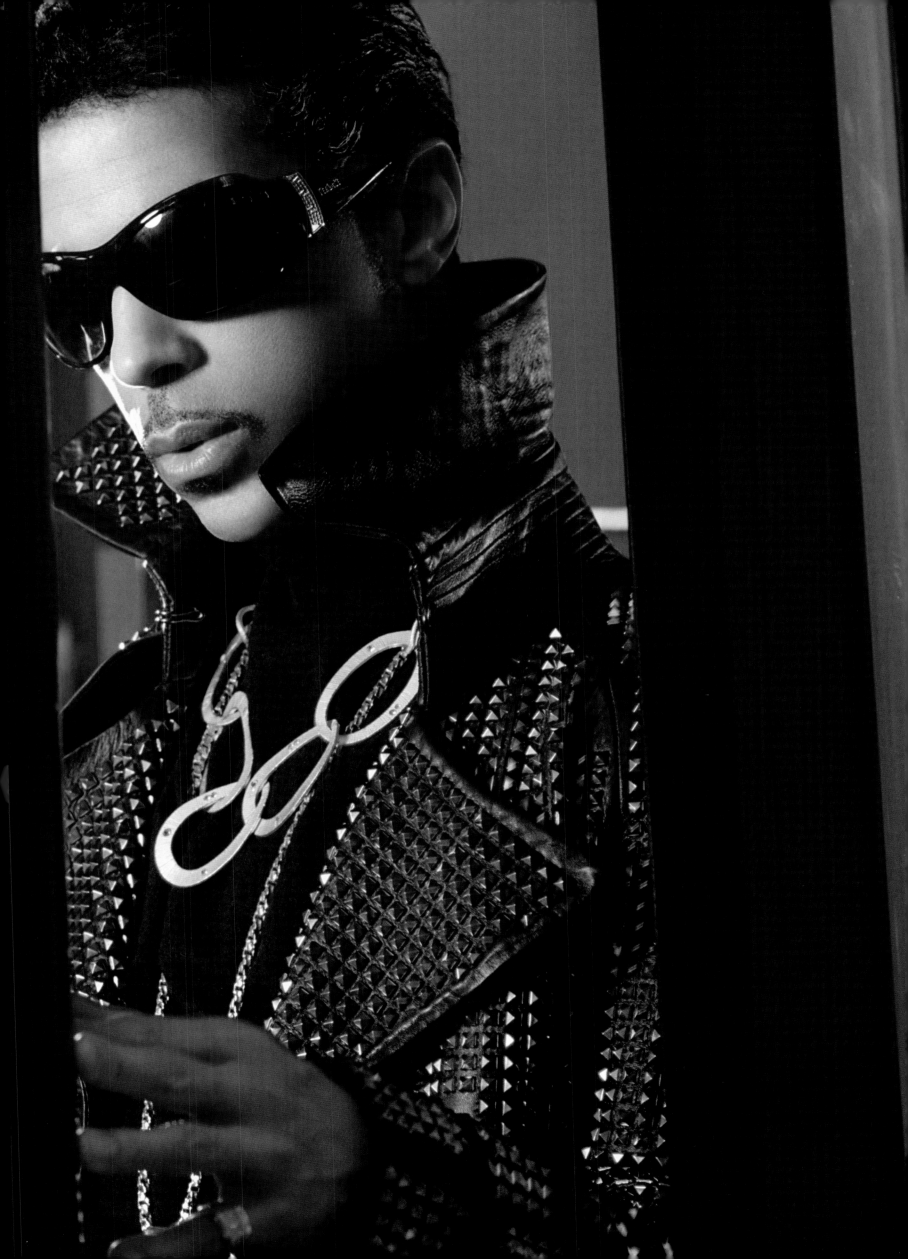

AURAS ASCENDING FRO
REPLENISH THE PROTEI

M THE VOLCANO 2 MARS
N FROM THE STARS

RESOLUTION

THE MAIN PROBLEM WITH WAR IS THAT NOBODY EVER WINS
THE NEXT GENERATION GROWS UP AND LEARNS 2 DO IT ALL OVER AGAIN
NO MATTER WHO STARTED THE ARGUMENT, JUST MATTERS HOW EACH ONE ENDS
HOW MANY PEOPLE REALLY WANT RESOLUTION?

THE MAIN PROBLEM WITH PEOPLE IS THEY NEVER DO WHAT THEY SAY
ONE MINUTE THEY WANT PEACE THEN DO EVERYTHING 2 MAKE IT GO AWAY
DROPPIN' BOMBS ON EACH OTHER IN THE ACT OF SAVING FACE
TELL ME NOW PEOPLE, HOW IS THAT RESOLUTION?

EITHER U DO OR U DON'T, EITHER U WILL OR U WON'T
MAKING AMENDS IS A DIFFICULT PILL 2 SWALLOW
WHAT CAN WE LOSE IF WE TRY?
WITH NO WATER A FLOWER DIES
WITH LOVE IN THE LEAD, RESOLUTION WILL FOLLOW

LOVE IS LIKE A CIRCLE—NO BEGINNING AND NO END
A BROKEN HEART WILL MEND IF U LOVE IT LIKE UR BEST FRIEND
HANDLE UR HEART WITH CARE, IT'S DELICATE AS THE WIND
WHEN THE STORMS COME AGAIN, PRAY 4 RESOLUTION

EITHER U WILL OR U WON'T, EITHER U DO OR U DON'T
COME ON EVERYBODY ALL OVER THE WORLD ...

1:31AM

...HOW MANY PEOPLE REA

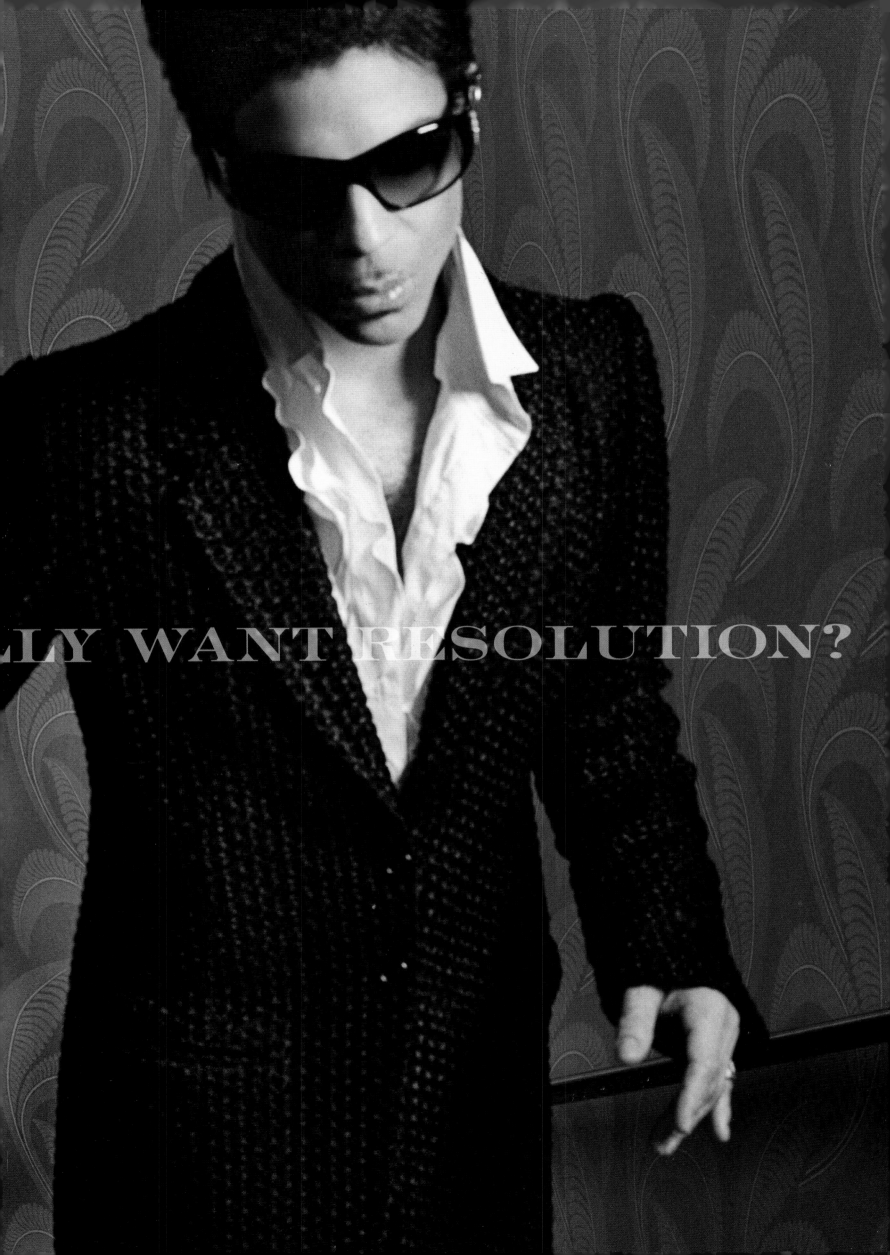

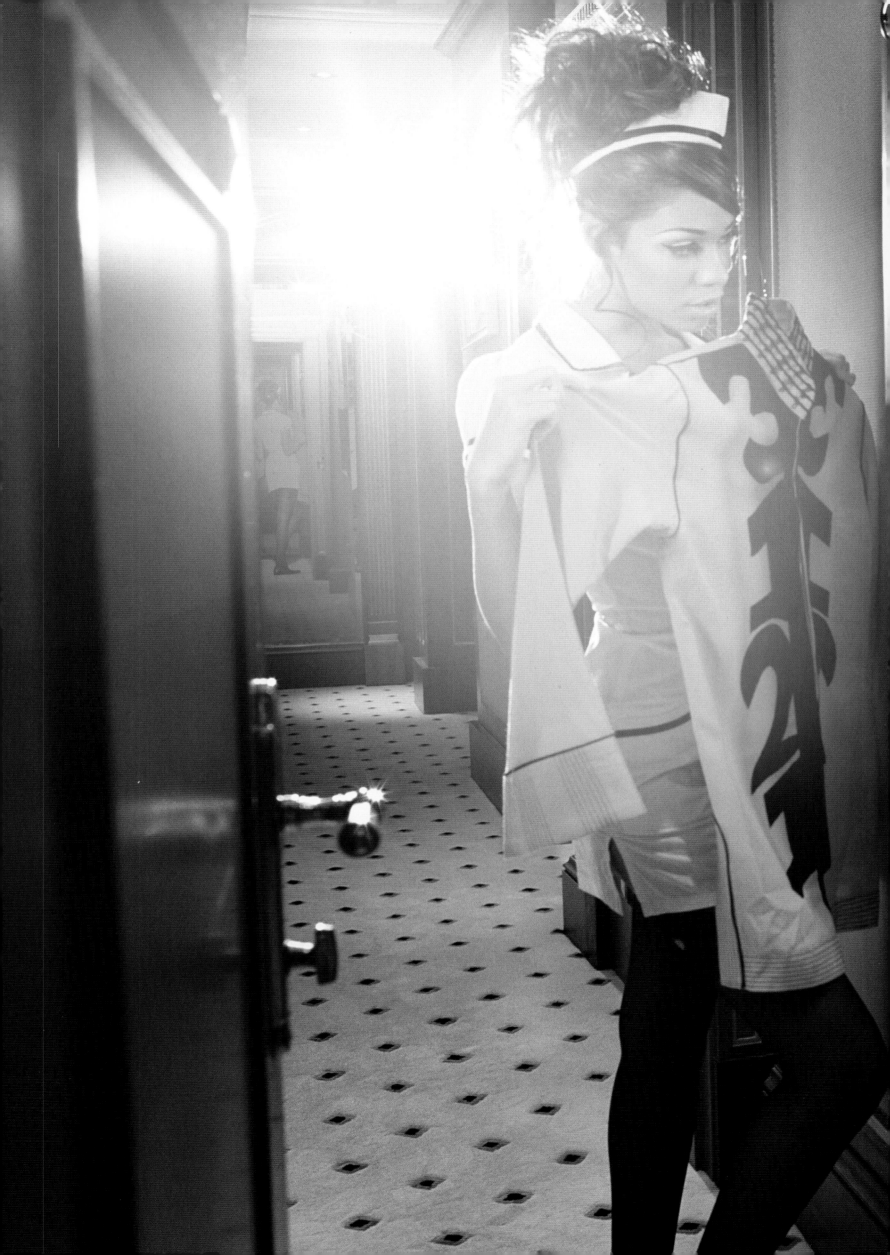

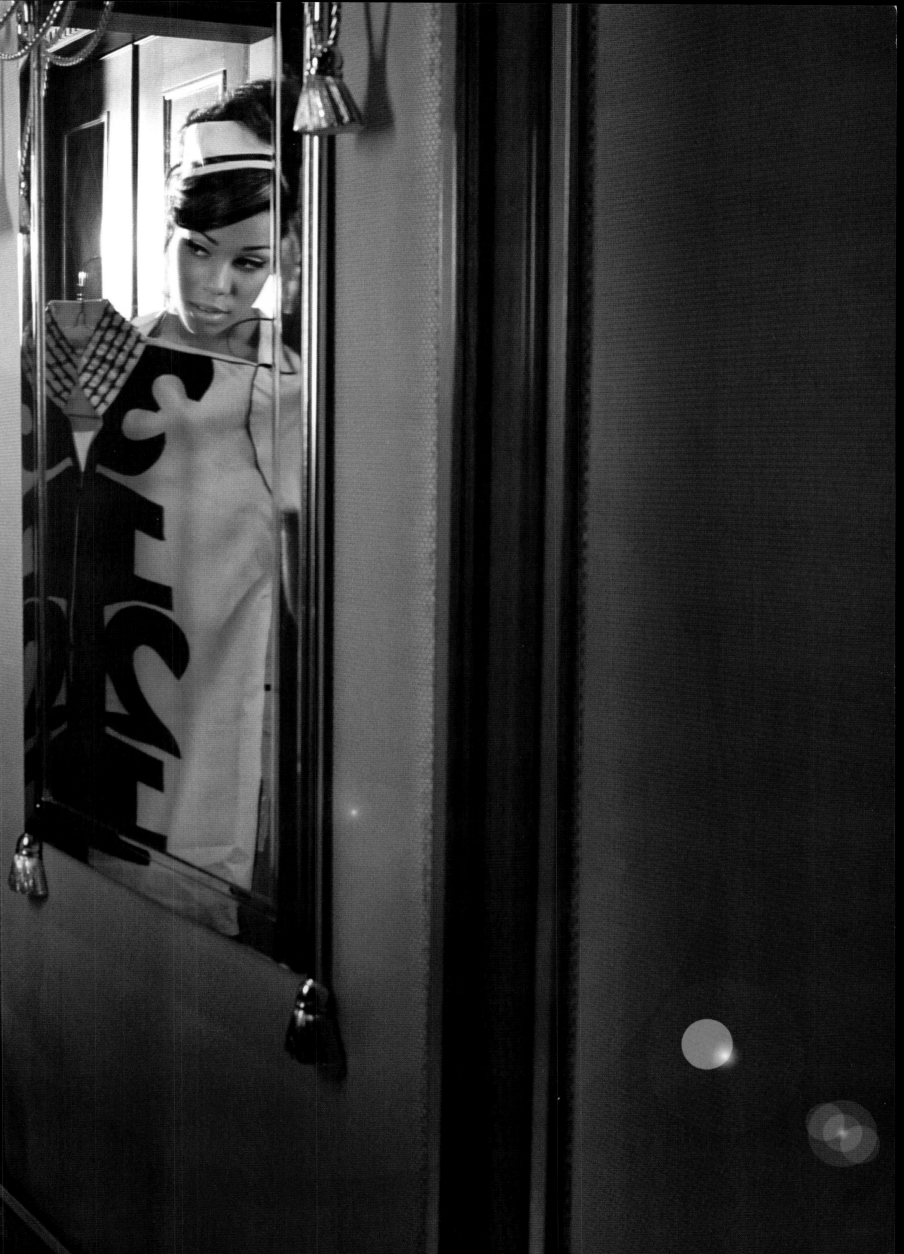

SHHH ... BREAK IT
EYE DON'T WANT N
2 HEAR THE SOUN

Thank you to the NPG ...
an eclectic band of talented artists who make amazing music,
and look really good doing it.

Greg Boyer / Horns, Trombone

Lee Hogans / Trumpet

Mike Phillips / Sax, Vocoder

Morris Hayes / Keyboards

Renato Neto / Keyboards

Josh Dunham / Bass

CC Dunham / Drums

Marva King / Vocalist

Shelby J. / Vocalist

Nandy and Maya McLean / Background Vocalists, Dancers

21 NIGHTS

STYLE SOURCE DIRECTORY

NIGHT 1 OF 21

image 2,3,4: Custom Suit Designed by
DEBORAH McGUAN;
Made by ARTURO PADILLA for
RANCHO TAILORS, Los Angeles,
www.ranchotailor.com or 310.839.5971.
Accessories: VERSACE Sunglasses gift
from Donatella Versace, Versace Boutique,
Beverly Hills, www.versace.com.
Umbrella by ASPREY, London,
www.asprey.com. Driver, the ever dapper
GRAHAM for PRO-MOTIVE
www.pro-motive.com.

NIGHT 2 OF 21

image 2,3: Custom Suit Designed by
DEBORAH McGUAN;
Made by Tony of LORDS, Los Angeles,
www.lordsusa.com.
Silk Dress Shirt by ARTURO PADILLA
for RANCHO TAILORS, Los Angeles.
Accessories: Cufflinks by JEWELS BY
HEMLA, Los Angeles 213.488.0811.
Tie by ROBERT TALBOLT, available at
www.nordstrom.com.

image 6,7,8: Coat by JASMINE DI MILO, London,
www.jasminedimilo.com.
Accessories: VERSACE Sunglasses,
NIKON Camera.
Gold and Silver Cuffs (silver cuffs worn
by Prince underneath coat) by
PHILIPPE AUDIBERT, Paris,
www.philippeaudibert.com

NIGHT 3 OF 21

image 2: Coat Designed by DEBORAH McGUAN;
Made by ARTURO PADILLA for
RANCHO TAILORS, Los Angeles.
ANDRE'S SHOES, Los Angeles,
www.andre-1.com 323.876.5565.

image 3,4: Coat by ANN DEMEULEMEESTER
www.anndemeulemeester.be, available at
Dover Street Market, London. Shirt by
GEORGES RECH www.georges-rech.fr,
available at Brown's, London.
Pants by ARTURO PADILLA for
RANCHO TAILORS, Los Angeles.
ANDRES SHOES, Los Angeles.
Accessories: Custom Bling by BELLE
EPOQUE, Los Angeles 213.488.0811 and
non-conflict diamonds by DeBEERS,
www.debeers.com. Ear Cuff's, Prince's own.

NIGHT 4 OF 21

image 3: Coat by ANN DEMEULEMEESTER
www.anndemeulemeester.be, available at
Dover Street Market, London. Shirt by
GEORGES RECH www.georges-rech.fr,
available at Brown's, London.
Pants by ARTURO PADILLA for
RANCHO TAILORS, Los Angeles.
ANDRES SHOES, Los Angeles.
Accessories: Custom Bling by BELLE
EPOQUE, Los Angeles 213.488.0811 and
non-conflict diamonds by DeBEERS,
www.debeers.com. Ear Cuff's, Prince's own.

NIGHT 5 OF 21

image 1,2: VERSACE Sunglasses,
gift from Donatella Versace.

image 3,4,5: Black Silk Shirt and Silver Suit.
Made by ARTURO PADILLA for
RANCHO TAILORS, Los Angeles.
Accessories: The Twinz imported from
Australia. Dresses by SHANGHAI TANG,
available in London and Mandarin Oriental
Hotel, Miami; www.shanghaitang.com.
EHSANI SHOES, Los Angeles,
available at www.melodyehsani.com.

NIGHT 6 OF 21

image 1,2,3,5: Red Suit by LORDS, Los Angeles.
Black Silk Shirt by ARTURO PADILLA
for RANCHO TAILORS, Los Angeles.
Dresses by SHANGHAI TANG.

image 4: Coat by ROBERTO CAVALLI,
www.robertocavalli.com.
ANDRE'S SHOES, Los Angeles.

NIGHT 7 OF 21

image 2: Custom Suit Designed by
DEBORAH McGUAN;
Made by ARTURO PADILLA for
RANCHO TAILORS, Los Angeles.

image 4,5: H&M dress, www.hm.com
EHSANI SHOES,
www.melodyehsani.com

NIGHT 8 OF 21

image 1: Manicure by O.P.I

image 5,6: Black ALEXANDER McQUEEN
Sweater, www.alexandermcqueen.com.

NIGHT 9 OF 21

image 1 & 4: CLASS by ROBERTO CAVALLI Silk
Tunic Dress, Harrods. MIU MIU
Two-toned Platform Pumps, available at
www.neimanmarcus.com.

image 2: Suits, Musicians' own.

image 5: J.GERARD Jacket, available at
J.Gerard on Melrose, Los Angeles,
www.jgerarddesignstudio.com.

image 6: Suits, Musicians' own.

NIGHT 10 OF 21

image 1: JASMINE DI MILO Sequin Dresses,
available at Harrods.

image 3,4,5,6: CLASS by ROBERTO CAVALLI
Metallic Black and White Shirt,
available at Harrods, London, or
www.neimanmarcus.com.
(image 3-holding) VIVIENNE
WESTWOOD Graphic Red and White
Tie Shirt, www.viviennewestwood.com.
(image 6-holding) High-neck Multi-colored
Ruffled ROBERTO CAVALLI Shirt.

NIGHT 11 OF 21

image 1,3: Custom Red Suit by LORDS, Los Angeles.
Sunglasses by VERSACE.

image 4: Gloves and Top, H&M www.hm.com

NIGHT 12 OF 21

image 2: Dresses by JASMINE DI MILO, London.
Hat by PHILLIP TREACY, London.

image 3: Hat by PHILLIP TREACY, London.
Shirt by ROBERTO CAVALLI.

image 4: Jacket designed by
DEBORAH McGUAN.
Made by ARTURO PADILLA for
RANCHO TAILORS, Los Angeles.

NIGHT 13 OF 21

image 1,2: Outfits by H&M, www.hm.com
Shoes, by GUISEPPE ZANNOTTI,
available at www.neimanmarcus.com.

image 3,4: Tops, Hot Pants and Hose by H&M,
EHSANI SHOES. available through
www.melodyehsani.com
Shirt and Jacket by ROBERTO CAVALLI.

NIGHT 14 OF 21

image 2: Outfits by H&M
Shoes by GUISEPPE ZANOTTI.

image 3: Shirt by ROBERTO CAVALLI.

image 4: Jacket Designed by
DEBORAH McGUAN;
Made by ARTURO PADILLA for
RANCHO TAILORS, Los Angeles.

NIGHT 15 OF 21

image 2,3: All Coats by JASMINE DI MILO,
London. Available at Harrod's.
Leggings by AMERICAN APPAREL.
www.americanapparel.net
Sunglasses by VERSACE.
Symbol Bling by BELLE EPOQUE,
Los Angeles.

image 6,7,8,9,10: Electric Blue Sequin Dress by
MATTHEW WILLIAMSON,
www.matthewwilliamson.com
Black 3/4-length Wool Coat by
DIANE VON FURSTENBURG,
www.dvf.com.
DIOR Sunglasses and
CHRISTIAN DIOR Snake Skin
Strappy Sandals. www.dior.com.
VERSACE Navy Blue Coat and
Sunglasses. www.versace.com D&G
Camisole. www.d&g.com.
GAULTIER skirt, MIU MIU Black
Patent Knee-length Boots and
BURBERRY Patent Full-length Gloves
all available at www.net-a-porter.com.
MATHEW WILLIAMSON Purple
Wool Coat, www.matthewwilliamson.com.

NIGHT 16 OF 21

image 2,3,5: Custom Silk Suit and Cufflinks by
CHRIS BEALS, London.
Shirt by GEORGES RECH,
available at Vivaldi : 212.734.2805.

image 6,7: Black Knit Lace D&G Camisole.
GAULTIER Skirt.
Fabulous CHRISTIAN LOUBOUTIN
Slingback Pumps.
Accessories: VERIZON WIRELESS
GLOBAL BLACKBERRY, courtesy of
Jeff Martin. VERIZON WIRELESS
LG PHONE, available at
www.verizonwireless.com.
iPOD and APPLE COMPUTER,
courtesy of Thuy-An Julien, available at
Apple Stores nationwide.
Patent Leather Tote VIA REPUBBLICA,
available at www.nordstrom.com.

image 9: Burnt-orange Treated Sweater
ALEXANDER McQUEEN, Black Silk
Slacks by CHRIS BEALS, London.
Black Cut-out Blouse CLASS by
ROBERTO CAVALLI,
www.robertocavalli.com.
Asymetrical Black Skirt,
VIVIENNE WESTWOOD.
Accessories: BURBERRY Patent Leather
Belt, www.burberry.com.
Emerald-cut Amethyst Ring encased
in gold, by DIOR.

NIGHT 17 OF 21

image 3: Ambience created by JO MALONE
candles available at www.jomalone.com or
www.neimanmarcus.com.

image 4: 'Ilona' Necklace PAUL & JOE
available at www.net-a-porter.com.

image 5: Symbol Bling by BELLE EPOQUE,
Los Angeles.

NIGHT 18 OF 21

image 2,3,4: BURBERRY Full-length Studded
Trench Coat, www.burberry.com and
www.net-a-porter.com.
VERSACE Sunglasses.

image 5,6: Edwardian Silk Multi-colored Shirt and
Coat by ROBERTO CAVALLI.
Non-conflict diamonds by DeBEERS.

NIGHT 19 OF 21

image 1,2,3,4: Black Leather Corset Belt and Studded
Platforms by BURBERRY,
www.burberry.com and
www.net-a-porter.com. Red Silk Cape
dress by MATTHEW WILLIAMSON,
London. White VERSACE Coat with Silver
Hardware, gift from Donatella Versace.
White Ruffled GEORGES RECH Shirt.
Accessories: Black Leather Corset Belt
and Studded Platforms by BURBERRY,
available at www.burberry.com and
www.net-a-porter.com.
VERSACE sunglasses.

NIGHT 20 OF 21

image 2,3,4: BURBERRY Full-length Studded
Trench Coat, www.burberry.com and
www.net-a-porter.com. Black Silk
Turtleneck LOUIS VUITTON.
VERSACE sunglasses.

NIGHT 21 OF 21

image 1: Coat by ANN DEMEULEMEESTER,
Shirt by GEORGES RECH, available at
Harrods, London.
Pants by ARTURO PADILLA for
RANCHO TAILORS, Los Angeles.

3121

GIRLS AND BOYS

SONG OF THE HEART

DELIRIOUS

JUST LIKE U (monologue)

SATISFIED

BEGGIN' WOMAN BLUES

ROCK STEADY / featuring Beverly Knight

WHOLE LOTTA LOVE

ALPHABET STREET

INDIGO NIGHTS

MISTY BLUE / featuring Shelby J.

BABY LOVE / featuring Shelby J.

THE ONE

ALL THE CRITICS LOVE U IN LONDON

PRINCE / INDIGO NIGHTS / LIVE SESSIONS

All songs composed by Prince except:

"3121"
(Prince)
Intro contains renditions of "The Entertainer" (Scott Joplin). "Alexander's Ragtime Band"
(Irving Berlin), Irving Berlin Music Company (ASCAP) All Rights Reserved. "Music, Music, Music"
(Bernie Baum/Stephan Weiss), Warner/Chappell Music, Inc./Anne-Rachel Music Corporation (ASCAP),
Bughouse (ASCAP), All Rights Reserved.

"BEGGIN' WOMAN BLUES"
(Prince/Joseph Pleasant/Ben Raleigh/Hilda Taylor)
Universal Music Corporation/Emancipated Music, Inc. (ASCAP) / Songs of Universal, Inc. (BMI) /
Wise Brothers Music LLC (ASCAP) / Edward B. Marks Music Company (BMI).
Contains interpolations of "Beggin Woman" (J. Pleasant) Songs of Universal, Inc. (BMI) and
"Three Handed Woman" (B. Raleigh/H. Taylor) Wise Brothers Music LLC (ASCAP)
and Edward B. Marks Music Company (BMI). Used by permission. All Rights Reserved.

"ROCK STEADY" / featuring Beverly Knight
(Aretha Franklin)
Springtime Music (BMI), All Rights Reserved.

"WHOLE LOTTA LOVE"
(John Baldwin / John Bonham / James Patrick Page / Robert A Plant)
WB Music Corp./Flames Of Albion Music (ASCAP), All Rights Reserved.

"MISTY BLUE" / featuring Shelby J.
(Bob Montgomery)
Cherry River Music Co./Dimensional Songs of the Knoll (BMI), Talmont Music (BMI), All Rights Reserved.

"BABY LOVE" / featuring Shelby J.
(Jerry Seay)
Satsong Music (ASCAP) All Rights Reserved.